Highland Sketchbook

A YEAR IN GLEN ESK

DEREK ROBERTSON

HarperCollins*Publishers*

First Published 1992
© Derek Robertson 1992

ISBN 0 00 434590 8

Reprint 9 8 7 6 5 4 3 2 1 0

A catalogue record for this book is
available from the British Library

Printed in Hong Kong

Contents

For Deirdrie

who tolerates dead birds in the fridge
and a temperamental artist in the house.
Without her, this book could not have been written.

Burn Names

Where the Branny turns its quern
And Deuchary's a black clay burn,
The Gealet's slope is short, abrupt,
Badlessie, the enclosure's tuft,
Bennyglower chatters, clattering sound,
Adedazzle moves deiseil right around

Burn of Cochlie, place of husks,
Burn of Keenie, deep in moss,
Dalbrack in its dappled dell,
Burn of Bathie, cowbyres' smell,
Burn of Corlick with its stepping stone
Ademannoch's trout, the monks' own.

Burn of Reehewan is the slope of Ewan,
Corriehausherun's folk run in a band,
But the Waters of Mark and Tarf and Cat
Belong to the clans of Horse, Bull, Wildcat,
Whose totems warn you're in their territory:
They were here and always will be.

Valerie Gillies, M.A., M. Litt., F.S.A. Scot.
August 1991

Introduction

As a child, I grew to love two landscapes: the rolling hills of the Fife countryside where I was raised, and the rugged, open horizons of the Coigach peninsula in Wester Ross where I went on family holidays. It wasn't until my late teens that I was introduced to the Angus glens, and found there Lowland woods and meadows meeting with the wild moor and hillside of the Highlands. It was inevitable that I should fall in love with this landscape too.

I can't remember starting to draw and paint or becoming interested in the wildlife and countryside around me. It was something that was always there. I explored the fields and woods around my parents' house in ever widening circles and spent rainy days indoors, drawing from books and assembling vast and often, I am told, unpleasant collections of just about anything I could find, catch or carry back from my expeditions. As I grew older, I took voluntary work on nature reserves for weeks on end. I began to pack sketchbooks on my journeys and spent more and more time drawing my subjects from life. When I returned home, I would often spend days working up paintings from these sketches. I was also looking at the work of others, the painters of the Renaissance, the Impressionists, Surrealists and even modern abstract painters and sculptors. So, in a sense, I didn't consciously decide to become an artist. I just knew that I wanted to spend as much time as I could drawing, painting and experiencing the wildlife and countryside that I loved. Four years at art college further broadened my artistic horizons, and it was during this time, after two years of training, that I gained a ringing licence from the British Trust for Ornithology. I was now able to develop a deeper understanding of the birds I painted by observing and sketching them in the hand.

Every glen has its own character but most of the plants and animals in this book may be found in any of the other Scottish glens. What made me choose Glen Esk for this project was its proximity and the variety of its structure. Entering the glen through the foothills of the Highlands, you leave behind the Lowland woods and fields. At first the glen is a shallow valley through which the River Esk curves in wide, horseshoe loops around gravel banks and islands. The valley-floor is a rolling terrain of mounds and sandy hillocks formed by glacial deposition, and on the hillsides are stretches of birchwood and pockets of conifer plantation. Further up, the glen narrows, the hillsides steepen and the road and river travel together through the birchwoods. Beyond these, the glen opens up onto pasture and wet meadow land. Gaining height now, the ground gives way to moorland and heather, and the metalled roads end. The river is narrower and faster. Here, it splits into branches that pass through dramatic fissures and ice-gouged gorges where birches and rowans cling onto inaccessible ledges. Above there, the branches split again and again as you climb up the small valleys that cut into the hills. Finally, the sources of the Esk are reached; threads of water trickling through mossy bog and peat or sulking, black lochans, cradled below the face of ice-gouged corries. Above here is the open heather of the

hilltops and, on the remote summits, fragments of relict, tundra vegetation.

It is this sense of journey that I have tried to convey by progressing, month by month, up the glen, to give a sense of a particular time and place in each of the paintings and sketches. Of course, this book is not a planned list of examples showing what is to be found in each locality. It couldn't be. In the same way that habitats have no rigid boundaries, I have not tried to impose precise restrictions on what I should paint and where, but have tried to give a flavour of the place through each of the incidents I have depicted. Sometimes there were particular animals that I wanted to portray - a badger, a wildcat and fox cubs - and I spent a considerable amount of time trying to find them, but for the most part I relied on chance encounters. I often went to a suitable area and waited for something to happen. Something always did because there is always something new and exciting going on if you look and listen, and are aware of the natural world around you. So I have tried to depict the unexpected events and coincidences, as well as the familiar experiences, that made up my year in the glen.

The landscape of the glen, although rich in flora and fauna, has been shaped extensively by the hands of men, and working in the countryside, one becomes aware of the history of the landscape. Because agriculture is less intense here, the evidence of past generations is more visible and, perhaps because of the desolate nature of the glens, their passing is more deeply felt. Looking out over the Bronze Age field systems, burial grounds and stone circles, the Iron Age forts and medieval castles, or the ruins of deserted crofts, I often feel as if I am standing in the presence of ghosts.

Under human influence the landscape in the glen is still changing, sometimes for the better but all too often for the worse. Every year, more and more areas of marshy ground and wet field corners are drained and ploughed. Returning to a field that last year was alive with breeding waders and covered in marsh flowers, I have often found a quiet, sad stretch of green pasture. Glen Esk has mercifully been spared much large-scale conifer planting but nearby, vast tracts of moorland and hillside, the breeding sites of endangered birds of prey, have been smothered by a canopy of pine and spruce. Landowners and farmers cannot be expected to sacrifice their livelihoods, and it has been their land management in the past that has made the glens what they are today, but if we truly value our natural heritage then I think we have to question the fact that taxpayers' money is actually subsidising some of these destructive schemes, and ask ourselves how much we are prepared to pay to protect these habitats and the plants and animals that they support. Apart from damage to their habitat, other threats face birds of prey in the Angus glens. During the time I was preparing this book, there were incidents of illegal egg theft, persecution and poison baiting in the area I was working. A friend found a hen's egg that had been injected with enough poison to kill eight people. He was wise enough to handle it carefully because the substance it contained, phosdrin, can be absorbed through the skin with fatal consequences. The egg had obviously been set out to kill crows, but with a total disregard for the safety of protected birds of prey, pets and, of course, people.

Working in the glen

For me, art is about learning – learning about what you are portraying and finding out something about yourself at the same time. Perhaps this book will show you something of what I saw and experienced, and a little of what I learned, while I was in the glen. I hope so. I also hope that it gives you a flavour of the rich diversity of wildlife that can be found in the Scottish Highlands. If I tried to do the work over again, I do not think that it would look the same. I would miss the incidents that made up this book, and another set of events would catch my attention.

I really enjoy working from life, not just for the opportunity to learn more about my subjects but also to experience the spontaneous and exciting moments that can fuel my imagination. By portraying these events, I enter vicariously into the natural world of these creatures, a world that runs parallel to our own; a world of drama, violence, and passion from which we have become separated by a fragile layer of civilisation. It is this immediacy of life's struggle and the immutable forces of nature that may, I think, be what I am striving for in my paintings; that and the delight of creating something 'living' from the making of marks on a blank page.

However, the wildlife artist's struggle can be more than aesthetic, especially when your chosen subjects are unpredictable, secretive and highly mobile. Add to that a changeable climate and rugged terrain, and the question on my mind soon turns from 'What is the meaning of Art?' to 'Why didn't I bring my anorak?' Over the course of the year, I have contended with all that the elements could throw at me: downpours of rain and running watercolour paint, several soakings in heavy mist, thunderstorms, snow, freezing fog that turns paper to ice; freezing paint and freezing fingers, not to mention a rucksack full of snow, an impromptu tobogganing trip down a hillside and the occasional undignified tumble into a burn. However, bad weather isn't the only difficulty – good weather can bring its own set of problems. There were midges and mosquitoes; nettles and thistles; sore eyes from drawing on white paper on a sunny day; even mild sunstroke (believe it or not). And then there was the collapsing fence and the dive-bombing gulls. I have had sketches washed out by rain and snow; frozen solid; dropped in burns; crushed in my rucksack and spattered with bird-droppings. The last I saw of one particular sketch was as it disappeared over the hillside, caught in a strong wind, and heading in the general direction of Aberdeen.

When I am drawing out of doors, I usually take as much equipment as I can comfortably carry with me in a rucksack. Usually this is a couple of sketchbooks, a pencil case with pencils, pens, conté, rubbers and sharpeners, a watercolour box with brushes, a tube of white watercolour paint and a small bottle of water. If I think I can carry them to where I am heading, I take some sheets of plain and coloured paper stretched on a small drawing board. Binoculars, telescope and tripod battle for space with waterproof clothing, sandwiches and a flask of coffee. I try to include a couple of small glass jars to carry back plants or insects I can't identify on the spot (bino-

culars turned the wrong way round make a good magnifying glass for inspecting small details). Sometimes, I also need to take a portable, canvas hide, rolled up and tied to the top of the rucksack. Once all this is packed I usually have to unpack it again and make a few rationalisations before I am sure that I can carry it to wherever I am going.

I try to finish off as much of the paintings as I can out in the field, while my subjects are actually in front of me, but this isn't always possible so, sometimes, I 'tidy up' the work in the studio by referring to notes I have made at the time. Often the drawing looks quite satisfactory in its sketched state and any more work would make it look stilted and awkward, so I just leave it the way it is. Some of the more polished work – especially the oil paintings – are put together from field sketches entirely in the studio. Most of the details of how the paintings were completed are given in the text of the diary. The diary entries, incidentally, were written either soon after the events they describe, back in the studio, or were jotted down on the spot.

I have been privileged to have been able to spend a whole year exploring Glen Esk in words and paintings. The progression of the seasons and the journey from the foot of the glen to the summits took on a sense of pilgrimage, one of physical, artistic and spiritual discovery; in the same way, perhaps, that art can look inward and outward at the same time. This may seem pretentious, but to look out over the snow-swept vista of the glen from the high tops on a bright, winter morning and watch an eagle cast its shadow across the hillsides and over the boiling, brown waters of the river that runs through ice-bound chasms far below is a truly inspirational experience that has an almost religious quality. Such experiences convince me that the natural world should be cherished, not only because we rely on its bounty for our own survival, but for its innate beauty and its power to make us acknowledge and question our own place in a greater scheme of things.

Some words of advice

The countryside should always be treated with respect which means that you should always follow the Country Code, and remember that people on the land earn their living from it. Many species of birds and some mammals are specially protected by law and their nests and young must not be disturbed without special permits from the National Environment Research Council. However, the nests and young of all wild animals should be treated with care, and disturbance should always be kept to a minimum.

Finally, be aware of the dangers of walking and climbing on the hills, especially in winter. Every year people are killed and injured on the Scottish mountains, so do not risk your safety, and that of the rescue services, by venturing onto the hills ill-equipped, ill-prepared or without the necessary experience for your planned journey.

Acknowledgements

I would like to thank the many people who have helped me in the course of preparing this book. Firstly, my publishers at HarperCollins in Glasgow, and especially James Carney for his advice and enthusiasm. My thanks also go to the landowners, farmers, gamekeepers and other residents of the glen who allowed me access to their land and generously gave me information and advice. I also received a great deal of help from local naturalists, especially from fellow members of the Tay Ringing Group, and I would like to specifically thank Steve Moyes, Mike Nicol and Mathew Sleaman.

Derek Robertson 1992

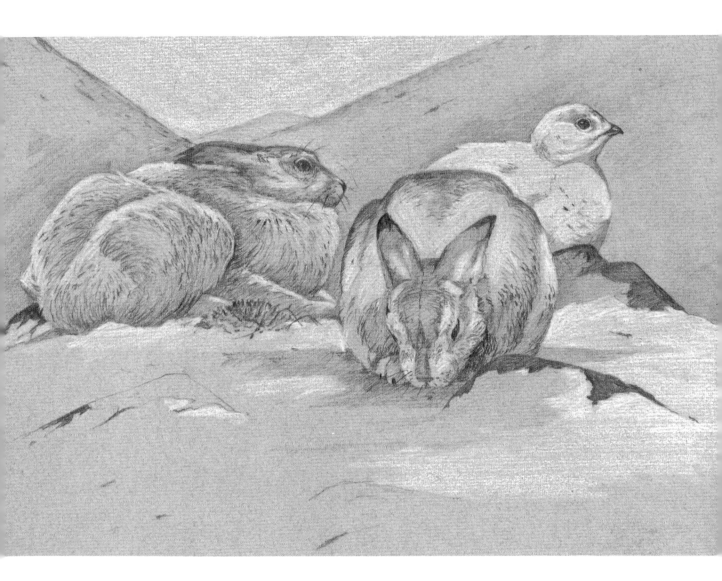

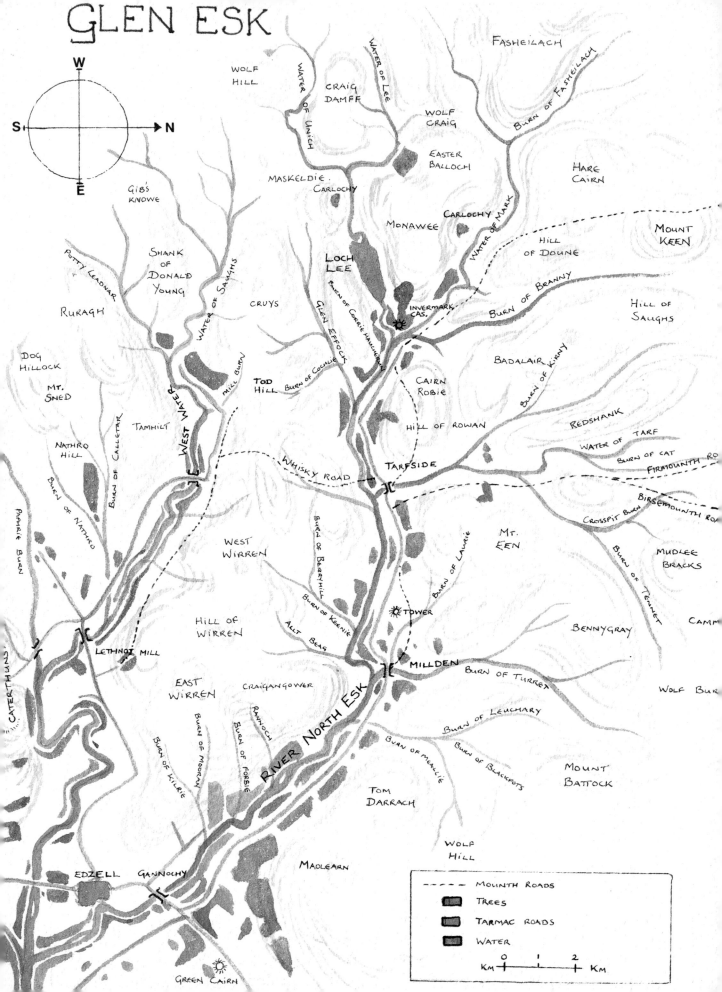

March • The glen mouth

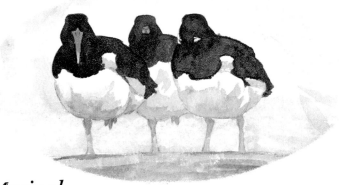

Thursday 1st Arrival

I suppose that it was the sudden, warm weather that brought me to the glen mouth today. Winter's spell seems to have broken, its last fury spent. Branches and fallen trees are strewn at the road's edge and my car splashes through fresh puddles.

Here, at the foot of the glen, I can see the last wisps of snow clinging to the hills and the rivers have burst their banks with the spring melt-water. The river is the life force of the glen. It has the most ancient of names, 'Esk', a name perhaps given by the first settlers. It means simply, 'water' (*uisge* is the Gaelic word for water, still used by a handful of people in the district). It now overflows with new life and the flood pools team with birds flocking in expectation of the new season.

I stay and watch at a particular pool that I know, lush with rushes and green moss. Birds have gathered here anticipating spring, oystercatchers, gulls, curlew and redshank heralding the new season. The birds' plumages hold a secret code, a series of maps and ciphers often hidden to us. Faint traces of winter plumage are still etched upon these birds but a flush of spring colour is emerging, flowing through skin and bill and eye.

There is a thrill of excitement in the flocks, an uncertainty between them. Some are about to fly up into the glen to nest but are not yet ready to breach the pass up-river. Some will go further afield. The wigeon that wait on the banks and swim in the pool will soon depart on journeys that may take them beyond the Arctic Circle: the birds of winter leaving. They are torn between their deep-winter instincts to flock and to hold to the water, and the necessity to disperse, to pair and to breed. They are enacting an ancient spring ritual that stretches back beyond man's time in the glen. As if to remind me of this there is a flat-topped mound that reaches up beside the pool: the Green Cairn, an Iron-Age fort that once stood guard at the entrance to the glen.

The tensions in the flocks differ. Oystercatchers and curlews brood on a mud bank and the wigeon murmur together in subdued excitement but the gulls chatter and flurry, bathing and splashing at the pools' edge. In a sudden explosion of wings they lift into the air and sweep out into the fields.

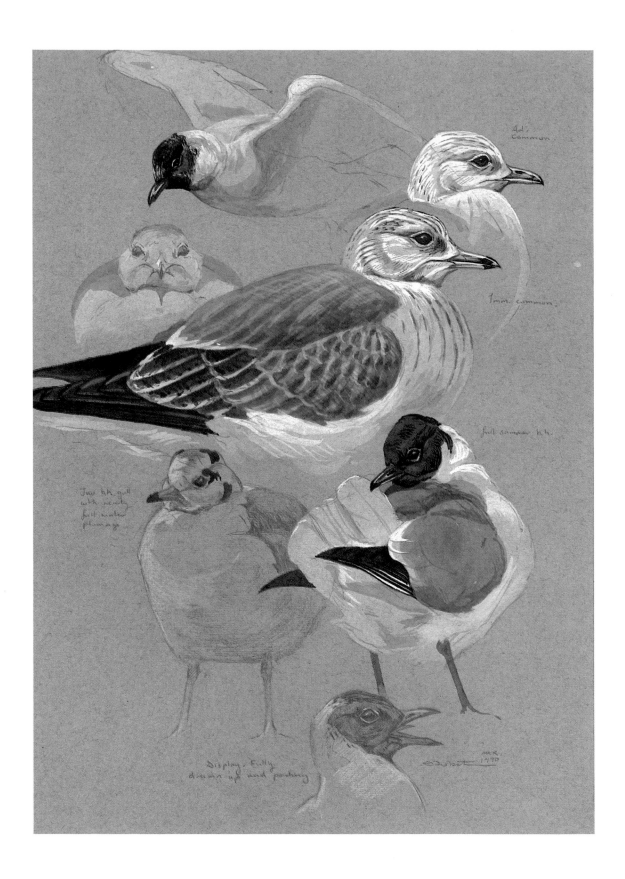

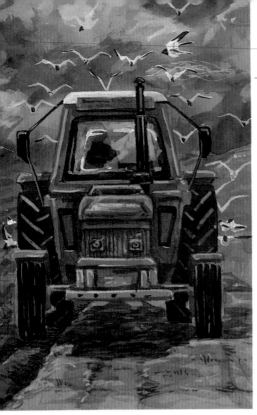

Saturday 3rd *Ploughing*

Long before I arrive at the pools I can hear the gulls. Not at the secluded pond where I saw them before, today they are dancing in a white cloud behind a tractor that cuts rich, red-brown swathes through the turf. A hundred sharp eyes or more scan over the newly broken ground.

This turning of the earth seems to echo the season which is emerging around me. Spring is breaking out from winter's grasp; shoots and buds are emerging, even snowdrops are beginning to show below the field hedges. The gulls' excitement is infectious. Oystercatchers are 'piping' in the fields, following just behind the white clamour that harries every swathe of the plough. Now and then a pair will fly to a far corner of the field and dance around one another in intricate courtships.

The weather is warm and breezy but frost still clings to the shadowed lee of the hedge where an old horse-plough lies among the snowdrops. In the next field, two Clydesdale horses graze idly, their steamy breath lit between the warm sun and the cold air. The tractor thunders by me with its wake of gulls.

Spring seems to have a powerful scent all of its own. A sweet smell almost, that emanates from the plants and trees and from the very soil itself. As the tractor passed I could smell the rich loam sweetened with green grass. Sap rises in the dead-looking twigs and branches or pushes in green swords from the turf. Even the chaffinch seems to have a strange fragrance in his song.

I had become so enthralled by the chaffinch's song that I was unaware that it has become overcast and I suddenly notice that I am cold. Like the sun, the chaffinch, too, has hidden, and the wind whips the top branches of the ash tree where he was singing moments before. I didn't see him go.

from ploughed field near the Green Cairn.
MARCH '90

A melancholy overtakes me and the old plough seems to have a special poignancy. I pick up a piece of leather that is sticking out of the new furrows. It is an old piece of shoe with rusty, copper-blue lace holes. Perhaps it belonged

to a farmhand who drew the old plough, now in the hedge, perhaps even with some ancestor of the Clydesdales in the next field. The feeling of loss is heightened by eerie bird calls far above me. I can't see them above the clouds but the golden plovers seem to lament this sudden loss of spring. They are flying off the high hills where they were exploring and I can see the band of black cloud which swept them out of the glen (perhaps it is not yet ready to receive its summer guests). Strange how you can almost taste snow even before it begins to fall and the air now seems to be laden with it. There is an old rhyme in this district about the golden plover. They are supposed to give advice to the ploughman and sing, 'Plough weel, shave [sow] weel, harrow weel.' The tractor man seems to be taking heed of their warning and hurriedly finishes the last row before the weather closes in. I hadn't walked back to the end of the field before the first snow-flakes began to drift over the hedge-top.

Sunday 4th *Late snow*

I visited the pools again. Snow is dusted over the fields and lies crisp in the shadows. The pool has a thin film of ice but at one end it is thicker and gulls stand on it, preening quietly. All is subdued, waiting for spring to resume its course. The oyster-catchers are packed in a tight flock and the wigeon are hidden behind the rushes. Flakes of snow whip across the field. Blown off the hills, they seem to be part of the fierce, chill wind itself.

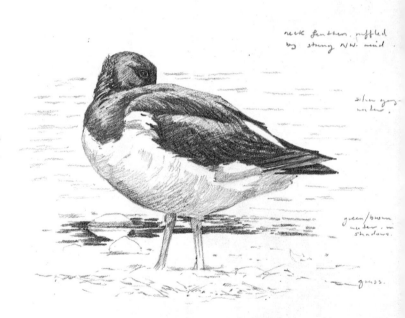

Tuesday 6th *Drying out*

I took a hide to the pool edge and waited for the birds to settle. On my first visit six days ago, some 500 wigeon swarmed over the Green Cairn when I splashed my way through the rushes but now there is only one left. She is hiding in a small puddle at the far end. The water level is dropping, creeping back to the lines of rushes where some puddles remain in moist moss throughout the year.

The first, unruly burst of spring has ended and all is settling down into its accepted course. With the departure of the winter birds, some of the tension has subsided; the frantic bathing and preening, needed to burn up the gulls' excitement, is now less frequent, less intense.

head moulting in
adult.

b.h— gulls.

swimming

moulting

bathing

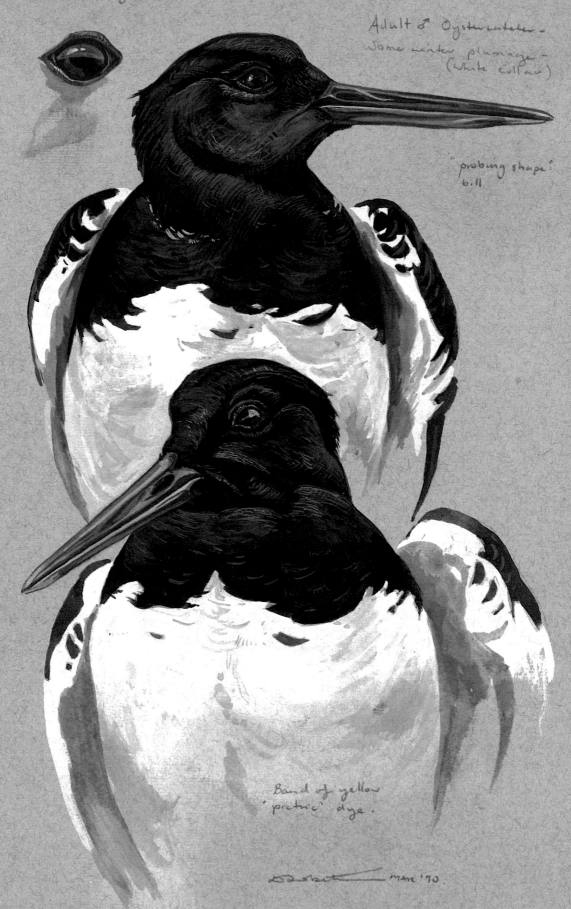

'detail of "keyhole" - shaped iris'

Adult ♂ Oystercatcher -
Some winter plumage -
(white collar)

"probing shape"
bill

Band of yellow
'picric' dye.

Sunday 11th *Drawings*

Short, jerky lines scratching across the pages. Pages and pages of pencil marks fill my sketchbooks in a welter of half-finished lines and thoughts. Here and there some scribbled words appear among the emerging forms. 'Cold, blue, morning light from side. Whole body in shadow.' Many are enigmas merging with one drawing or another where a bird's head or wing appears for a moment from the chaos and then flits back into smudged obscurity.

Now and again I turn a page to find an image frozen, complete. An oystercatcher captured between the leaves of the book; texture, light and the liquid gleam of an eye. Spring's restlessness seems to flow unchecked and, unable to linger on the vitality of its heralds, these drawings become a direct involvement in the movement and excitement of the season. Sitting in my hide, drawing frantically, the process becomes a meditation. The object is no longer to portray what I see but is an automatic reaction to light, movement, sound. Tired, my legs becoming sore, I have to stop and there is a sudden stillness on the pool. Did the movement really end when I finished drawing? The mood of the setting seems to have changed, or more probably, my own perception of it and the whole atmosphere, the emotions that it inspires, seems to be conveyed by these oystercatchers.

A small flock waiting quietly on the point. Intrigued, I have to make one more drawing.

Wednesday 14th *Painting*

Wet weather and low, grey clouds. Visiting the glen mouth seems unnecessary today when my studio is full of sketches and notes. Tokens snatched during the passage of spring.

I spend today painting the small flock of oystercatchers, trying to re-create the feeling of the original experience. The sketches that I made of them are pinned up against one wall and I can still see the scene in my mind's eye: birds, water, sky, light.

If the sketches were a direct, automatic involvement in the experience of the place, then this painting is more of a reflection. I am trying to express the particular moment that impressed the experience upon me, to evoke the emotions that the event instilled in me, an abstracted response that goes beyond the image of six oystercatchers on a muddy point. The hypnotic efforts of painting take me back to the original scene and, in creating the image, I feel so identified with the subject as to be temporarily a part of its very existence. I seem no longer to exist outwith the image. A medium between paint, brushstrokes and the subject itself, caught up in spring's creation.

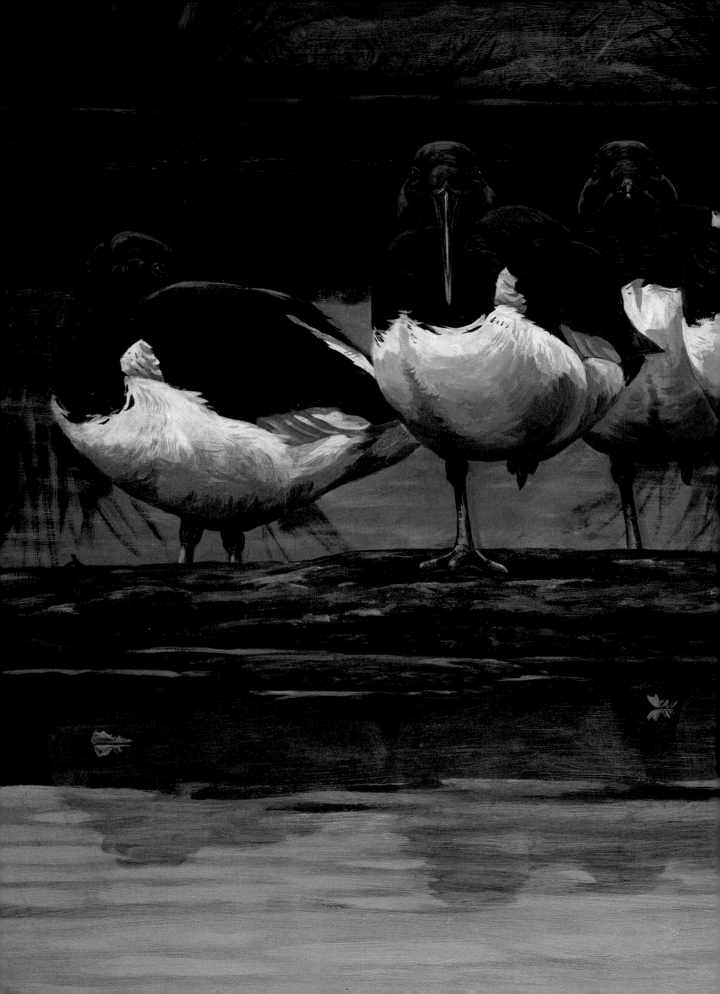

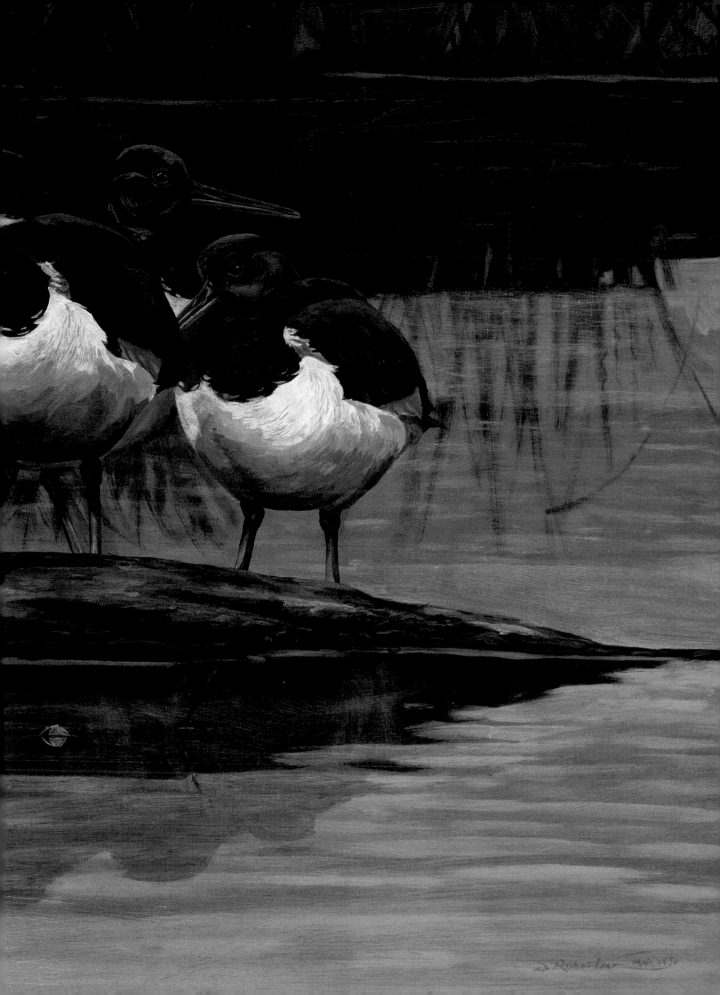

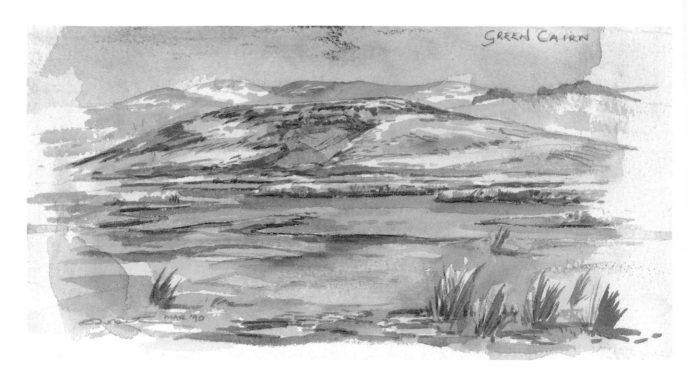

GREEN CAIRN

Wednesday / Thursday 28th/29th *Mist netting*

Every year members of the Tay Ringing Group catch birds on the flooded pools at the mouth of the glen. The recoveries of these birds show their movements up into the glens to breed and their subsequent wintering grounds. Some of the birds we retrap ourselves by cannon-netting on the coast. Others turn up further afield.

We met at the Green Cairn at 8 o'clock, just before it got dark, so that it would be easier to put up the nets. Steve Moyes, Matthew Sleaman, Mike Nicoll and myself put up seven nets, strung between bamboo poles. In the dark, birds fly into the loose material of the net which forms a pocket in which they are caught.

The conditions are perfect. The moon is only a faint sliver disc and is obscured by cloud so it will be a dark night. The birds will not be able to see the nets strung across the pool when they fly in to roost. The oystercatchers and curlews will be marked with coloured dye as well as the usual metal rings so that we can see where they are breeding and how far from the pool they travel before setting up territory. The dye will only last a few months until the birds moult in the winter.

While the others mark the birds and take notes of age, sex, weight and measurements, I go to extract the birds from the nets. On the first trip to the net things look good. A few trips later and things really begin to get busy. The nets are so full of birds that they begin to sag in the middle and I have to raise them higher. Between trips I help to process a few birds but always have to get back quickly to extract more. At one point the nets are so full that I have to close half of them up but even when I leave I can see as many birds caught as I am carrying away.

It is pitch black and I cannot use a torch to help me see because I might scare birds away or show up the nets in the torch-light. I have to use my sense of touch to carefully remove the birds. I can only make out their general form in the faint gleam

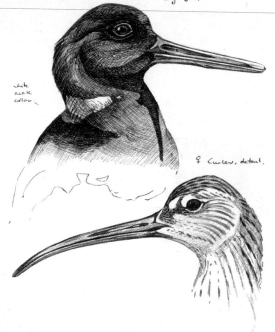

reflected from the water. As I work, birds are flying above me and I can hear dozens of wings flapping through the air and the swish of birds catching in the net only a few feet away. However, the most potent impression is given by the birds' calls: weird and eerie piping, bubbling notes like some loud and macabre lament. I can pick out the different birds by their voices: the high pitched fluting of the redshank, the excited 'kleep-kleep-kleep' of the oystercatchers and the almost human quality of the curlews' wailing. In this isolated place, with

my sight restricted to shades of dark grey, the feeling of disorientation is intense but excit-ing. These creatures are inhabitants of a strange world and for a few hours I am caught up among them.

By one o'clock in the morning it begins to get a little quieter and I am able to have a closer look at some of the birds that I have been drawing here over the past few weeks and examine the subtler aspects of their plumage. Our torches begin to run out and we realise that we have only just enough rings to mark the birds we have caught so far. As the wind begins to pick up we pack away the nets and concentrate on finishing the birds that we have caught.

One or two birds have rings from previous years and we will be able to check up on their details later. Many of the oystercatchers

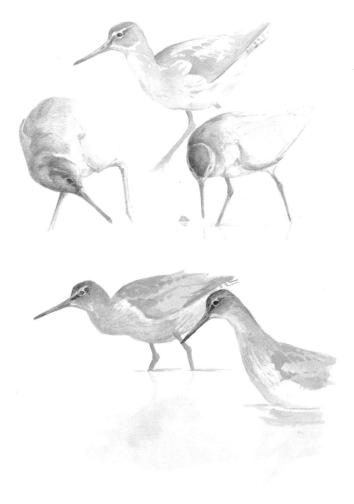

have lost toes. The wounds are completely healed but we caught one that already had strands of wool wrapped around its foot. If left, the wool tightens on the toes which swell up, cutting off the blood supply until the dead tissue falls off or the bird dies of infection. The birds tangle up in the wool when feeding on sheep pasture in the summer but it rots in salt water when the oystercatchers move to the coast in winter.

Finally all the birds are done. It is after 4 a.m. and it has turned really cold. The tally for the night is 114 birds; as well as the oystercatchers, curlews and redshanks, we caught a young male lapwing. Packing up the last bits and pieces, we have only one torch still working between us and as we walk to the car it too begins to fade.

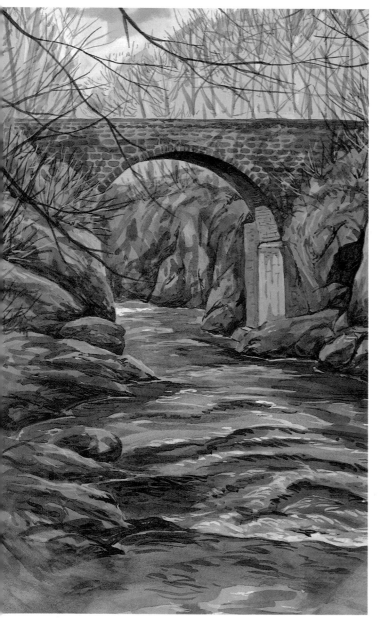

Friday 30th *Gannochy Bridge*

Where the River Esk flows out from the glen it cuts through the rock and forms a narrow, dark cleft with deep river pools and waterfalls. The walls of the defile are thick with green mosses and ferns that hang precariously to their seemingly impossible anchorage. In places, you can make your way down muddy slopes to the water's edge where the Esk runs in white torrents over sheer rock, lies brooding in deep, dark pools or laps thoughtfully on tiny beaches of gravelly sand.

The bridge which spans the river here crosses the crevice and towers high above the water. Built of red sandstone it is patched here and there with granite blocks, bricks and cement but essentially it is the same structure that was built in 1732, chiefly through the efforts of one man.

Before the Gannochy Bridge was built the only crossing was a ford, slightly upstream where sand collected at the shallows; the Gaelic *Gainmheachaidh* from which Gannochy derives means 'sandy'. The crossing was treacherous and many lost their lives in attempting it. There was, however, a rich farmer in the glen called James Black and one night three locals disguised as the ghosts of some of those lost at the crossing visited him while he slept.

By all accounts the man was so overwhelmed with fear that he decided to build the bridge, paid for the entire construction himself and built the parapet with his own hands. The receipts for the building of the bridge still exist and his tombstone stands in the Lethnot churchyard with this inscription:

No bridge on Earth can be a bridge to heaven,
Yet let to generous deeds due praise be given.

In a cleft of rock, wedged next to the bridge and held in by tree roots, a dipper is sitting on its nest. Already she has four brilliant-blue eggs and stares back at me intently. By coincidence she bears James Black's (Blacksmith) name: in Gaelic the dipper is known as 'The Blacksmith of the Stream'.

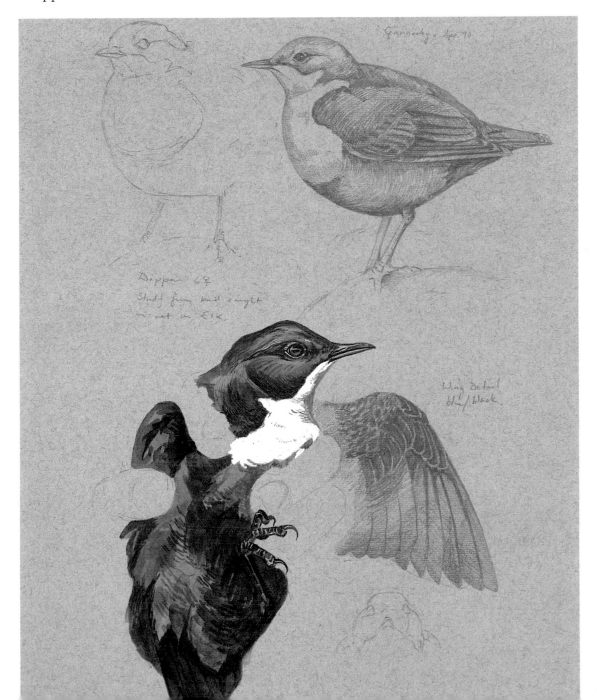

April • The low woodlands

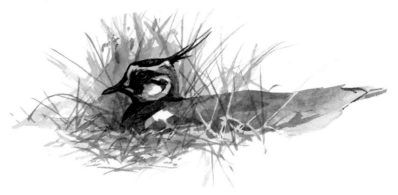

Sunday 1st The wild wood

Lower down the glen, especially near the river, there is a variety of woodland that reflects a chequered history of clearance, plantation and natural regeneration. At the mouth of the glen there are beechwoods that stand like rows of sentries at the edge of the road and their golden-brown leaves lie in thick drifts below the walls. On the steep sides of the river-bank, and in a few other isolated areas, there are patches of mature, deciduous woodland. Alders grow on the low, wet ground, giving way to oaks, elms and sycamores higher up. Further uphill there are woods of decrepit birch and rowan, with strips of conifer plantation, sitka spruce and scots pine here and there.

At one time, of course, most of the low ground was covered by the ancient, wild wood but this was cleared by successive generations of farmers for farmland, or simply burnt to drive away the wolves that would prey on livestock. There was a ready market, too, for timber to make ships, buildings and coffins. Some 17th-century maps I have seen show that there were still extensive areas of mature forest in the glen, mainly of oak and pine. Today there is little of this kind of woodland left. Remnants survive only on the steep side of the river bank where clearing would have been difficult. Elsewhere there is very little natural regeneration because of the intense grazing pressure from sheep and deer. Yet where small areas are fenced off, birch scrub springs up miraculously to begin a new succession of woodland.

Unlike many of the Angus glens there is, fortunately, very little in the way of conifer plantation on the Esk. Planted in small sections, these trees can actually improve the variety of habitat but the policy of turning whole hillsides over to regimented forests of conifers not only alters the character of the landscape, but creates a relatively barren habitat that supports a less diverse system of flora and fauna.

As if to mark the true beginning of spring, I found some early-blooming primroses near the river, nestling between the roots of a huge oak tree. Fanned by a light breeze, the delicate yellow flowers constantly changed hue as they danced in and out of dappled shadows. Primroses are very much

plants of mature woods but they can be found growing right up on hillsides and indicate where old forests once stood before they were cleared. Further on, thick butterbur leaves uncurled themselves in the warm sunlight that bathed the river-bank, and their chunky-green flowerheads burst into tiny posies of pink and white starlets, sparkling against the dark loam of the bare earth.

I had just about finished sketching when it began to rain, and I had to take shelter below an overhanging boulder. From where I sat, I had a clear view out of the woods and onto the open hillside beyond the river. I was more than a little surprised to see a badger trotting down off the hill and into the wooded burnside below. He stopped at one point and raised his snout skyward, then, shaking energetically, he threw a cloud of spray around him as he cleared the water from his coat before carrying on his way.

Monday 2nd *Below the elms*

It is unusual to see badgers during the day and I have never before seen any on the open hill. I returned to the hillside where I had seen the badger the day before and soon found where it had entered the woods. Below the barbed-wire fence was a polished scoop in the earth and strands of yellow-grey hair were caught in the lower barbs. In the wood itself there were no distinct pathways that you might expect near a sett and it was quite far down the burn that I found some well-worn tracks through the bracken and fallen branches. I managed to follow one of these to a sandy bank that was held together by a facade of twisted roots that reached down over a shelf of rocks from the gnarled elm roots above. There were two holes excavated in the bank, below the rocks, and mounds of sandy earth spewed out from each entrance. I set some twigs across the holes to see if they were in use but I could tell from the heavy press of badger prints and the fresh latrines dug nearby that they were.

Wednesday 4th *Frogs and tadpoles*

I checked the badger sett this morning. The twigs had been moved from both entrances and there was newly disturbed earth among the nearby bracken. I positioned some strong branches horizontally across the fork of a nearby tree that overlooked the sett and placed some thick, green sprays of fir in front of the platform to act as a makeshift hide.

I made my way to the edge of the birchwood, where a jumble of huge, moss-covered boulders spill over the slopes and brood like watching trolls between the white tree trunks. This is the site of long disused mining excavations for tin, iron and silver. Below one of the ridges is a small pool, choked with green pond weeds. In its shallow margins is a bubbling mass of frogspawn, incubating in the sun-warmed water. At one end, some of the eggs were already hatching into tadpoles that wriggled among the living, black soup of their own kindred.

A beautiful, bright, spring morning; I started a composition of some frogs that were basking in the shallows but three times, fierce hailstorms soaked my paper and sent me scrambling for cover among the rocks. When I returned, of course, the frogs had gone and I had to wait until they re-surfaced before I could continue working.

Sunday 8th *A night among badgers*

As dusk settled on the woods I climbed the tree overlooking the badger sett and made myself as comfortable as possible for the night ahead. I had brought a small torch with a red filter that I clipped to the end of my drawing-board. As the last grey light faded from the sky I watched pipistrelle bats hunting above the trees and every eight minutes (I timed it!) a woodcock passed overhead giving a high pitched, 'tsi-wick' call. It was marking out its territory, I suppose, but did not give the low, croaking note that usually accompanies these 'roding' displays.

After a couple of hours, and despite a shower of rain, I was actually beginning to doze off when I heard something large move among the bracken. I hadn't seen the badger leave the sett, so perhaps this one had arrived from somewhere else. In fact I still couldn't see it, only hear the crashing and snuffling sounds emanating from the shadows below the bank. I unclipped my torch and shone it at the nearest entrance, only to see something white dip out of sight. Then, rising like some spirit from the grave, a grey head appeared above the lip of the burrow. The broad, black eyestripes were facing straight at the lamp and I thought of turning it off but decided that any movement would only cause greater suspicion. The badger sniffed the air and padded off into the shadows towards the thrashing sounds that still continued among the bracken. I heard a high pitched squeal and then the noises moved off and were gone.

Half an hour later they were back. Two badgers trotting around in the moonlight just twenty yards from the tree in which I sat. After a while I tried to make some sketches but it was too dark to see quite what I was doing and I had to use the light reflected from the graphite of the pencil to guide my drawings. Twice the rustling of paper sent my wary models scuttling back to the sett, but each time they soon returned. Finally they disappeared again into the shadows and the tingling pain in my legs persuaded me that I should leave my perch. I found that I didn't quite have the full use of my limbs and struggled clumsily down the tree.

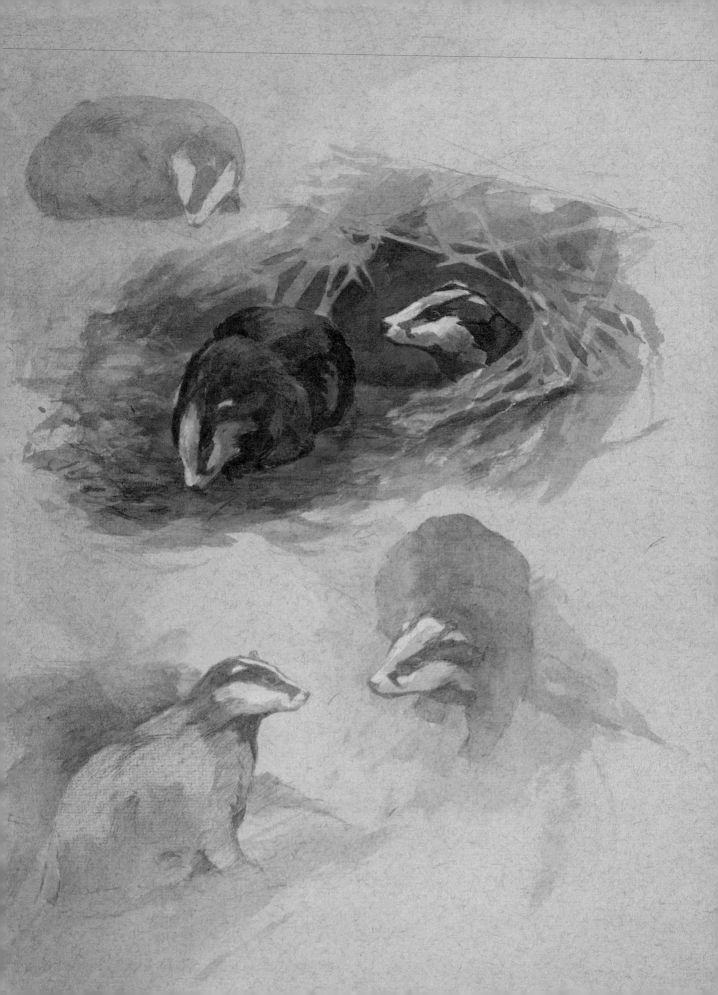

Saturday 14ᵗʰ **The Devil and the miller's wife**

'Is this where the miller's wife met the Devil?' I asked.

'Yes, that's right', replied the man at the gate. 'The house used to stand by the old mill there, but it's gone now.'

There were several people who had told me the story. It concerned the miller of Lethnot, a certain Mr. Black, who was brother to James Black who built the Gannochy Bridge in the mid-18th century. The miller had a reputation as a drunkard and a brawler, and one night he argued violently with one of the neighbouring farmers at the local ale-house. Still angry, he returned to the mill and his waiting wife. Determined to get the better of his adversary, he soon decided to go out into the night and ambush the farmer as he went home. His distraught wife tried to dissuade him but to no avail, and as he opened the door she called out in desperation, 'Who will look after me when you are gone?' Slamming the door behind

him he replied, 'The Devil if he likes!' whereupon a column of smoke shot up through the floor of the mill. As the Devil materialised before her, the goodwife had the presence of mind to pick up her young son and drop him through the window. The boy fetched the minister and a crowd of sceptical local men. As they reached the mill-house they could smell the brimstone. Holding the church bible before him, the minister flung open the door and demanded that the Devil return whence he came. The apparition disappeared instantly, back through the floor.

The Devil, however, may have had his revenge, for the same minister who confronted him, it is said, chased a black cat up the stairs of his house with a pitchfork one dark, New-Year's night, fell, and broke his neck. I did a drawing of the new mill-house that stands nearby, and it, too, is now disused. It stands just behind the site of the old building. A small party of greenfinches were feeding on seeds along the bottom of a nearby hedge. A yellowhammer was singing in an elm tree above the burn - brilliant, canary-yellow against the light sky. Appropriately enough the yellowhammer, according to local folklore, sings the words, 'De' il, De' il, De' il tak ye.' (Devil take you.)

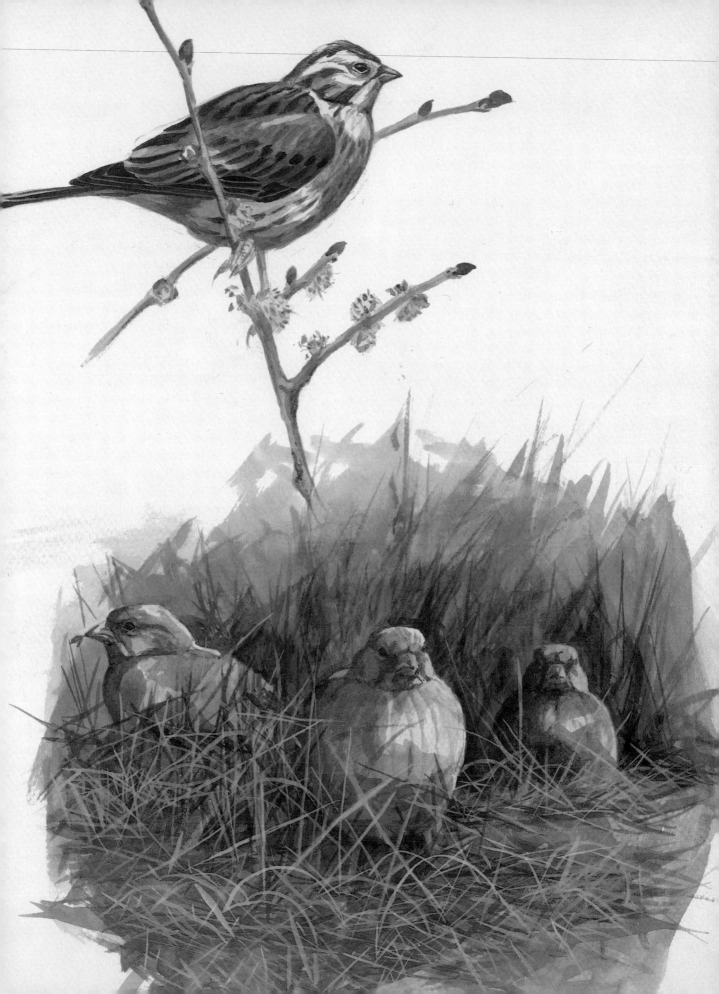

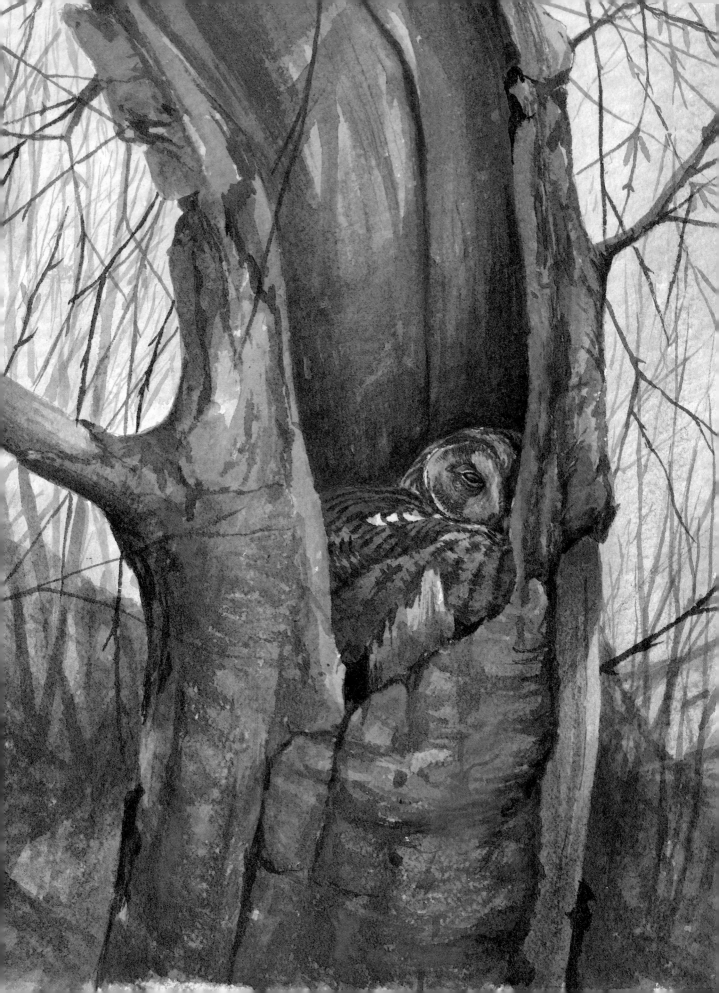

Tuesday 17th *The witch in the wood*

I knew that I would find her here. Almost every year, a tawny owl uses this nest-site in a shattered old birch tree that stands barely three yards from the roadside. The first time that I saw the nest I couldn't believe my eyes. A friend and I had just checked a nearby dipper nest for the second time that season, and had put rings on the chicks. Walking back, I looked up and saw the birch tree blink. We must have walked past it at least three times without seeing her.

I sat down with my telescope among some trees on the far side of the road so that nobody would see me and spent most of the day painting the owl. Once or twice she peered over the edge of the hole at me but she soon settled down again. Several cars, a man walking his dogs and a girl on her horse passed right under the nest. As the girl rode past, her head could only have been six feet from where the owl sat.

Highland folklore names the tawny owl as the 'Witch of the Woods', perhaps because of their eerie calls or the long hours of silent meditation that they apparently spend during the day. This bird seems to have a spell that makes her invisible. Her plumage is a magical work of art that turns soft feathers into shattered deadwood.

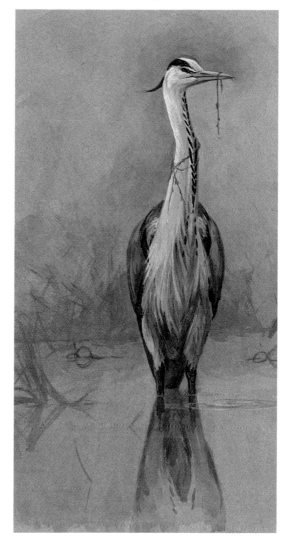

Thursday 19th *The heron in the pool*

I went back to the quarry pools today, to draw some more frogs but they were all gone. The tadpoles had all hatched and some were getting quite large.

I soon discovered why the frogs had made themselves scarce. Right in the middle of the biggest pond a heron was standing absolutely motionless, and watching me. We stared at one another across the still water. It had obviously been hunting in the pond-weed because green strands were wound around its neck and one long stem was draped over its bill, still wet and dripping. A drop of water fell into the pool and broke the heron's reflection into dancing circles. Fortunately it stood, there for a few minutes longer and I was able to scribble down some sketches before it lost patience with me and flopped awkwardly into the air, wheeled in a broad circle around the pond and departed.

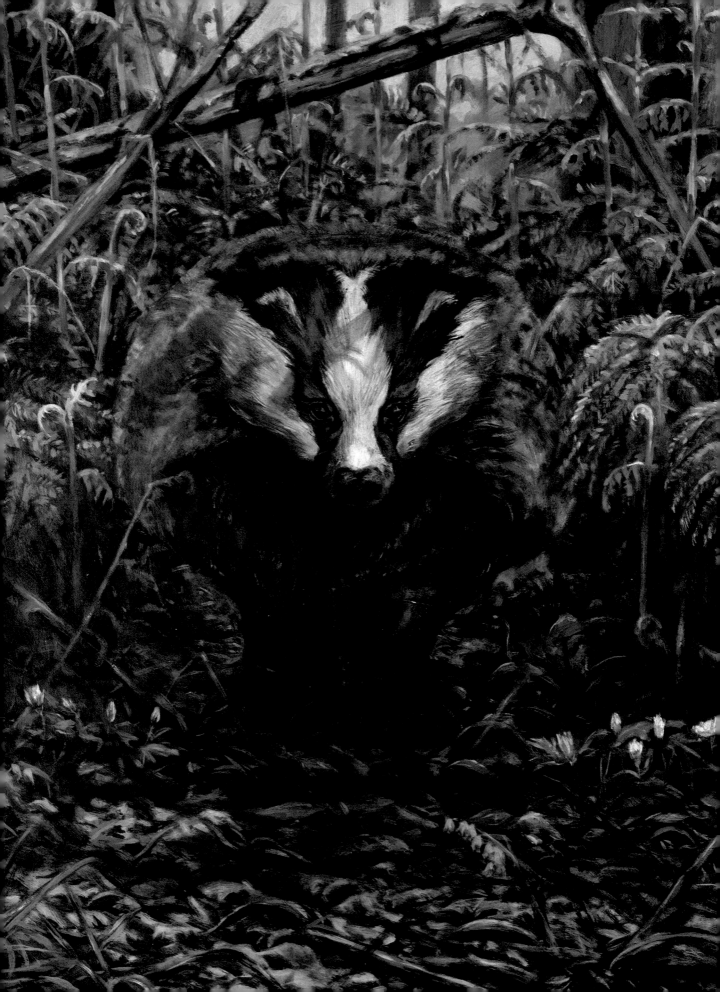

Saturday 21st · *Brock and bracken*

It was a beautiful, warm evening when I went to the badger sett again; this time, I positioned myself at a site closer to the entrance and just a few feet above the ground. The dead bracken around me was pierced by the long, green spears of new spring growth, and wood sorrel and some bluebells were flowering among the leaf litter.

From further up the burnside, I heard something moving in the cover. I looked through my binoculars at a bank of bracken just in time to see the striking black and white mask of a badger trot into view. I hadn't expected any to be out of the sett, let alone returning during the day and, although I was downwind of the burrows, I was actually upwind of this badger s approach. A few yards further and he caught my scent, looked up suddenly, turned and went back the way he came. I am sure that he didn't see me but badgers have a very keen sense of smell. I waited until the early hours of the morning but without any further sightings.

Monday 23rd · *Return from Africa*

A day of migrants. I saw sand martins in the glen today. There were birds on the coast last week, but this is the first day this year that I have seen them on the Esk. They were feeding frantically above the river and calling like broken radios: a harsh, drawn out twittering. Higher up on the hillside and at the edge of the woods, wheatears were 'clacking' to one another and were already establishing their territories. Their white rumps, that give them their name, flash among the gorse and scree. I only saw males. They seem to arrive earlier and claim territories with which to attract a mate.

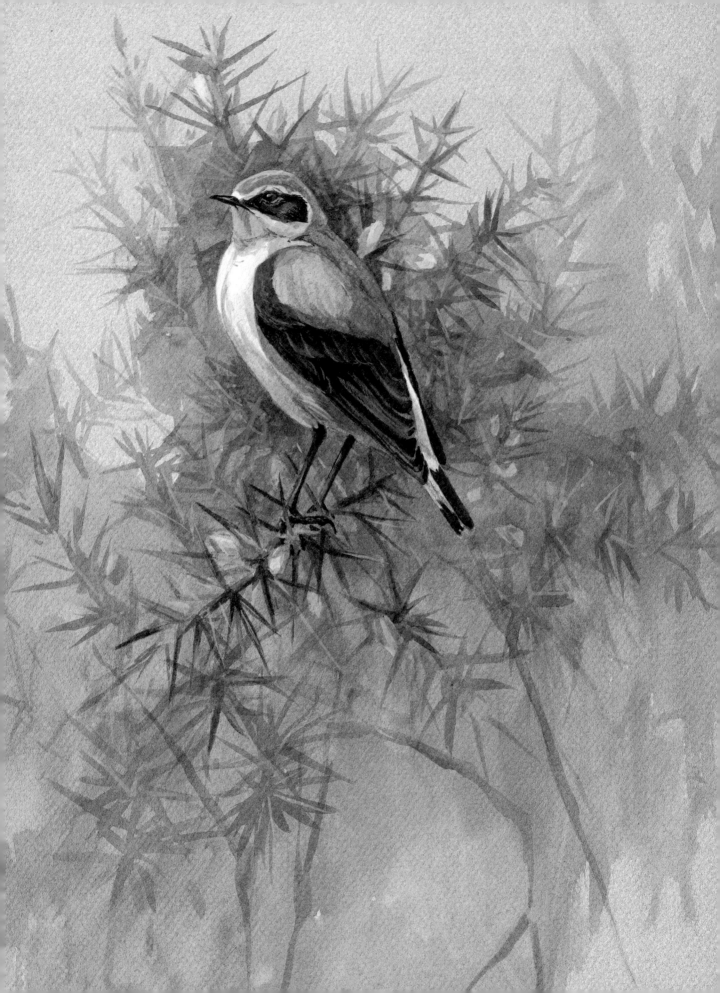

chiffchaff singing
in Sallow Tree.
E.L. '91

There was a heavy shower of rain and hail at midday and I retreated to the car. I ate some sandwiches and watched the torrent beat against the windscreen. When the deluge eased and the sun broke through, I rolled down the window and recognised the sudden burst of song from among the sallow trees next to the car. "Chiff-chaff-chiff-chaff-chiff-chaff". A chiffchaff, of course, but quite uncommon in this area. Scanning the trees I managed to get a fix on it and watched it dart among the dripping branches of the sallows, still strewn with catkins, and just breaking into bud. Twice more it climbed high into the trees and sang before moving on.

There is a familiar joy in watching the return of these migrants from Africa. Like meeting old friends returned from their travels. Watching these birds, at this time of year, you can sense the exhaustion of their journey, their recognition of familiar ground. I can almost smell the warm air of Africa on their tired wings.

Saturday 28th **The blackcock lek**

I spent the morning drawing blackcocks at the edge of a small plantation of spruce and birch. It is quite a small lek of only five males, but I saw at least three greyhen during the course of the morning. My hide had been there for a week so that the birds would get used to it. They had, but unfortunately so had a heavy woodpigeon who had chosen to use the roof of my hide as its own, private sun-lounger. Twice it landed on the canvas above me, causing the roof to sink downwards until the pigeon was actually supported by my head. I eventually had to move, and it clattered off noisily, scaring my nearby models.

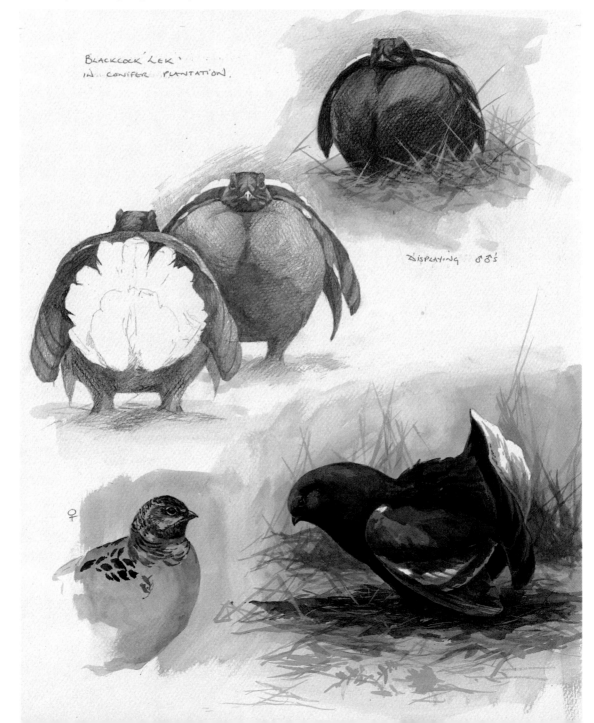

BLACKCOCK 'LEK'
IN CONIFER PLANTATION.

DISPLAYING ♂♂'s

♀

May • The winding river

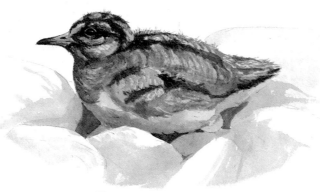

Tuesday 1st Common Gulls

May Day and May dew. I walked down to the river and left a clear trail in the wet grass behind me. Some of the later migrants have arrived now and I could hear a redstart singing, high up in the alder trees. Far across the glen, a cuckoo was calling.

Where the river winds in a great arc among the woods and pasture it throws up ridges, banks and islands of smooth, round boulders. I arrived at one such place just as the morning sun had begun to dry the moisture from the grass. A flock of common gulls clamoured above the gravelly spit which they had chosen for their nesting colony. Some were already sitting on nests so I waded across the river to see how many had laid eggs. Most of the nests were still empty depressions of dried grass among the rocks but a few had single eggs. I found a vantage point a good distance away and set up my telescope to watch the birds return to their nests. They soon settled down again and I started drawing one of the pairs: the female brooding her single egg and the male dozing while he stood on sentry duty nearby. I probably saw and drew some of these birds earlier this year at the flood pools lower down the glen. I feel that they have quite a different character now, a sense of busyness and urgency quite unlike the expectant excitement of early spring.

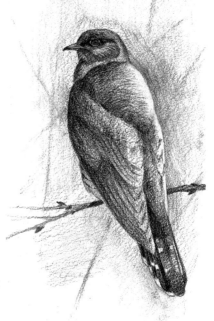

The first day of May was the old Celtic festival of Beltane, the first day of summer, and today I already feel that spring, with its first gasp of newborn life, has passed. For me it seems to end when the early chicks fly from their nests and today, I saw fledgling blackbirds and thrushes in the woods and hedgerows. The dippers too have fledged and they chase up and down the river after their parents. Already I feel the early tensions of the breeding season ease into the full bloom of summer.

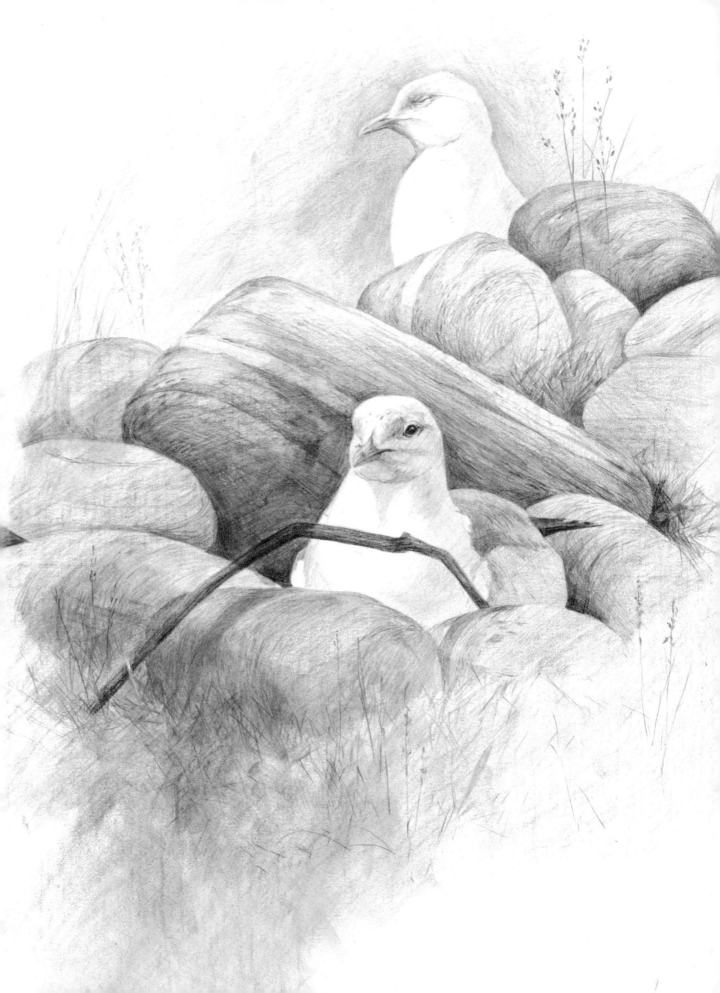

Thursday 3rd **Wild pastures**

The leaves are on the trees now and the first flowers dapple the meadows. In the grazed pastures there are daisies, lesser celandine, buttercup and dandelion. In marshy corners, the delicate, pink flowerheads of lady's smock flutter in the softest of breezes. For some reason it is this flower that I associate most with this particular time of year, perhaps because it grows in profusion in the meadows where the lapwings nest and where their newly hatched chicks stagger and peck among a pink jungle of flowers. I picked a few leaves and ate them (they tasted sweet and peppery) before I went back to the car to get my paper and paints.

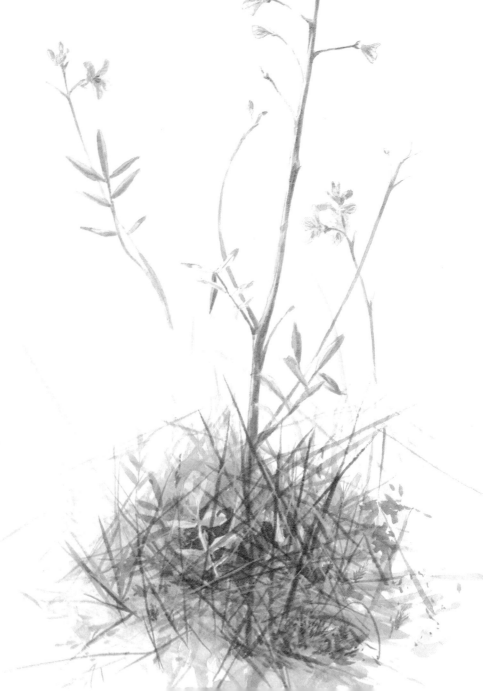

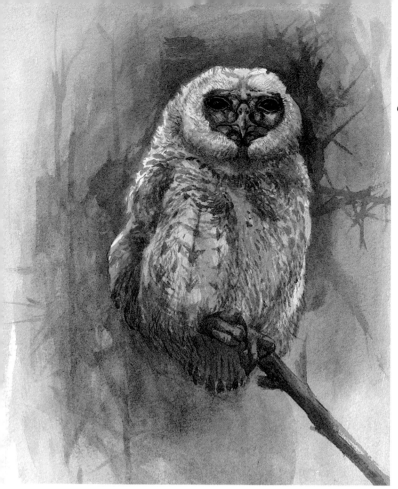

Saturday 5th The charnel house

I went to a tawny owl nest today to draw and ring the chicks. I found that one of them had already left the nest, rather unsuccessfully, and was fluffed up, glaring at me, from among the leaf litter. I picked it up and did a painting of it before I put it back in its nest, safely out of harm's way. There was another chick in the nest, slightly smaller but well fed. Tawny owls have the endearing habit of clicking their beaks when they feel threatened, rather like the sound of a Geiger-counter. This makes them look and sound suitably dangerous but they don't have enough strength to do much harm while they are still in the nest.

Tawny owl nests have an aroma all of their own. A mixture of bird droppings, rotting wood and the ripe remains of rodent corpses. These two chicks stood on a carpet of gore that included the bodies of two rats, a small rabbit, a blackbird and an assortment of short-tailed field voles, wood mice and shrews. From below the tree I could see a small cloud of insects, obviously attracted by the smell, hovering above the nest hole.

Tuesday 8th Spring harvest

It was a beautiful warm day so I left early to spend as much time as possible in the glen. I took my drawing books and paints and carried them down through the woods at the river's edge. Lush, spring growth has all but hidden last year's leaf debris and the air is thick with the scent of wildflowers and blossom. I crunched through the vegetation beneath the trees, crushing garlic leaves beneath my boots, and I was engulfed by the drowsy aroma. The wide, dark green carpet of garlic that ran from the river to the edge of the woods was already beginning to burst into flower but many of the flowerheads were still curled in their protective pods. As I passed I picked some, the hollow stems popping as they snapped, and ate them while I made my way downstream.

I found some clumps of sweet cicely and collected their leaves, pungent with the smell of aniseed, to take home for salad. I decided to fill up my bag while I was at it and collected some garlic pods, young leaves from the dandelion and rosebay shoots and the bright, yellow flowers of some nearby broom.

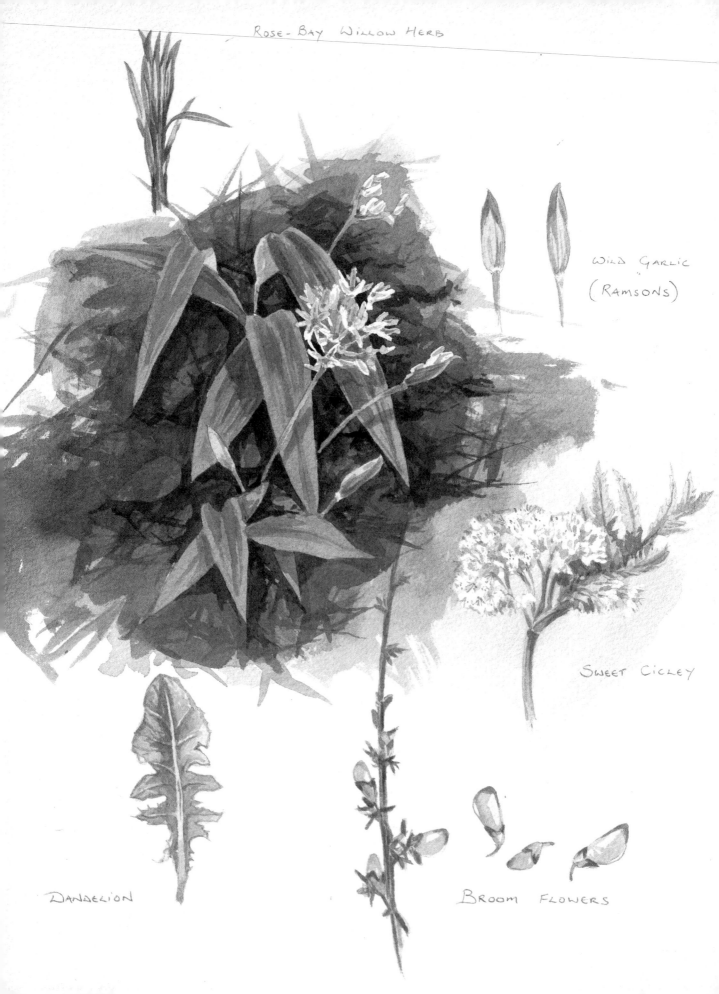

ROSE-BAY WILLOW HERB

WILD GARLIC
(RAMSONS)

SWEET CICLEY

DANDELION

BROOM FLOWERS

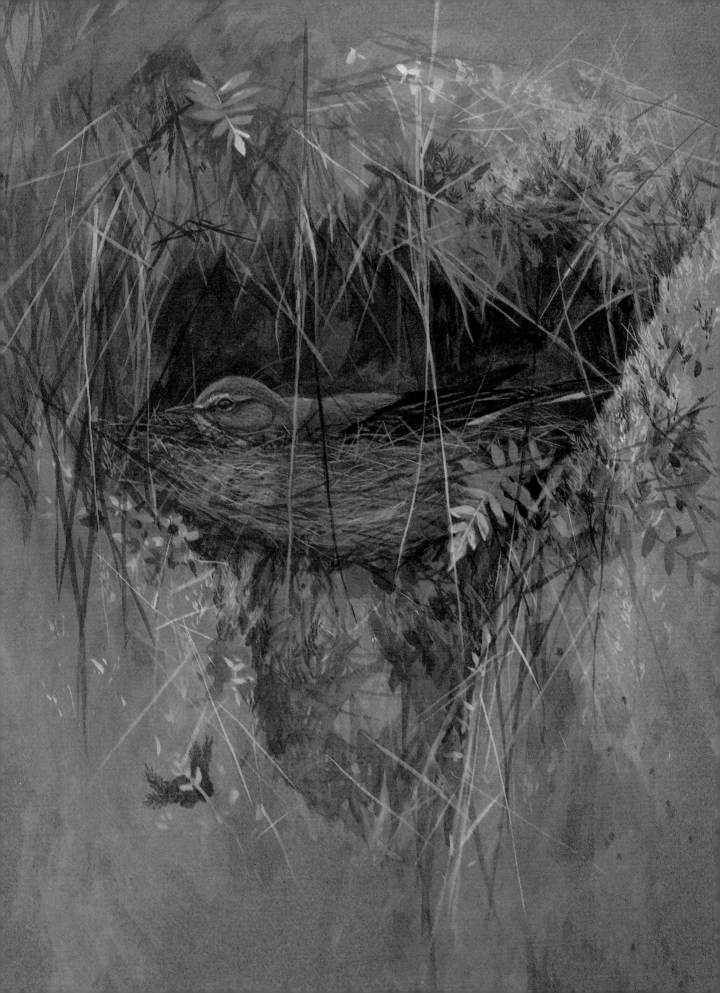

Thursday 10th **Craigendowie**

As I walked along the riverbank I flushed out a grey wagtail from her nest in a mossy crevice of overhanging rock that dripped with moisture from a tiny waterfall. The nest was just too high and the rocks too slippery for me to see inside, but on my way back I set up my telescope and watched her brooding her chicks. It was a warm, bright day, but she was hidden in an overhang of deep, green shadows and water trickled down over the plants around her.

Just a little downriver from the wagtail's nest is a deep, dark pool in which, it is said, a water horse or kelpie once hid. Another one of these mystical beasts, reputedly the last one to be seen in the glen, occupied a stretch of the Esk near Corhairncross. Such creatures were believed to lure passers-by to their deaths but there doesn't seem to be a dangerous presence at either of these sites any longer.

Near the Kelpie's Pool in Glen Lethnot is the farm of Craigendowie, where a Peter Grant once lived. In 1820, a local minister, who was visiting Mr. Grant, discovered that he had fought for the Jacobites at Culloden when he was 16, had been captured and later escaped from Carlisle Castle (this would make him 90 years old). The minister applied to King William IV for a pension on Grant's behalf who signed the papers as 'His Majesty's Oldest Enemy.' The king awarded Grant his pension which he received for a further fifteen years before he died.

Monday 14th **A meadow of lapwings**

The grass is growing quickly now, and the marshy fields near the river are thick with rushes and spring flowers. Some of these fields are particularly good for nesting lapwings who lay their eggs among the cover that the deep grasses provide.

I was able to park my car at the side of the road and watch some adult birds from a discreet distance. If disturbed near their eggs or chicks, lapwings will alarm and, with some experience, it is possible to tell whether the eggs have hatched or how old the chicks are from this behaviour.

I made a painting of one of the adults that was guarding its young as they struggled through the green tangle of grasses. From time to time the family party would cross a small area of open ground and I could see the chicks, their white napes glowing conspicuously in the strong sunlight, and then they would disappear once again into the depths of the meadow. Only the adults' heads peering over the grass-tops gave any further clue as to where they had gone.

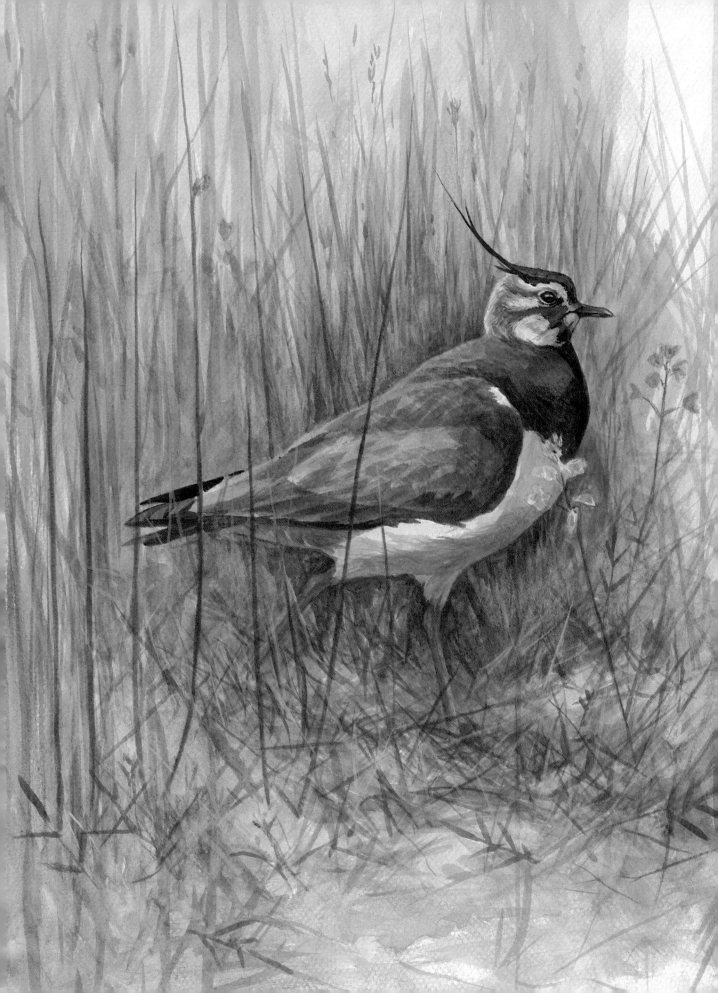

Wednesday 16th *Horseshoe river*

The continuous shifting of silt, gravel and boulders, and the consequent erosion that this causes makes the course of the river a series of wide loops as it passes through more level ground. In places, the river has worn through these loops, straightening its course once again and cutting off a whole arc of the river which silts up over the years and eventually dries out. Such places are havens for wading birds which nest and rear their young in the marshy habitat that the isolated horseshoes provide or, like the oystercatchers, nest among the ridges of boulders which give excellent camouflage for their eggs and chicks.

I was exploring one such place and making sketches of an oystercatcher sitting on her nest when I caught sight of a movement among the heather on the far side of the rocks. Craning its neck out over the high vegetation was a brooding curlew. She (female curlews have distinctly longer bills than the males) was watching me intently and was obviously quite alarmed by my presence but she was unwilling to leave her eggs. I made some drawings of her before I got up and moved a bit further away so that she would settle down again. As I stood up her mate appeared from some nearby cover, running with his head low and skulking, his tail up and his long legs striding across the short grass. He gave a wary call of alarm as he ran, 'cloo-cloo-cloo…cloo-cloo-cloo', quite low and quiet. He found a vantage point and watched me suspiciously. Fortunately, the female was less concerned and, perhaps relaxed by my retreat, tucked her bill between her shoulder blades and began to doze again in the warm sunshine.

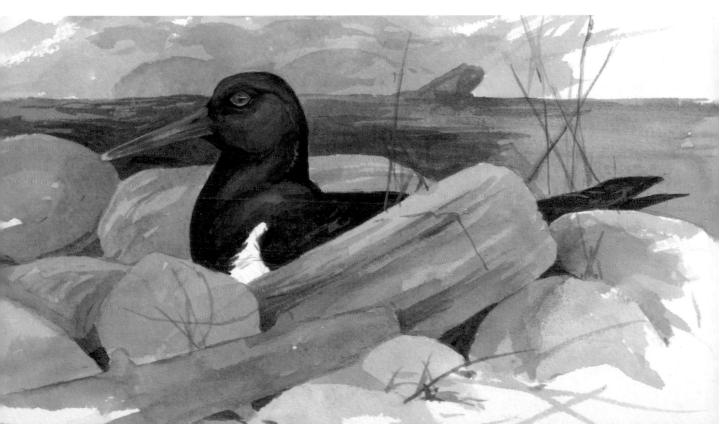

BROODING ♀ CURLEW
LETHNOT, ESK. MAY

Friday 18th **The dead chaffinch**

Things are getting so busy: a pair of meadow pipits mobbing a cuckoo that sulks in a bush near their nest, lapwing chicks in the fields, warblers singing in the woods and birch scrub. Everywhere I go, lapwing, redshank, oystercatchers and curlew alarm at my intrusion.

Even at the height of the breeding season, teeming as it is with newborn life, there are moments of poignant tragedy. Under an overhang by the river, I found a dead roe deer, bejewelled with shining carrion-beetles, and later, when driving up the road, I saw a female chaffinch hopping around a few black and white feathers that stuck up from the tarmac. They were all that remained of her mate. She called plaintively, as if in confused grief.

Confronted with an incident like this I find it tempting to be anthropomorphic in my understanding of animals – attributing to them my own emotions and morals – which is to misunderstand and belittle the unique experience of life which each species lives. In similar circumstances, I have had to recognise my own, unconscious assumption that animals, because they do not experience the world as we do and are less capable of intellectual thought, do not feel such deep pain or emotion and that, because of our intellectual superiority, their existence is somehow inferior - perhaps simply a series of reactions to external stimuli rather like that of a computer. However, animals often possess abilities that far surpass our own, arrogant intellect. A bird's migration, a bee's hive or a bat's sonar are all elements of lives as complex and beautiful as our own but because we call this behaviour 'instinctive' (and how instinctive is our own behaviour?) it doesn't mean that it is any less real. Indeed, if an animal lives entirely in the present that is informed by its own highly developed senses then its capacity to feel pain and emotion may actually be far greater than ours. The chaffinch was still calling as I drove back down the glen.

Monday 21st **Lapwing chicks**

They are not the best camouflaged of wader chicks but given the right area, such as a rough pasture pock-marked with cattle hoof-prints and sheep dung, lapwing chicks can be difficult to spot. I saw these ones running around in just such a field

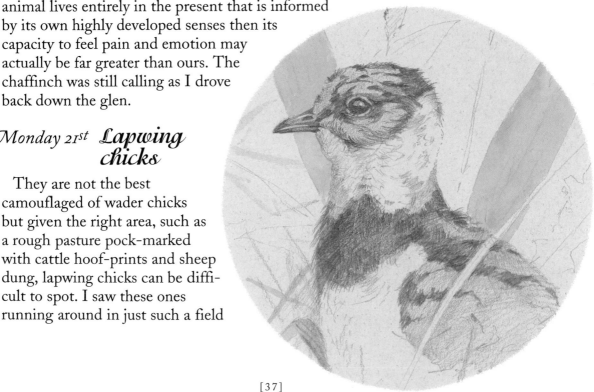

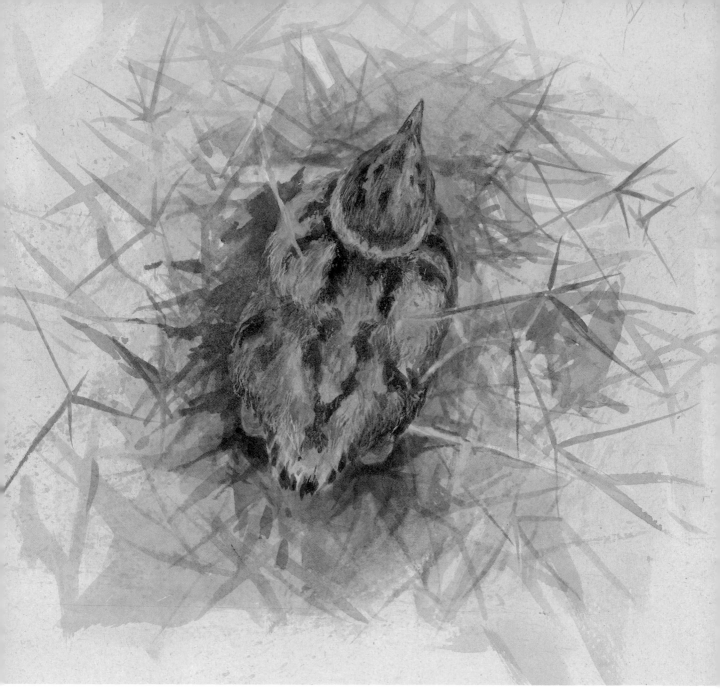

and made some sketches of them; memorising where they were, I jumped out of the car and ran across the field towards them. Immediately, the parent birds flapped into the air and screeched loudly as they hovered above me. On the first alarm call the chicks ran a short distance and then dropped invisibly into the grass. When I reached the spot where I had last seen them, the parents' alarms reached a crescendo as they swooped in frantic aerobatics. I searched around me, very careful of where I placed my feet, and there, looking for all the world like a piece of dried mud or sheep dropping, was one of the chicks. I made a painting of it as it lay in the grass, and then put a ring on it and its two siblings.

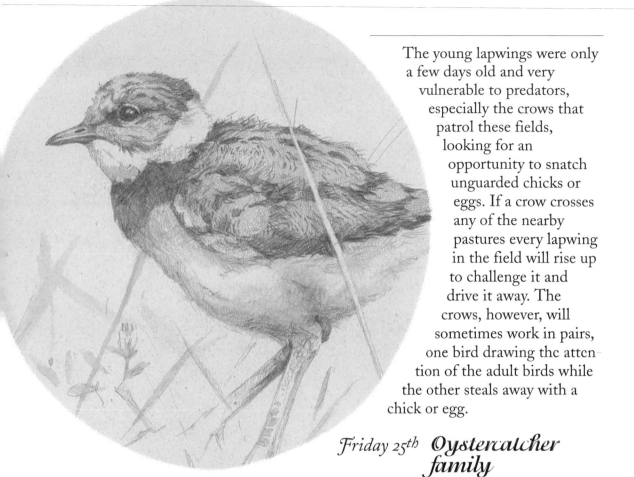

The young lapwings were only a few days old and very vulnerable to predators, especially the crows that patrol these fields, looking for an opportunity to snatch unguarded chicks or eggs. If a crow crosses any of the nearby pastures every lapwing in the field will rise up to challenge it and drive it away. The crows, however, will sometimes work in pairs, one bird drawing the attention of the adult birds while the other steals away with a chick or egg.

Friday 25th Oystercatcher family

I may well have seen these same oystercatchers at the flood pools in March. Indeed, one of them has a ring on its leg but I couldn't read the number despite watching it for nearly an hour through my telescope. They were making their way through the gull colony and leading their newly-hatched chicks (the first ones that I have seen this year) away from the shingle bank where they hatched to the denser cover of the sedges at the edge of the fields where feeding would be easier.

The chicks' movements are cautious and ungainly but quite charming none-the-less. Only a day or so old, they tire easily and every few yards they stop and call to their parents who are urging them across the dangerously open space between the boulders and the rushes. At last, they reached the edge of the field and made their way into the deeper cover that it afforded. I moved a little closer to watch them. The female was brooding one of the chicks and the others were staggering towards her. The male, unlike the female who was actually beginning to doze, was obviously uneasy about my presence and skulked low in the sedges nearby.

After a while, I crossed over and caught the chicks, their stone-coloured camouflage quite inadequate among the short, green grass. I did a sketch of one, put rings on them and then released them again. As I walked away the parents returned and, when I looked back, the female had already started to brood.

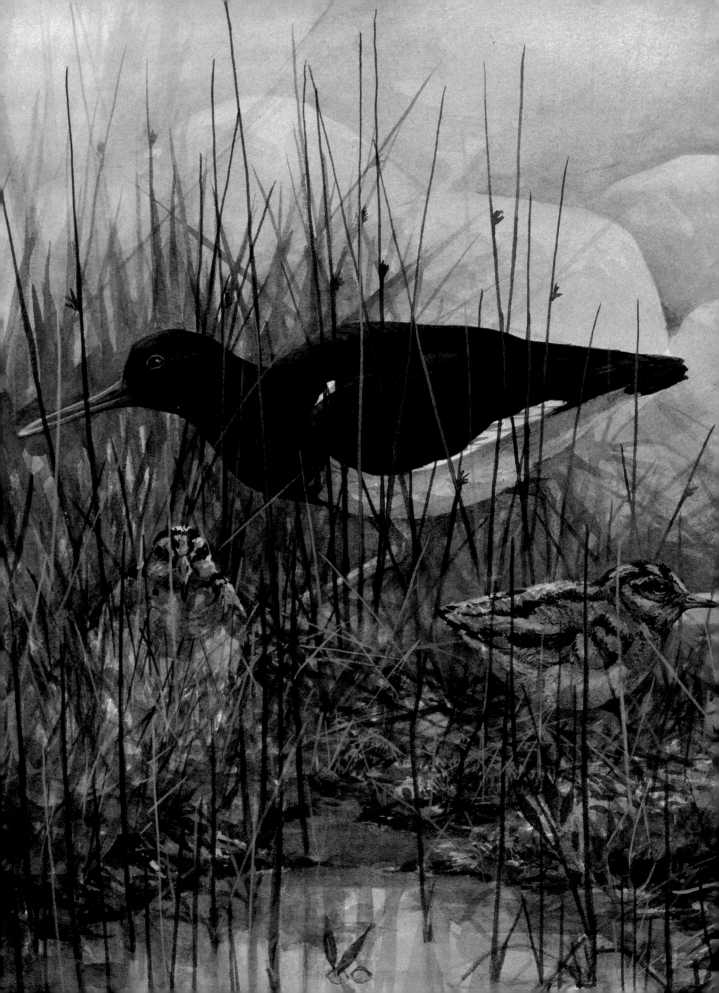

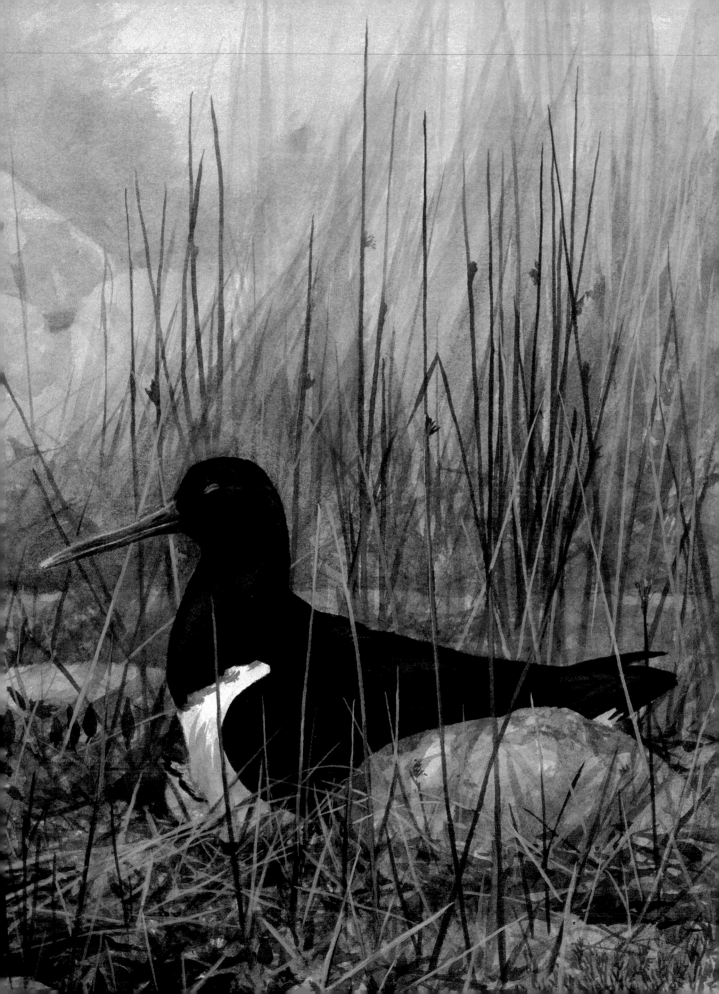

Monday 28th *The hatching egg*

I went to the gull colony today to see how many had completed laying their eggs and was surprised to find that one clutch was hatching already. I heard it first, the faint, high-pitched 'tseep-tseep-tseep', and followed the noise to a clump of dried grasses and sheep wool wedged between some boulders. In the nest was one newly hatched chick and one egg. It wasn't the chick that was calling though, it was the egg. I picked it up and whistled softly to it between my teeth and it answered back. Little cracks were starring across the egg's surface and out of a tiny hole stuck the tip of the chick's bill, the sharp point of the egg tooth showing white against the dark interior.

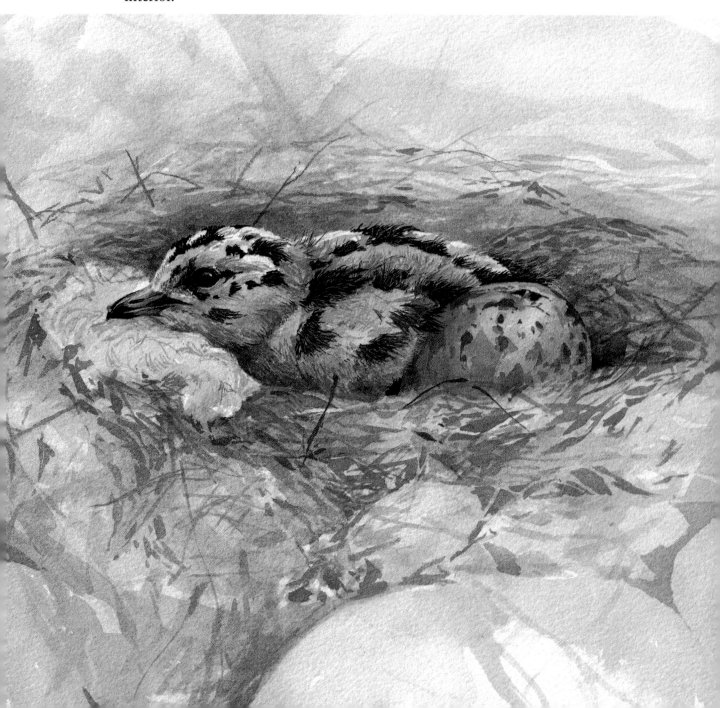

June • The burns

Friday 1st Flycatchers

A white fleck against the dark canopy of alder trees caught my eye as I followed the line of the burn up the hillside. Just as I focused my binoculars, the fleck spread into a white section of wing that disappeared again among the leaves. Following its flight with my glasses, I expected to see a chaffinch flit out of the canopy but the bird that balanced on the lichen-draped twig that I watched was a splendid, male pied

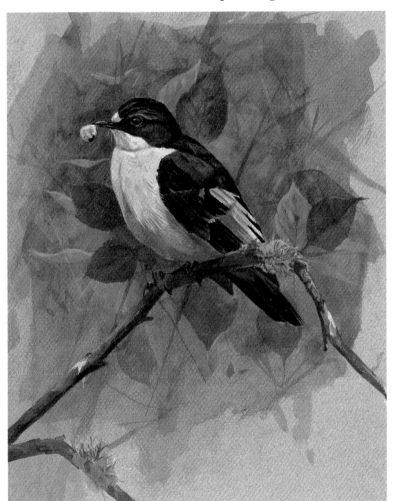

flycatcher, his black upper parts catching the soft, blue light that filtered through the leaves above.

Pied flycatchers are very scarce in Angus and I was surprised to see this one that was obviously nesting nearby. In his bill he carried a small, white globe that gleamed like a pearl. He flew from the branch and, crossing above the burn, he dropped the faecal sac onto the bank below. Many birds remove their chicks' faeces from the nest in this way and deposit them at a distance so that they do not give away the nest-site to predators.

It took a while, but I found the nest in a small, twisted oak tree. The hole was quite high up and I wasn't able to negotiate the climb in wellington boots.

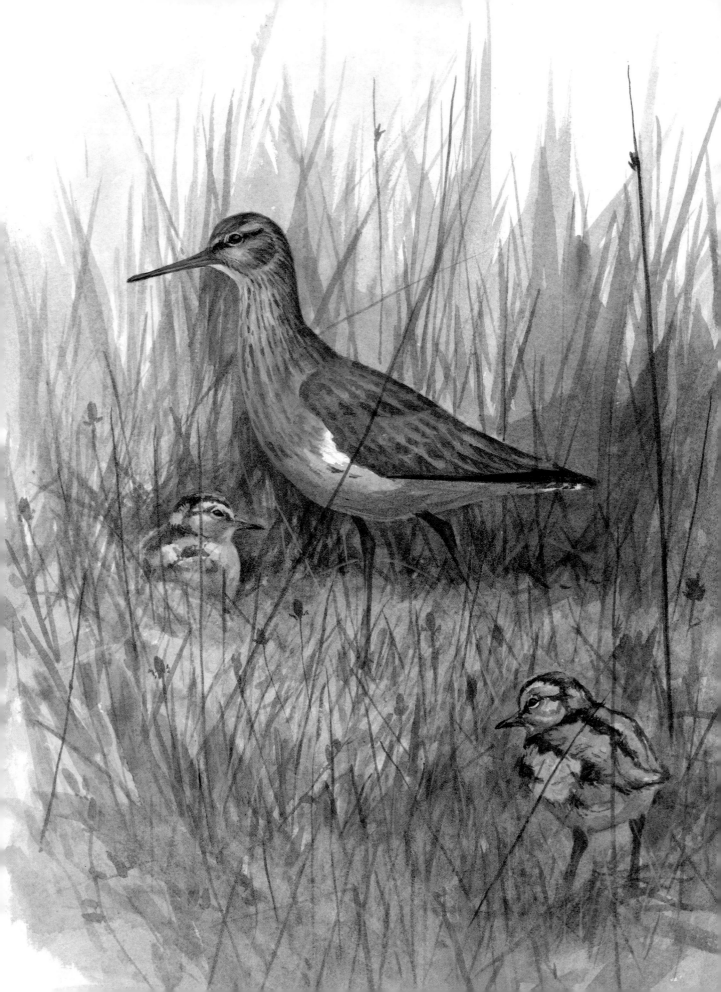

Sunday 3rd *Watchers in the marches*

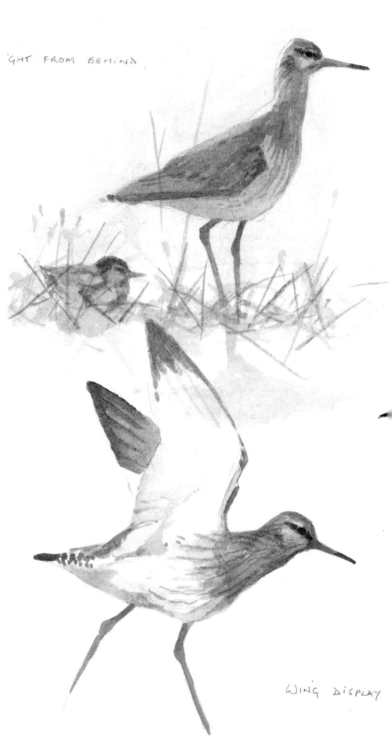

It is the height of the breeding season now and
I find that I am spending more time watching the frantic
activity of the creatures around me than actually drawing. I spent
the whole day at one piece of marshy ground that was a vivid
green and yellow flush of sedges and buttercups among the heather,
and even from a distance I could hear the gurglings of the burn that
ran through its centre.

There must have been more than
fifteen wader chicks in the thick cover:
lapwing, redshank, oystercatcher and
snipe. As the day passed, I made some
sketches and portraits of the redshanks
that were leading their chicks through
the marsh; they were ever watchful and
wary of my presence. Redshanks are
good parents and usually keep their
young in deep cover. They will alarm at
the first sign of danger and send their
chicks scurrying for a hiding place. I
always feel a surge of excitement when I
see the chicks' delicate heads appear
among the grass as they struggle towards
their parents' anxious calls: 'tuu-tuu-tuu'.
They are beckoning them away from the
side of the marsh where I am sitting. I
got up and chased after them, hoping to
catch and draw one of the chicks. The
adults rose into the air on stiff-flittering
wings, crying 'tu-ee tu-ee tu-ee', and cir-
cled around me as I splashed through the
wet sphagnum and puddles. It took me a
good ten minutes to find two of the
chicks. There had been a third but I was
quite unable to find it. For such small
birds they can run incredibly quickly, are
extremely well camouflaged, and will
actually push their way under grasses and
leaves to hide. I once found one with
only its tail sticking out of the entrance
to a mouse hole.

'GHT FROM BEHIND

WING DISPLAY

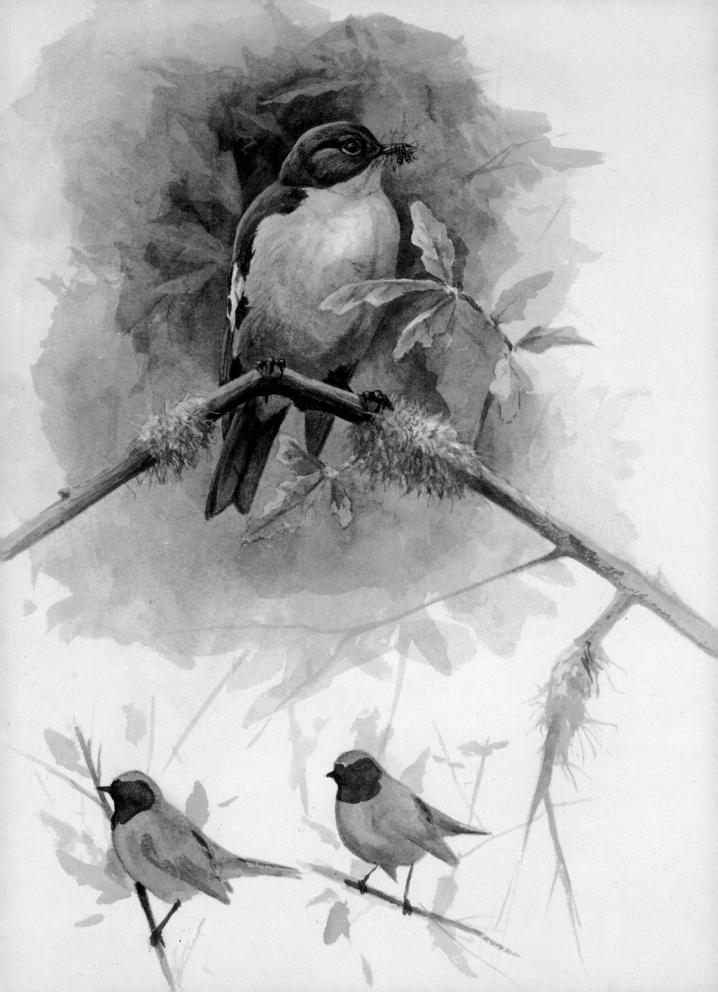

Friday 8th *To and fro*

I set up my telescope near the pied flycatcher nest and made a portrait of the female as she returned with food for her young. Every few minutes she would alight on a particular branch above the nest hole and pause as I watched her from below. The only movement was the blink of her eye and the futile waving of insects' legs, struggling against the grip of her delicate bill, and then a flash of wings and tail as she dropped from her perch, down to the lip of her nest-hole, and slipped inside. A pair of redstarts were also nesting nearby, and the male bird approached me several times, alarmed once or twice, and then disappeared again.

When I had finished the painting I climbed up the oak tree and managed to get my hand into the flycatchers' nest; my fingers just brushing the chicks' downy heads. In the darkness, I could feel their soft beaks closing round my fingertips as they begged for food, obviously mistaking my arrival for that of their parents.

Sunday 10th *Dawn chorus*

I arrived in the glen early this morning, just as the sun was rising weakly over a misty horizon. Although late in the season, there was an energetic chorus of songbirds in the trees around me as I stumbled through the birchwoods in the semi-darkness: redstart, whitethroat, willow warbler, blackbird and song thrush. In the glen below, I could hear the chirping of swallows; and above me on the hillside the bubbling trill of meadow pipits and the call of a single cuckoo.

Crossing the burn, I put up a common sandpiper. I think she had a nest or chicks under the bank but I couldn't find them. As she flew down the course of the burn her call seemed to take on the sound of the water that splashed through the rocks: 'killy-weet, killy-weet, killy-weet-weet'. I could see her perched on a rock mid-stream, all bobbing with worry, like some anxious, clockwork toy.

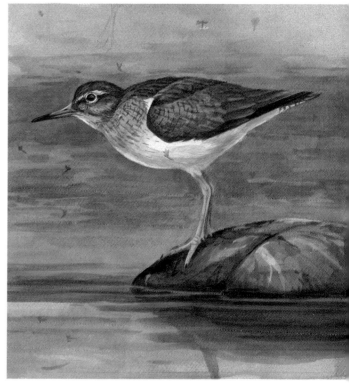

Many of the burns in the glen have Gaelic names that describe their size and character in terms of the sounds that they make: Kirny – chirping, Clearach – singing, Laurie – bubbling, Callanach – noisy, Effock – the little call, Mooran – bellowing, Cooriehauchun – the choir, and Tannar – the sound of water in a cave. Some of the other burns have animal names that suggest the sounds they make; Tarf – the bellowing bull, Mark – the snorting horse, Cat – the wailing cat, and Damff – the roaring stag.

Wednesday 13th *The one that got away*

I spent most of today sketching redstarts, and took a canvas up the burnside to rough out an oil painting of a male bird among oak leaves. There is something particularly striking about the contrast of the redstart's colours against the mature greens of high summer.

As I was driving back down the glen, I spotted a well-grown oyster-catcher chick running through the field next to the road. Hoping to catch and ring it, I stopped the car and tried to jump the fence. This particular wire fence however, was held up by some very old posts and, as I put my full weight on one of these while I vaulted the fence, the rotten base gave way. Somersaulting through the air, I landed on my backside just in time for the fencepost to spring back and strike my left arm. I can remember sitting, rather dazed, in the wet grass and holding my bleeding arm while the oystercatcher chick peered back at me as it made its getaway. I could have sworn I saw it smirk.

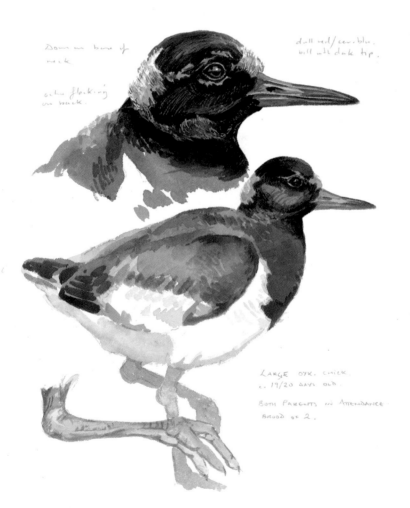

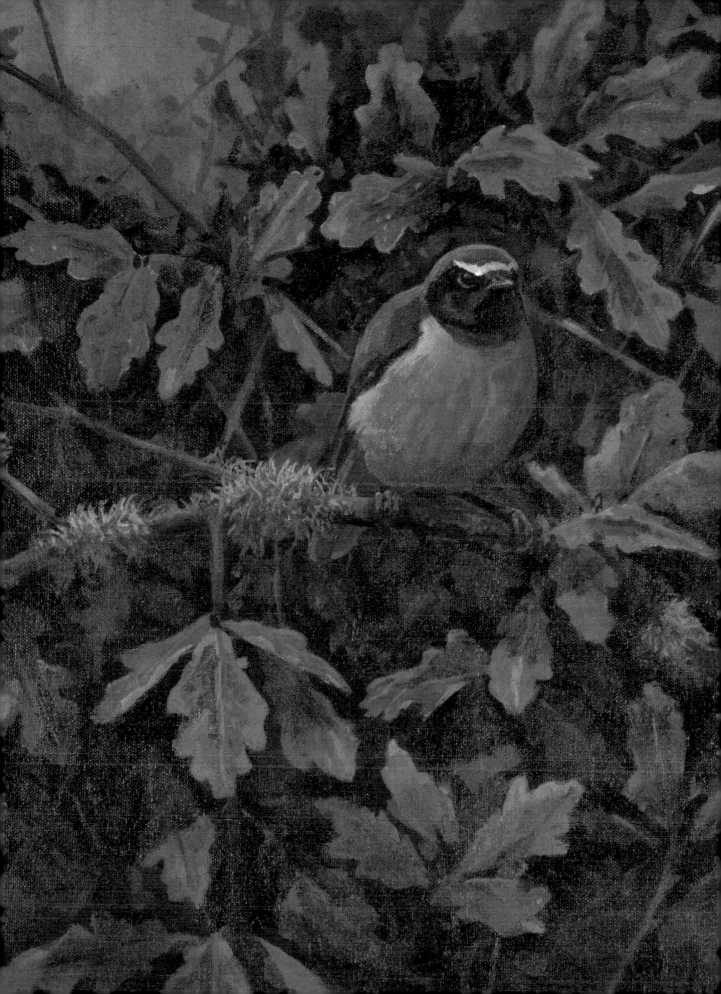

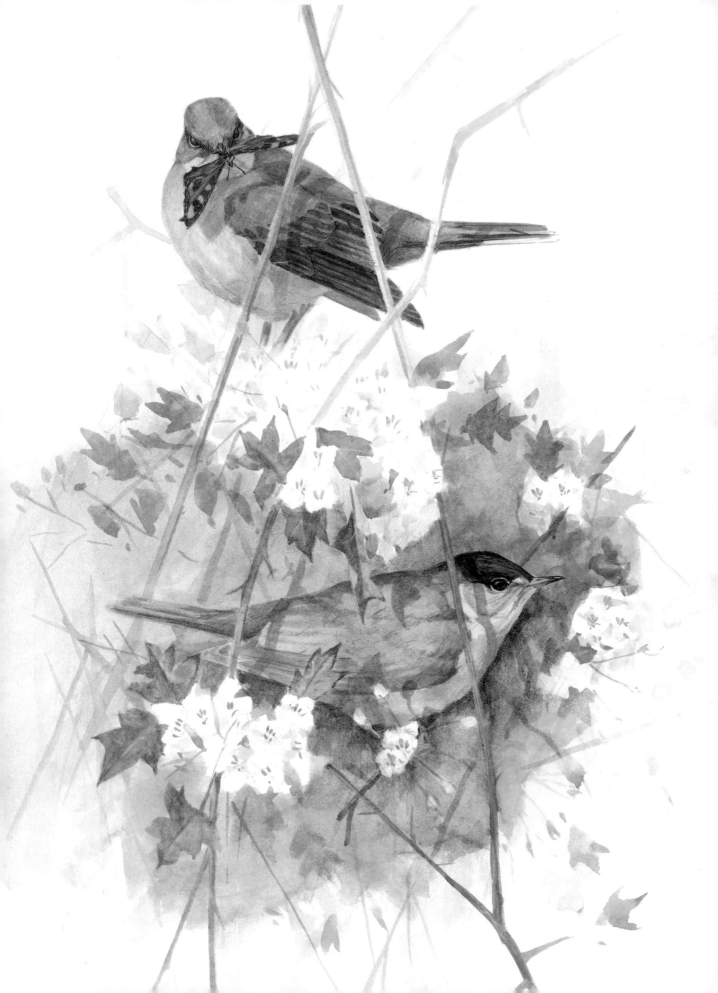

Saturday 16th *Summer blossom*

The hawthorn is in full bloom now, heady with the scent of buzzing summer. The clusters of white flowers crawl with small, black insects attracted by the distinctive aroma.

A good place for insects is usually a good place for birds and a succession of warblers are picking their way through the scrub: blackcap, garden warbler, willow warbler and whitethroat. Most of them have hungry young to provide for now and carry a writhing ball of insects in their bills as they skulk through the undergrowth towards secret nests. One particular sight was fixed in my mind. A contrast between a whitethroat, perched among dead twigs on the top of a bush, and a blackcap, flitting through the cool, green shadows of the lower branches. The whitethroat carried a tortoiseshell butterfly in its bill, the bright wings were stiff and lifeless.

Saturday 18th *Snipe chicks*

I am standing in the middle of a small marsh and my feet are wet, one boot quite full of water after stumbling into a grass-choked burn. Well, not standing but bent down and listening; bent down so low that I can smell the methane from the oozing mud and mosses, the buttercups and the waxy smell of the rushes. I can only faintly hear the thin, high 'tseet… tseet…tseet' which I am trying to locate more precisely. The call has a ventriloqual quality and it is only after fifteen minutes of painstaking searching through the vegetation with my fingertips that I find them – two tiny snipe chicks huddled among the grasses. Their downy plumage is a truly beautiful coat of grey-spangled browns and ochres and is the best camouflage design that I have ever come across. They could only be a day or two old, so small in fact, that I cannot put rings on them because they would simply fall off their legs.

In the afternoon, I made a few sketches of a sand martin colony, near the road. Earth has been cut away and sand extracted leaving a vertical face where the martins have dug their nesting burrows. The sand and gravel is a glacial deposit which was left in rolling mounds along the bottom of the glen by the retreating ice so long ago.

DAY OLD SNIPE CHICKS

FLEDGELING SNIPE.

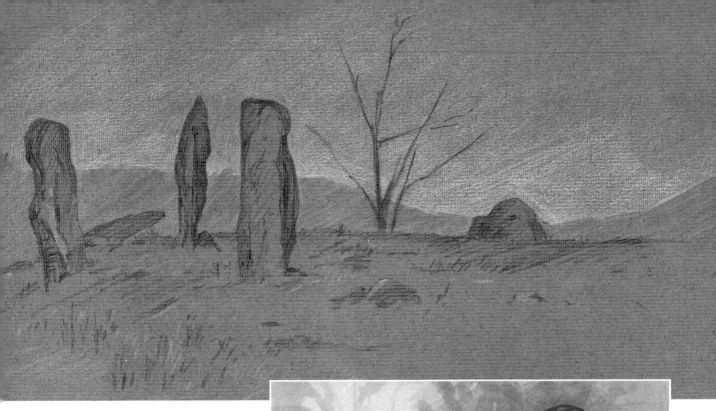

Thursday 21st *Solstice*

I walked up the road to the steadings at Colmeallie to draw the stone circle that I had picked out from my maps. As I turned a corner in the road, I was confronted by the sight of three rocky teeth that rose above a knoll on the sky-line.

The rocks were grey and gnarled, and a band of white quartz twisted through the contours of the tallest stone, some five feet high. I find that these Bronze Age circles always have a strong presence in the landscape; even this one which has had most of its stones removed. There used to be another circle, further down the glen at Dalbog, but it too was plundered for building materials and now it has gone forever.

It is midsummer today – the longest day – and I heard the cuckoo change his tune, 'cuck-cuck-coo', a sign that the summer season is turning. I took a sketchbook with me and walked up the burnside until I saw the cuckoo calling. I made some drawings of him, soft grey against summer green. As I painted I noticed the activity of insects in the deep grass where I sat: ladybirds, moths and beetles, and the frothy capsules of the froghopper bugs know as cuckoo's spit.

CAST SKIN

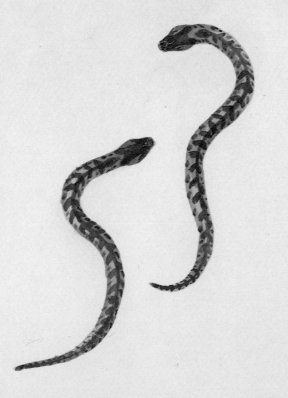

♀? ADDER.

YOUNG ADDERS.
(ONE YEAR OLD?)

Friday 22nd Vipers

Glen Esk is a good area for adders and I have often seen them basking in the sun on the moorland hill-tracks; the Hill of Nathro is, in fact, named after the snakes that can often be seen there.

Today, I found a large female (which tends to be browner than the males) lazing on the loose rocks near the burn. As I got closer, she began to uncoil, like wound elastic, and made her way slowly through the bracken stems and boulders. As she spread her weight I noticed how small her head and tail seemed compared to the thick muscle of her body. I find snakes fascinating – transfixing almost – but not in any alarming way, for although adders are poisonous none have ever attempted to bite me, even when I have been standing very close to them. They prefer to flee from intrusion if they can, and their venom is rarely fatal (I believe there has only been one death in Scotland in the past fifty years). There are still those who will kill them on sight, not because adders are dangerous, but because they feel they have an excuse to torment and obliterate. Nearby, I found some dried-out adder skin, possibly from last year. As snakes grow they cast the old skin which can only expand so far.

Wednesday 27th The burnside

As I follow the path of the burn downhill, I wander through a varied carpet of flowers. In the woods are cudweeds, sorrell, bugles and wild thyme and in the fields and meadows you find buttercups, chickweed, forget-me-nots and speedwell. Where the burn bubbles through the dark, acid peat, the moor is dotted with orchids, trefoils, lousewort, butterwort and milkwort, the more striking, perhaps, because they are set among the dead greens and browns of the heather.

Walking back through a piece of marshy ground, I put up a fledgling snipe chick that fluttered a few yards and then crashed into a ditch that drained into the burn. Its flight feathers were not yet fully grown, and after a couple of chases up and down the ditch it was too tired to fly any further. I made a drawing and ringed it before releasing it.

I heard a female cuckoo call today, the weird chuckling –'eeh-eeh-ahh-ahh-ooh-ooh-ooh'– that one might expect from a deranged monkey rather than from the hawk-like bird that ripples through the birches above the burn. It is this call that I associate with high summer in the glen and as the days wear on it can be heard more often at the edge of the birchwoods where the cuckoos are hunting for insects. 'In June he changes tune; in August depart he must', and when I hear it I know that the summer is already slipping away and that the cuckoo's short breeding season is over. In a few weeks, they will have left the glen and be heading south once again towards their wintering grounds in Africa.

July • The wood-edge

Sunday 1st *Boundary line*

There is something special about the boundary line between different habitats for it is here that plants and animals can be seen in unusual juxtaposition. The line of shadow, where the woods open up onto the wide, bright hillside, is a crossing point for many species. Meadow pipits and wheatears fly into the woods to glean insects that are sheltering from the heat of high summer. Woodland birds like redstarts snap up small moths that blunder out of the woods into bewildering sunlight. As I walked uphill, I flushed a large moth from the foxgloves and it flew out over the open heather. A spotted flycatcher darted from the trees and tried to catch it. Another flycatcher joined the contest and I could almost hear the click of beaks as they each made sorties, one after the other, to catch the moth which would close its wings at the crucial moment and fall out of harm's way. Finally there was a flick of feathers, a click, and the wide-eyed flash of moth-wings, and the flycatcher carried its prey back to a nearby perch and dismembered it. I don't immediately think of such small birds as predators but, on their own scale, they are dramatic hunters.

Monday 2nd **Moths and mosquitoes**

Where the ground is not too heavily grazed, a thick carpet of summer grasses grows between the trees and the heather. As I walked through the knee-high jungle, the flower spikes dusted the air with a cloud of bright, golden pollen that shone in the sunlight.

I lay down and began to paint some of the grasses and flowers around me. My knowledge of grasses is poor but here is an amateur attempt to name the ones I painted. From left to right: forget-me-not, meadow grass, plantain, hawkbit, pill sedge, rye grass, cocksfoot, soft rush, Yorkshire fog, another meadow grass and common sedge.

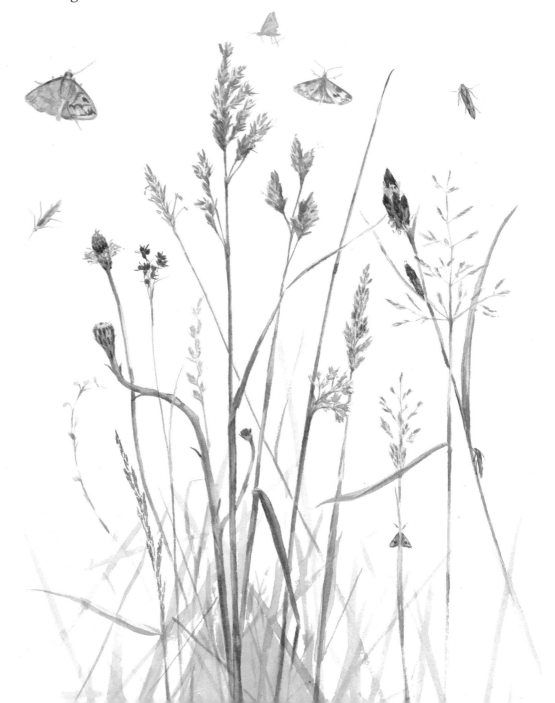

The vegetation is full of small moths, salt and pepper moths we used to call them as children, because of their silver-grey and brown wing markings. In fact, they are actually several different species and their classification is even more of a mystery to me than the identification of grasses. Another of the insects inhabiting the wood-edge was, however, all too familiar. The mosquitoes were not obvious because it was too windy for them to be flying but they lurked in the vegetation and latched onto my bare legs as I walked past. I regretted having worn shorts and spent a warm evening cursing and scratching at my legs.

Wednesday 4th *Beguiled*

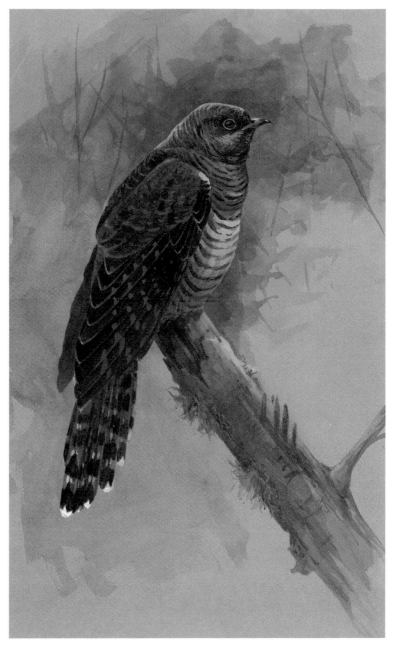

Another hot day, but muggy and oppressive, and the air is buzzing with flies that follow behind me in a droning, black cloud, to descend, if I stop, and cover my sweaty skin in their repulsive kisses. The skies above the wood-edge are switched by the wildly-sweeping wings of thirty or more swifts that have come to sift the heavy air for insects.

I saw a well-fledged young cuckoo perched on a rotting birch stump. As I watched, a meadow pipit flew out of the woods and the cuckoo opened its vast red and yellow gape. Mesmerised, the pipit landed on the stump beside it and pushed a beakful of insects into the beckoning mouth. While I made some paintings, I saw at least three individual pipits and a pied wagtail feed this one young bird. It is not only its foster parents that the cuckoo can beguile and this area at the edge of the woods, with its to-and-fro of avian traffic, is the perfect place for such a trickster to operate.

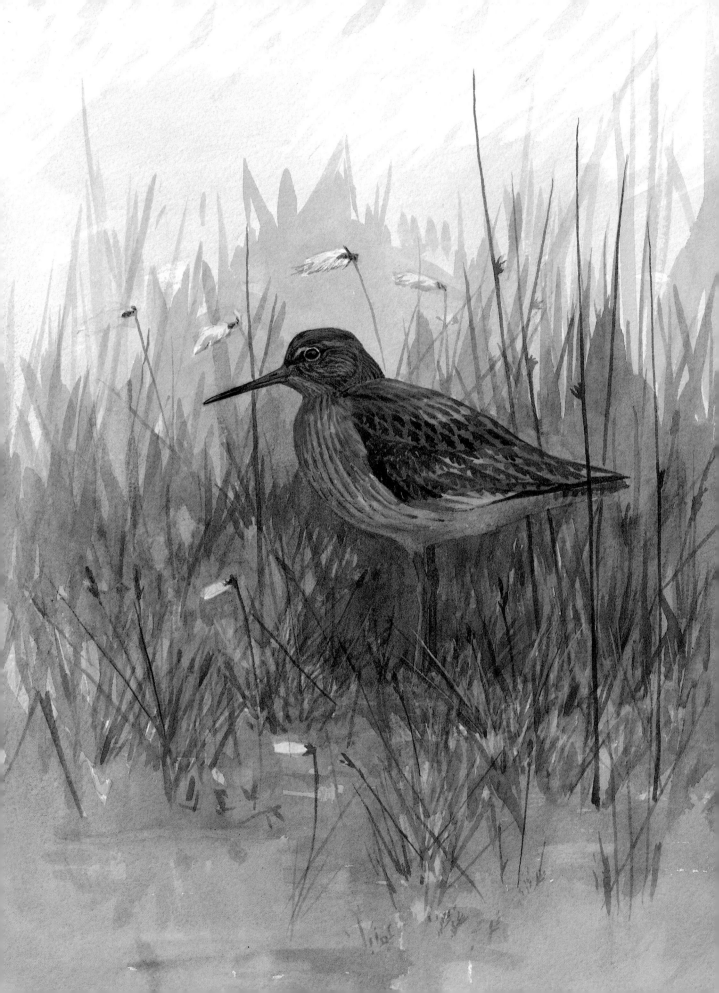

Friday 6th **Thunderstorm**

Once again it is a thick and heady day; dark and sulking. I made some sketches of the flies that landed all over and around me and also the big, black robber-flies that hovered at the edge of the shadows. This species seemed to specialise in catching small craneflies that rose, bumbling from the grass. I watched the robber-flies turn as they hovered, then dash and pounce, carrying off struggling bundles of wings and legs into the deeper shadows.

The air was throbbing with the dusty pressure of an imminent storm and I could hear the far-off rumbling of thunder. It was because I was watching the horizon for distant lightning that I nearly leapt out of my skin when the sky exploded and a fork of lightning struck the hills behind me. As the rumble died away, the rain began to fall in great, heavy drops, beating down sluggishly through the leaves and grass. In moments, I was soaked to the skin. I decided not to put on my anorak – I couldn't get any wetter. The rain wasn't cold but was still refreshing, a relief from the oppressive heat of the last few days and the woods were fresh again with the smell of wet earth and leaves.

I took the car further up the glen to where the woods meet open moor at the roadside and, clearing the mist from the windows, I scanned the rain-sodden rushes for any sign of life. There were several dejected-looking fledged redshanks huddling among the vegetation. Some have already left the glen and will have moved to their feeding grounds on the coast.

Tuesday 10th **Lizards**

I had seen lizards last year, basking in the sun on a tumble of rocks near the edge of the woods, so I returned there this morning while it was sunny but still quite cool. I set up my telescope and watched. There were several scurrying over the scree and broken branches but they were difficult to draw. They were too fast and their forms were unfamiliar to me.

I managed to get some details of one basking, motionless, on an exposed rock. Only once or twice did it change position, splaying its arms and legs out to catch as much warmth as possible. It didn't seem to have any particular colour, just a speckling of gold, green and grey that merged, at a distance, into a monotone brown.

There were a lot of butterflies out on the hillside: small whites, tortoiseshells, small coppers and meadow browns, and a single common blue, iridescent as an opal, gently fanning its wings in the still air.

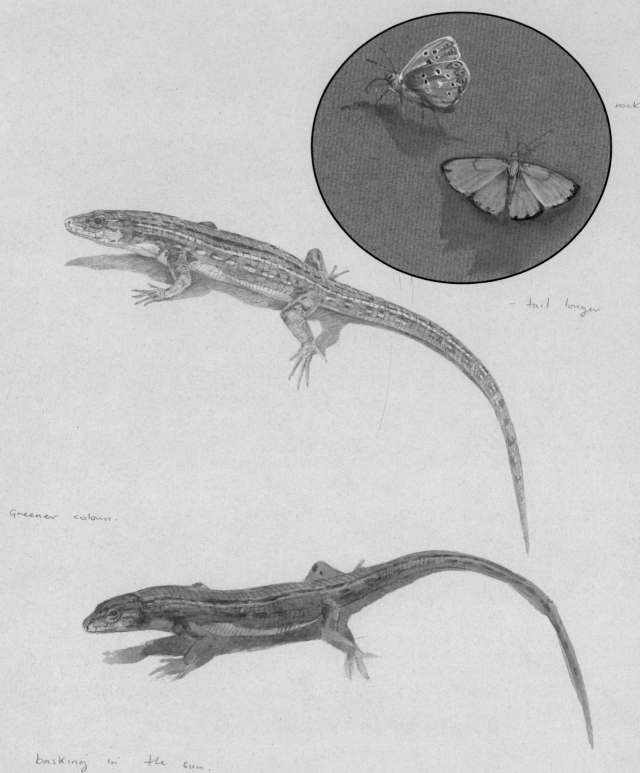

rocks

– tail longer

Greener colours.

basking in the sun.

COMMON LIZARDS. WOODHAUGH. ESK.

Thursday 12th *Teal family*

I found them hiding in some rushes on a small pool. The mother teal gave thin, little quacks of alarm as I walked around the edge, but I was unable to see the chicks. I could hear the stirring of water and see the vegetation quiver as they moved away. The duck had every reason to be anxious; this seemed to be her second attempt to raise a brood this season. Her chicks were too small to have hatched at the usual time in early June. Perhaps the first brood had been carried off by a fox or stoat.

I retreated to the cover of some nearby woods and was able to make a drawing of the family as they swam, in procession, among the thinner vegetation and waddled their way over exposed patches of turf.

Walking back through the pinewoods, I saw a red squirrel scampering about the forest floor. A couple of times it found something edible among the pine needles and, hunching over it, nibbled away daintily at the morsel held between its front paws.

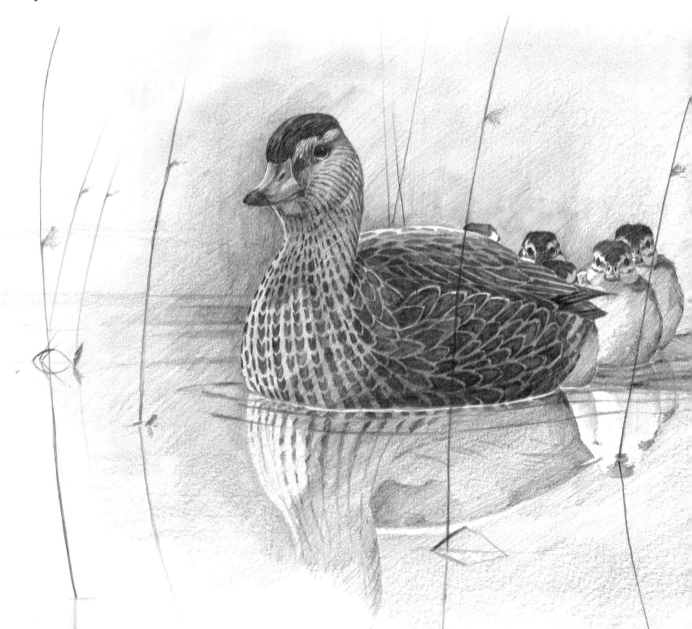

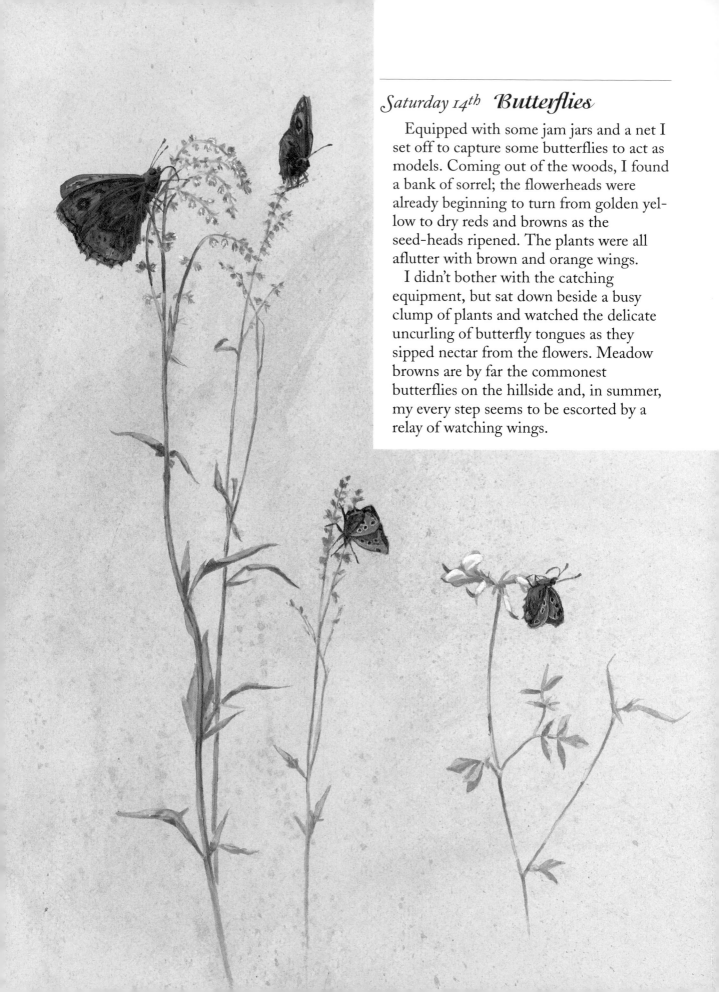

Saturday 14th *Butterflies*

Equipped with some jam jars and a net I set off to capture some butterflies to act as models. Coming out of the woods, I found a bank of sorrel; the flowerheads were already beginning to turn from golden yellow to dry reds and browns as the seed-heads ripened. The plants were all aflutter with brown and orange wings.

I didn't bother with the catching equipment, but sat down beside a busy clump of plants and watched the delicate uncurling of butterfly tongues as they sipped nectar from the flowers. Meadow browns are by far the commonest butterflies on the hillside and, in summer, my every step seems to be escorted by a relay of watching wings.

Tuesday 17ᵗʰ **Day and night**

A farmer had told me where I might find some fox cubs and I spent the day looking for their den. It was at the edge of the woods in a small plantation of pine and spruce that were only about two feet high, and the entrance to the den was scattered with tufts of rabbit fur and a few feathers. Shining blue and green carrion flies patrolled from one dried out piece of skin to the next and, as I knelt down to look in the burrow, I smelt the familiar stench of fox.

I found a fox skull poking up out of the excavated sand, an adult's with very worn teeth. It was probably a very old fox that had died in the den and had later been disintered by the new tenants.

I had a look around and found a lot of fox droppings among the heather. There were chewed feathers, bones, and strands of red fur sticking to roots that had been used as rubbing posts.

It was already late, so I decided to camp by the river rather than drive home. It was very warm so I did not bother with the tent, just my sleeping bag and the groundsheet. It meant that there was less to carry. As the light began to fade, I watched the stars appear above a patchwork of high cloud that caught the rosy pinks of a sunset, hidden from me behind the nearby hills.

I was just beginning to fall asleep when I heard a strange whistle that seemed to be coming from the river. It was still quite light so I took my binoculars and sketchpad and went to investigate. I got to the bank and was standing in the shadows of the alder trees, watching the calm flow of the water, when I saw a splash under the far bank, and then another, running into a silvery-pink ripple that cut through the reflections of the tree roots and then disappeared. Suddenly, I recognised what I had seen: otters. I sat down and hid in deeper shadows, watching as they chased one another through the slow current, their serpentine movements curiously echoed by the twisted alder roots that arched above them and the shattered reflections that rippled around them.

Now and then I heard a little, high-pitched snort and, once again, the drawn out whistle that had first attracted my attention. I watched them slowly make their way downstream until they were distant, black coils in the rose-grey glimmering of the river. It was too dark now to follow them, so I made my way back to my sleeping bag and settled down for the night.

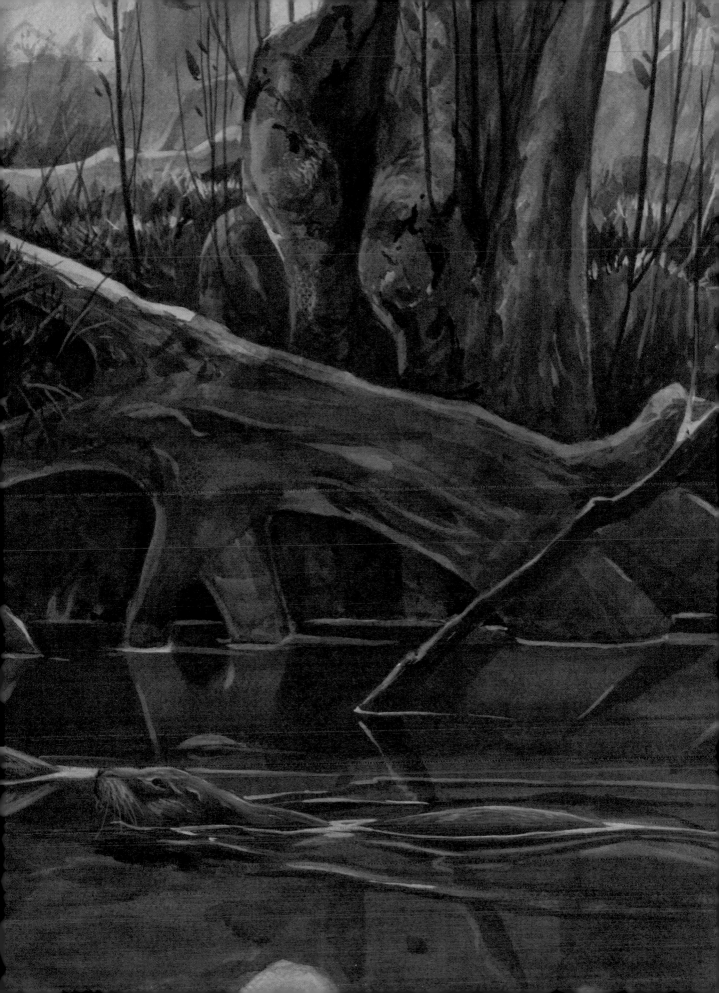

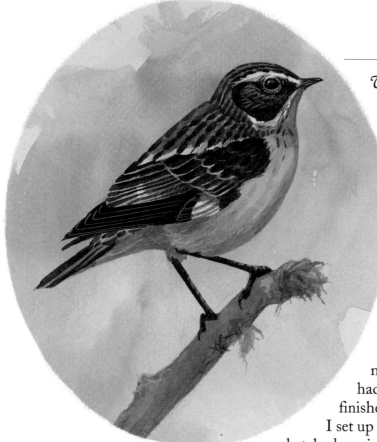

Wednesday 18th *Morning dew*

I woke up to the hazy greys of an early summer morning, before the sun had actually risen above the skyline, but I could see the intense, bright gleam of light reflected off distant hills to the east. I had woken because I was cold. The night air had condensed into a cold dew that soaked my hair, my rucksack and my sleeping bag. I put on the gas stove and made some coffee. A roe deer was grazing in the long, wet grass nearby. The sun soon broke over the hilltops and I laid out my wet things over some bushes while I had my breakfast. By the time I had finished eating they were dry.

I set up my 'scope at the edge of the woods and sketched a pair of whinchats that were hunting over the rough ground. They had several favoured perches from which they would pounce onto insects among the grass and heather below. Beneath each of these rocks and shattered birch stumps, crusted with droppings, I found a litter of moth and butterfly wings. Occasionally, a bird would fly out over the moor and, lacking any suitable perch, would hover over a likely looking piece of ground as it searched for prey.

Saturday 21st *Teal family*

A dull day, and mist lies across the hills, enclosing the glen in a curtain of light drizzle. All is quiet and, as I drive up the glen, the only movement is the ponderous amble of cattle by the roadside. The only sound is of slow chomping as they chew their cud.

Suddenly, the birchwoods exploded with the sound of alarming curlews and I saw two chicks make a long-legged sprint across the road into the thick vegetation beyond. For a few yards they ran low, their long necks bobbing and their heads held below the level of their backs, and then they were off at full pace, with heads held high like miniature ostriches. I pulled in to the side of the road and ran after them, finally cornering them at the fence bordering the wood. I put rings on them, made some sketches and then let them go. All the time the adult birds wailed around me and flew low over my head. The chicks ran a few paces then stopped, looking back at me as if confused that I was no longer chasing them, then they paced off towards the nearest rough cover and disappeared among a quivering line of grasses.

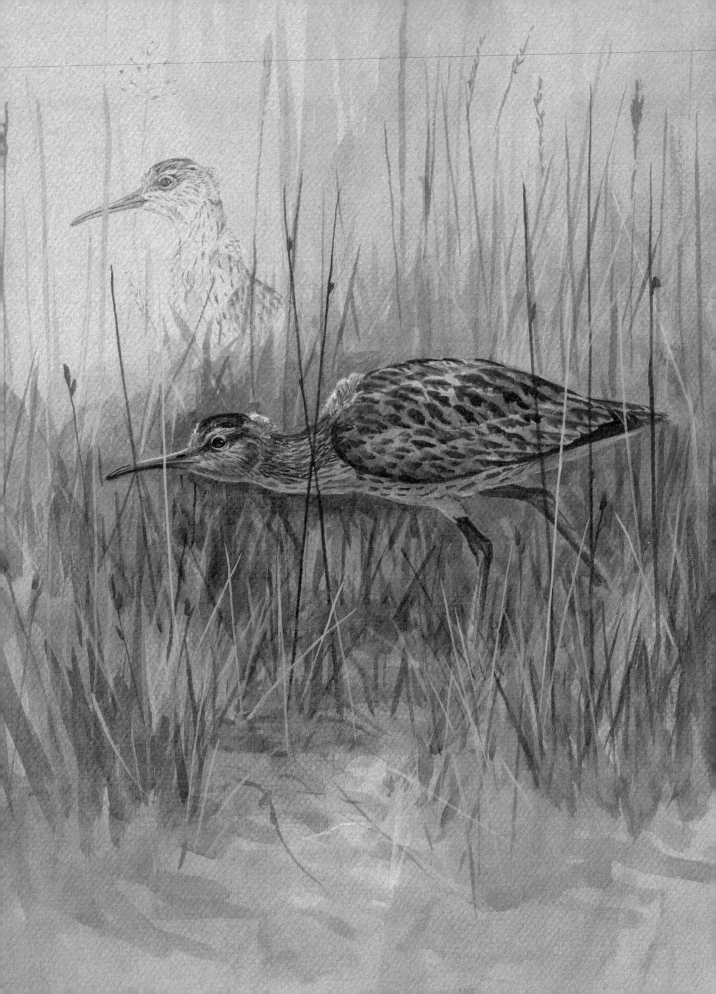

Thursday 26th *Foxes' earth*

It was a beautiful, soft evening and the slanting sunlight picked out a tracery of spiders' webs among the plantation trees. I managed to climb an alder at the edge of the woods and tied my telescope into a fork in the branches, fixing the line of vision onto the fox den some fifty yards away. It was a still evening and I hoped that, by hiding up the tree, my scent would carry over the foxes' heads.

Through my telescope, I could see a constellation of golden flecks above the entrance to the earth where the sun lit the jerky hoverings of insects.

It wasn't long before a fox cub poked its head up into view; his fur, caught in the sunset, glowed around the outline of his body like a red halo. Suddenly, two other cubs tumbled out, over the top of him, and careered down the hill. They stopped to take stock of their surroundings while the first trotted cautiously after them. I must have watched them play for two hours, until they grew tired and rested under the tree roots and heather below the den.

I was careful not to disturb them and moved slowly as I sketched them from my uncomfortable lookout. I waited until the cubs had moved out of sight again, then I slipped away. I am fairly sure that the vixen did not return while I was there or she would have barked, sending her cubs scrambling back into the den.

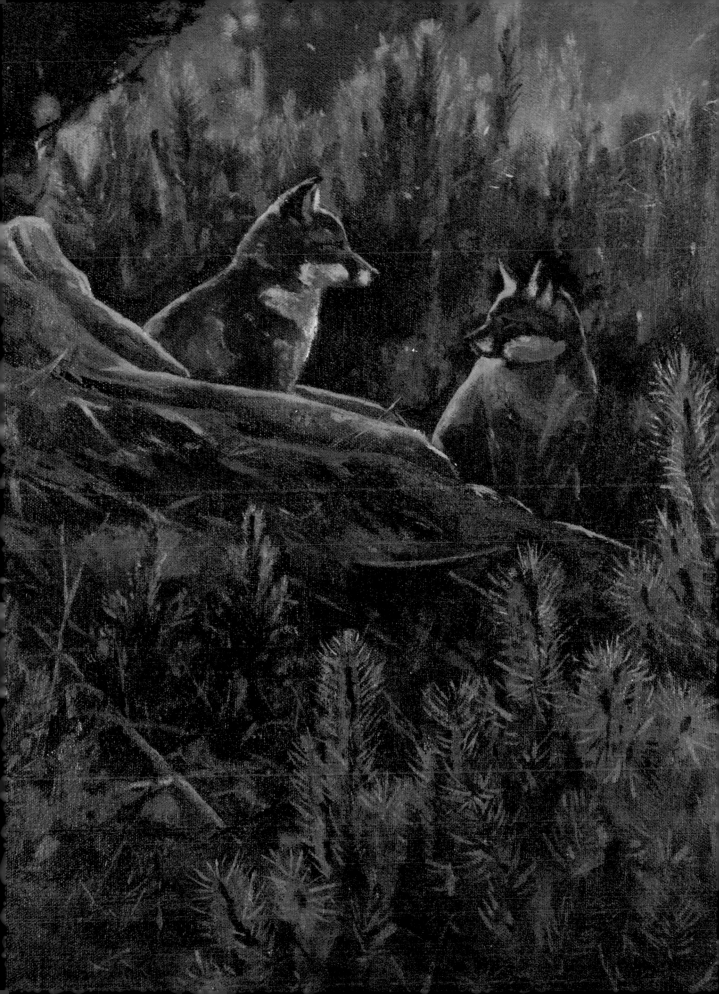

August • Hillside

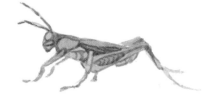

Wednesday 1ˢᵗ *Harvest*

A dry, dusty taste fills my mouth as I climb up the slope through the woods. Only the softest stirring of air moves the leaves above me and the gentle rustle is drowned by a chorus of singing grasshoppers. Their chirruping makes the air heavier and more oppressive. Birds are not singing now. The rush of summer has passed and the treetops are silent; the leaves are green but dried and worn, their lushness passed. The sun's rays pour through where numberless creatures have bored and gnawed their way among the canopy. High summer is a strange time: it has no real identity of its own but pauses between spring's growth and autumn's harvest.

I went up onto the hillside to see the slopes covered in heather bloom. A purple blanket draped across the contours of the glen, it becomes a patchwork where areas have been burnt for grouse rearing and gives the impression of some vast abstract painting. The blanket may seem fairly uniform from a distance but, close to, one can see that it is woven from several threads: ling, bell heather and blaeberry are twined together so that the individual plants become inseparable in the general tangle.

Out of the woods, I expected the breeze to be a relief but, veering, it drifted up the glen and brought a plague of black harvest bugs that covered both me and the hillside. Sure enough, looking down the hill, I could see swathes in the yellow fields at the glen-mouth. Further off were some distant plumes of smoke and, in the air, a faint scent of burning. The first days of harvest always come as something of a surprise to me. Summer seems to go by so fast.

The track that I walk along runs over the hills into Deeside. It is called the Firmounth and may be the oldest mounth (or hill) road in Scotland. Up until the last century, farmhands, mainly women and girls, from Aberdeenshire would cross through the glen into Angus to work at the harvest and then return after a few weeks to see to the later harvest at their own farms. At this time of year, hundreds of people would be walking along this track and into the glen.

I spent some time sketching moths and heather on the hill. Coming back, I walked along the dry beds of burns. These seasonal tributaries wait patiently for the autumn rains and some are called, in Gaelic, simply 'dry': Turret (Turaid) and Keenie (Caoinidh). Others have shrunk and make their secret way through channels in the peat. Disappearing down holes in the earth, burbling and gurgling to themselves out of sight. Some of these insignificant trickles, too, have their own names, like the Blackpots and Crosspits burns, describing their character and sound.

EGGER (GRASS) MOTH SP.

BELL
HEATHER.

♀ EMPEROR MOTH

Feathered antennae
on male -

♂ Emp. moth

EMPEROR MOTHS
MATING IN LING HEATHER

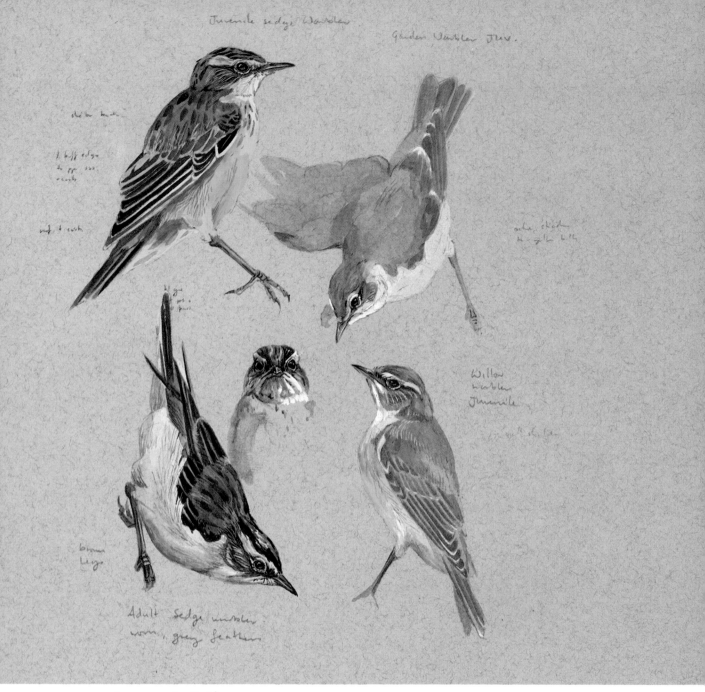

Juvenile sedge Warbler.

Garden Warbler Juv.

Willow Warbler Juvenile

Adult Sedge warbler worn, grey feathers

Friday 3rd **Migrants**

At half past three this morning, before the sun rose over the hills, I set some nets between patches of birch scrub on the hillside. A fantastic sunrise melted into the morning and for half an hour between the first light and daybreak a low mist formed in the glen so that the birches stood rootless in a white sea. A few birds began to move about in the bushes and, as the sun climbed, and the mist dispersed, they began to fly out of cover. I took several dozen birds out of the nets before the movement subsided in the heat of the late morning. I marked and measured the birds, mainly

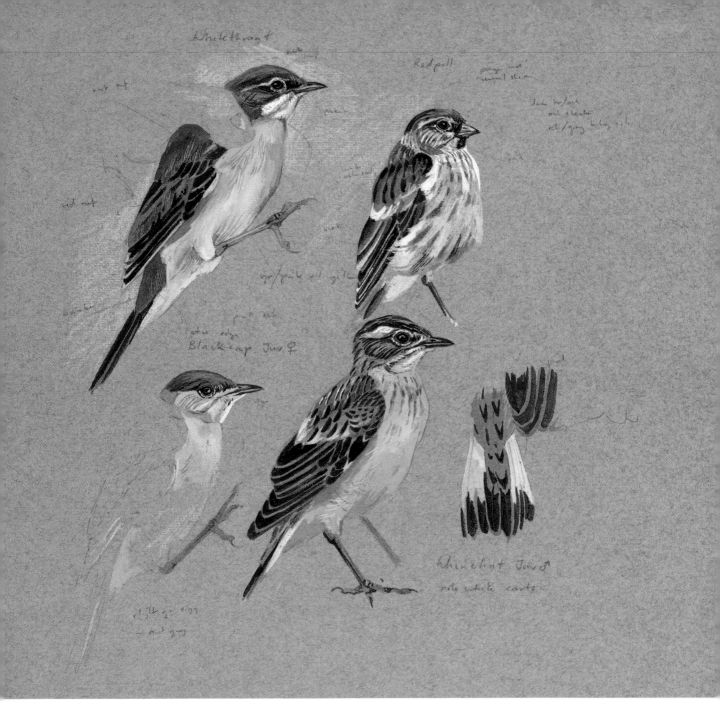

warblers, that were moving down the glen, 'coasting' along and feeding as they went. They are making their way south before they fatten up and start their migration proper. Just five or six weeks ago, many of these birds were still nestlings and now they are starting on a journey that will take them, with luck, through Europe and beyond, with many crossing the vast Sahara desert. In a week or so, some of these tiny scraps of life will be wintering in Africa. Many others, however, will have died along the way. There is some strange poignancy in seeing these birds now. They are tokens of summer leaving.

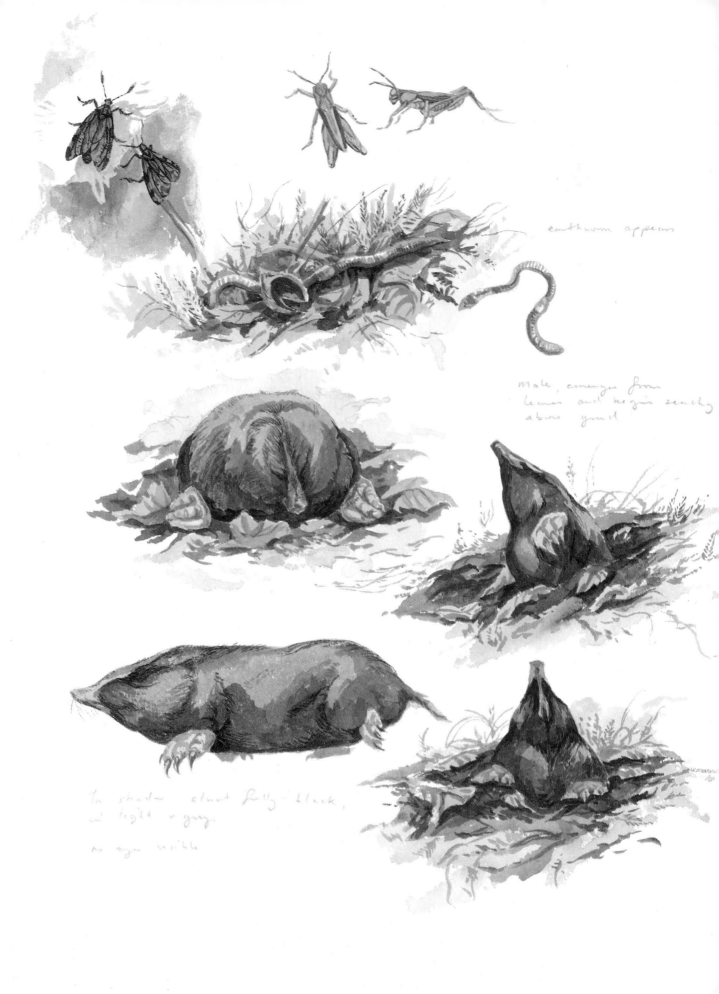

earthworm appears

Mole, emerges from
leaves and begins searching
above ground

In shadow almost fully black,
in light v grey.

no eyes visible

RUNNING AWAY.

CICINDELLA
CAMPESTRIS

PULLING OUT A WORM.

BURROWING
DOWN

BEETLES

STAPH. Gp.

Monday 6th *Earthquake*

A big sheet of paper taped to my drawing board. I planned to spend the day sketching insects on the hill but the sun was too bright and the glare from the white paper burnt my eyes so I sheltered further down among the birches. I was drawing grasshoppers when something rustled through the leaf litter. A big worm slid out into the sunlight and I thought it strange that it should venture out into this desiccating heat when another appeared, and then another. By this time, I had stopped drawing and was wondering what natural disaster they might have foreseen. A flood, perhaps, or an earthquake. Suddenly the 'earthquake' arrived. A louder rustling at first and then a pink snout poked out of the soft earth. The mole sniffed about and then scurried off through the leaves, rooting and snuffling as it went. It soon found a worm and tugged it out of the earth, chewing noisily. Only then did I think of trying to draw it but I must have made too much noise because it startled and then ran, impossibly fast, with pink feet flapping, back to its burrow and disappeared, kicking earth high into the air as it went.

I stayed on the hill to watch the full moon rise, huge and orange, a real harvest moon, like some vast, cosmic fruit hanging in the heavens. A fox was barking at the edge of the woods so I stalked round and watched it through binoculars from behind a rock as it howled up at the sky. After a while, I made my way quietly downhill, the fox still barking behind me as I reached my car. A day of chance meetings.

Thursday 9th *Field systems*

Driving through the glen in the early morning at about five o'clock with a still moistness hanging in the air, I saw a conspicuous white blob on the hillside and coasted the car into a lay-by. A fine roe buck was grazing on the slopes, stopping occasionally to turn around to me and give me a measuring stare. He seemed undisturbed by my presence, quite happy to know that I was too far away to be any sort of threat. He carried on feeding, his white, kidney-shaped rump turned towards me in a gesture of disdain. He crops grasses among ridges that seem out of place on the open hill. They are a vestige of ancient field systems built at a time when the climate was dryer by a culture that has long since passed. There have been many harvesters in the glen and now it is the deer's turn among the forgotten fields.

Far more recently, other fields were abandoned and now there are virtually no food crops grown in the glen. The old system of crofting that supported many families was turned over to deer forest and sheep pasture over a hundred years ago. Once, many of the fields were worked by runrig, the system of ownership where land was shared out in strips (rigs) each year, sometimes by drawing lots. Some places like Rannoch and Auchronie still carry names that describe the runs or shares (from the Gaelic *roinn*) and on the map many houses are named by the fields (*achadh*) in which they stand: Auchmull, Aucheen, Auchintoul.

Monday 13th **Refugees**

After a day of grace on the Sabbath, today is the Glorious 13th. I can hear volleys of shots in the glen as grouse up on the hillside meet a sudden end. This, perhaps, explains why there is one party of birds so near to the road, much further down than usual for this time of year. They are soaking up the strong sunlight, occasionally feeding or running among the heather. They seem quite unperturbed and I wonder if they have had to run the gauntlet of guns to reach here.

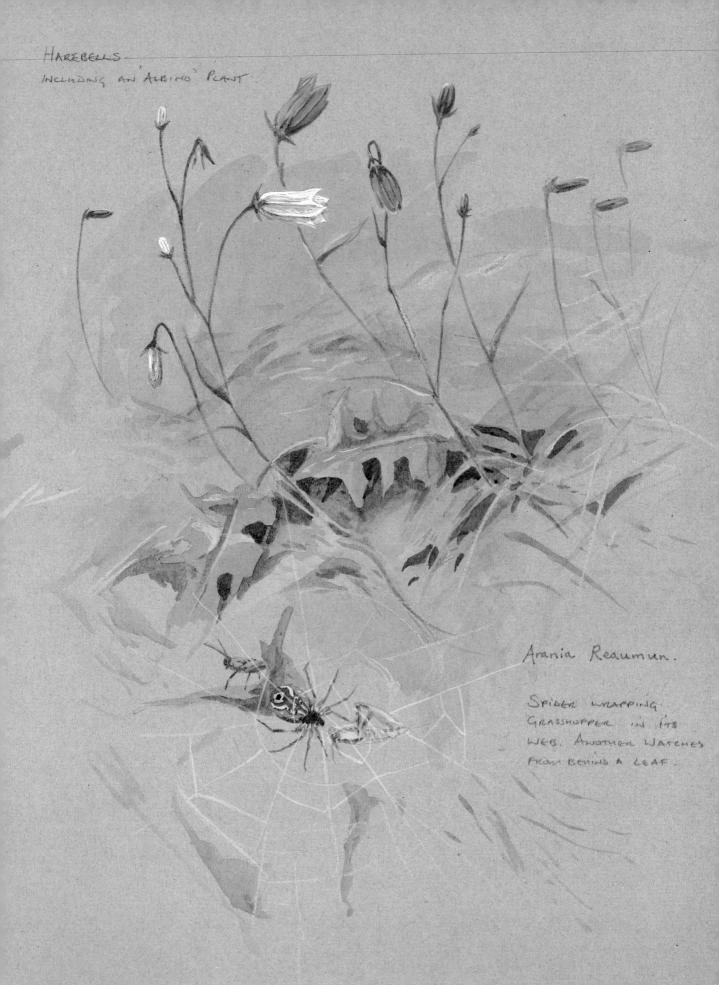

HAREBELLS·
INCLUDING AN 'ALBINO' PLANT

Arania Reaumun.

SPIDER WRAPPING
GRASSHOPPER IN ITS
WEB. ANOTHER WATCHES
FROM BEHIND A LEAF.

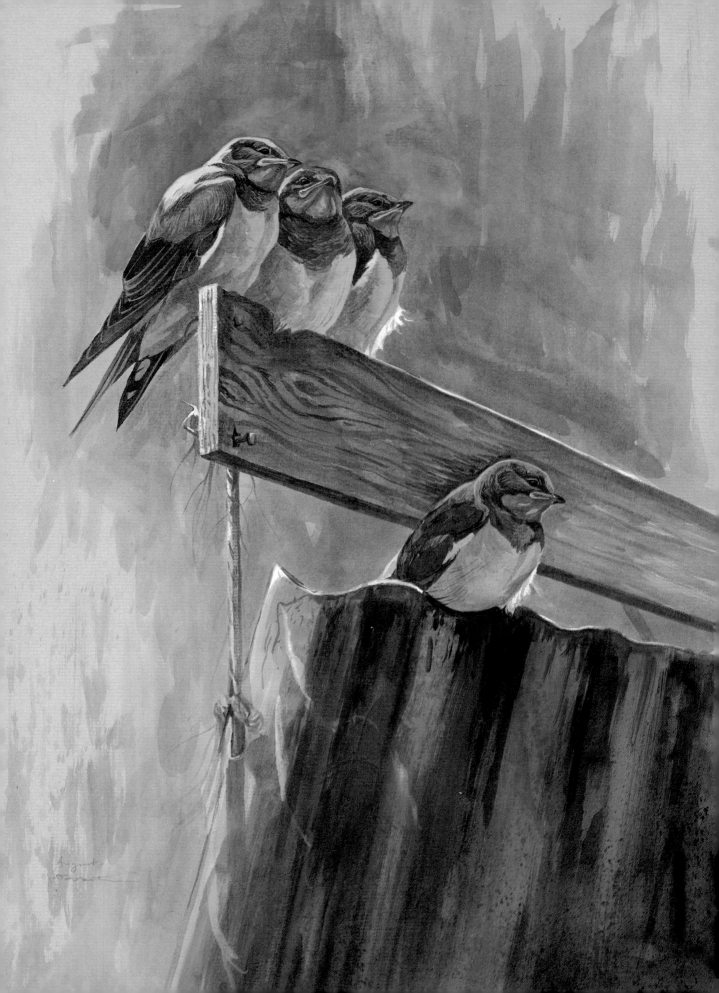

Friday 17ᵗʰ *Swallows*

I studied a late family of swallows, the second or, perhaps, even third brood to fledge this season. I have not seen any other swallows here for a while, although there are still lots nearer the coast; perhaps these are the last swallows in the glen this year. The youngsters are waiting in a gang near the sheds in which they were raised. The parents are busy ferrying food to the impatient chicks with an air of urgency. Perhaps they feel the migratory urge already. It is strange to think that of the entire family, the two parents and (in two or three broods) perhaps a dozen chicks, only two are likely to survive until next year, successfully returning to the same area. Deserts, seas, predators and sheer exhaustion will take their toll on the rest. Their lives run along a sharp edge.

Suddenly, an adult swallow returns and five beaks open wide, wittering and begging to be fed. Their entire heads seem to open up into a yellow gape; straining forward, eyes alert and wings flapping. In the strong sunlight, they seem to dance like flames of blue and red and yellow.

Friday 24ᵗʰ *Summer's end*

The red deer fawns are getting big now. Some have outgrown their baby fat and seem more like giraffes than deer; their legs and necks seem almost unnaturally long. I came across a herd of hinds and did some sketches using a telescope but they soon caught wind of me and made their way slowly off up the steep corrie-side in convoy. The fawns would call after their mothers by barking, a most unlikely sound from a herbivore.

Some parties of curlew are flying around, mostly heading down the glen. Some birds may remain until the weather turns really hard but the majority are making their way now to the coast. There is a tradition that the curlew are the 'Seven Callers' and that seven calling curlew flying overhead are an omen of death. I don't really believe this superstition, although by coincidence I saw just such a group of birds on the day I lost a close relative. The curlew, however, are an omen of the death of summer. It is strange to think of winter at summer's height but nature is already foretelling the change. Two or three whimbrel have been calling today, flying with the curlew. They have probably left the country of their birth already, moved on from the Arctic tundra by the first signs of the changing season.

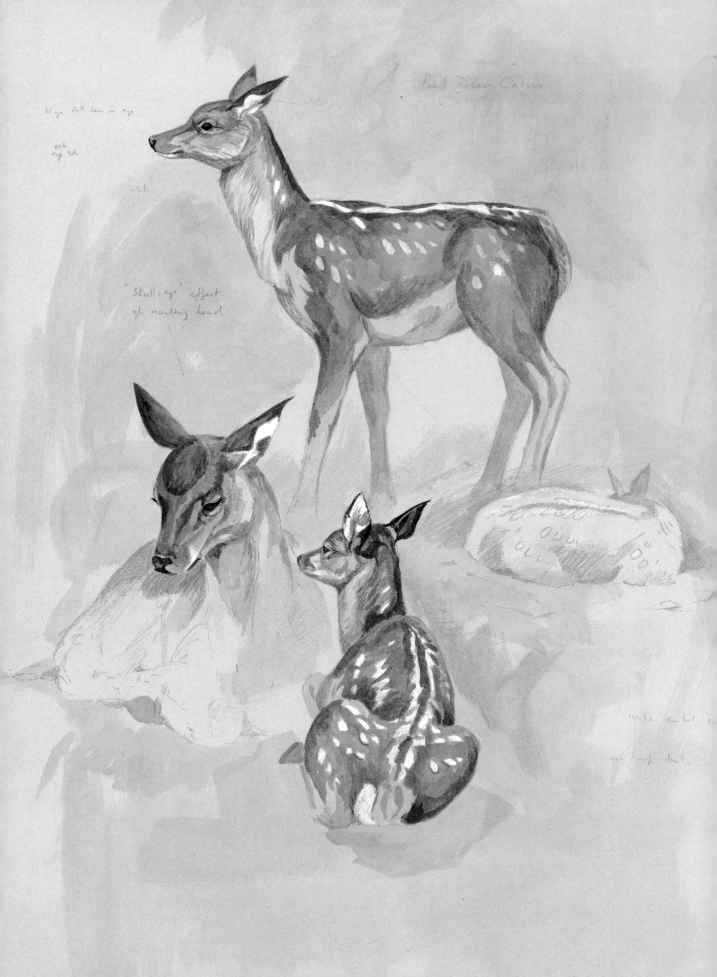

Red Deer Calves

"Skullcap" effect
of moulting head

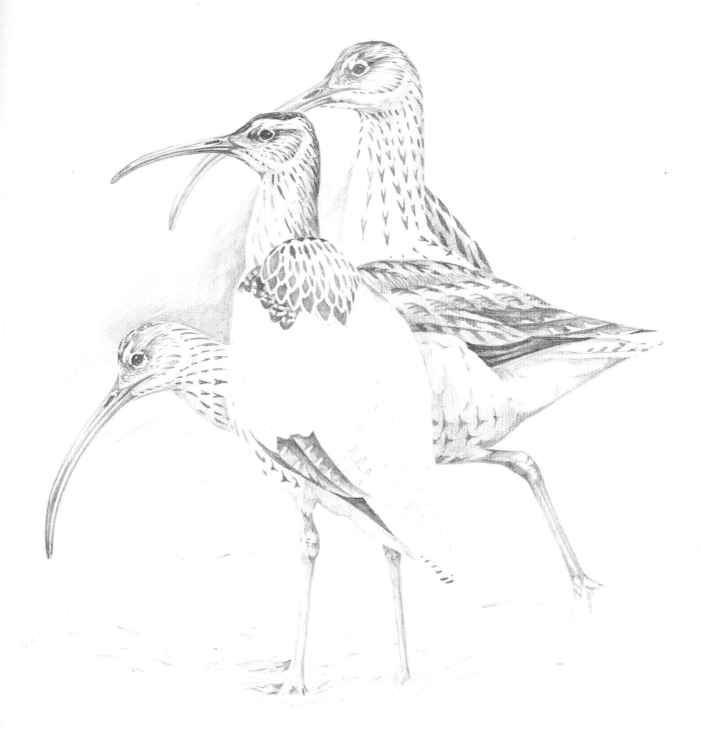

CURLEW AND A WHIMBREL.

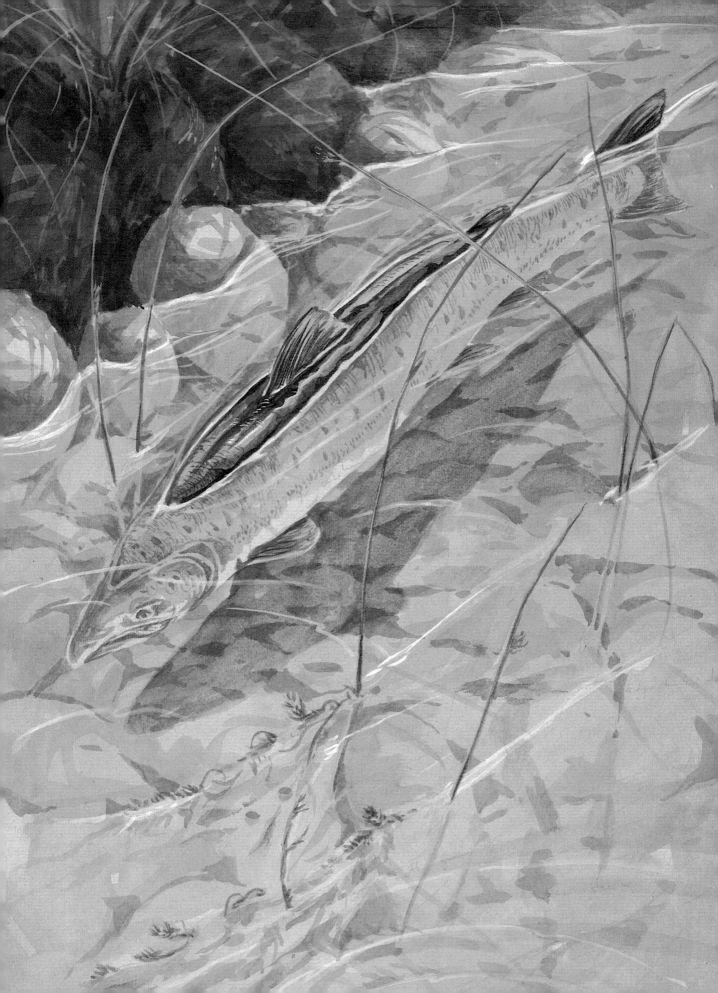

September • High woods and passes

Saturday 1st The gentleman

Sometimes, when I am drawing or painting an animal, my concentration can become so intense, my thoughts so entirely focused on the subject I am watching that, for a time, I identify completely with that animal, seeing through my subject's eyes almost. When that happens, I can finish a piece of work without noticing it, working almost by instinct. That aspect of drawing from life always surprises me afterwards and is, I think, the most rewarding thing about working in that way. It sheds a new and unexpected light on the things I see and, in turn, I hope, on the work that I produce.

This afternoon, on a warm, sunny day that brought a dusty breeze through the glen, I could almost feel the shifting flow of river currents and fanning of water through gills. Lights and shadows distorted by the water's surface. I looked up from the river into an alien world of air: imagination took over when I was trying to draw the salmon that was resting below the riverbank. He was a big male and for a time he basked in the shallow waters, seeming a ghostly blue against the brown rocks of the river-bed. His view of the world and of his own existence must be so entirely different from ours. Despite the gentle weather and the passive way in which he drifted, almost motionless, beside the bank I could imagine him forging through the deep Atlantic swell.

Monday 3rd Forest spirit

I watched the stag as he lay at the forest-edge, like the King of the Woods, chewing cud and watching the sun rise higher. Although woodland animals by right, this was one of the rare occasions where I had actually seen red deer in woods. The yellow light of early morning gave an orange glow to his coat and cast purple shadows about him. He had been running through low cover or perhaps rubbing the last of the velvet from his antlers. Dried leaves and grasses were hanging from them so that a small shrub seemed to be growing from his head. It might have been the light frost from last night that brought him down to the woods and there was still a chill in the air that the sun's rays had not yet been able to penetrate. On my way out of the wood, I picked a shield bug from my clothes. The frost seemed to have affected it badly and it wandered around in a sluggish kind of way, its antennae waving feebly.

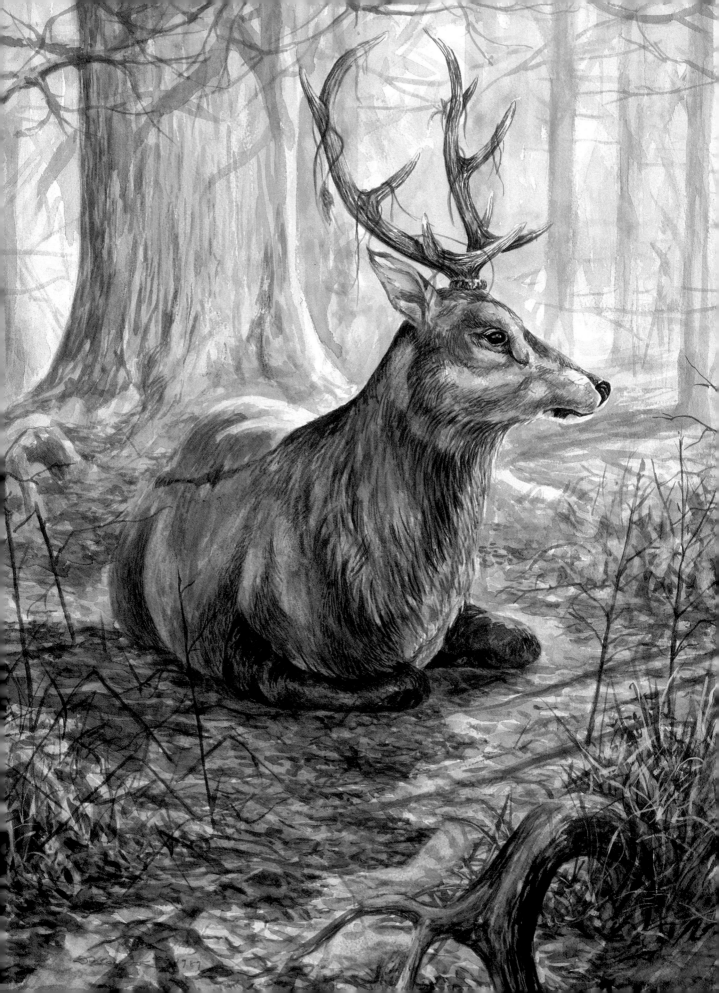

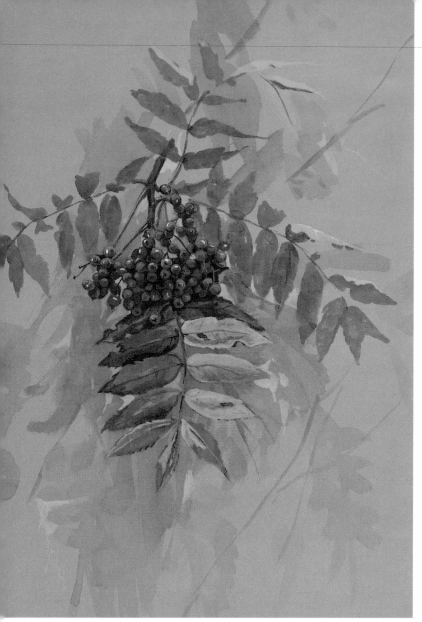

Thursday 6th *Rowans*

I've heard Glen Esk called 'the glen of rowans' and it is easy to see why. At this time of year they are laden with berries and in every crag and burn, where trees can take a hold, they are bedecked with clusters of red, gleaming fruits. Nature is stocking up for the winter and the berries provide a good food source for many birds through the cold months ahead. Already some of the trees further down the glen have been picked clean by flocks of thrushes. Rowans are everywhere in the glen and the place names reflect their presence: Hill of Rowan, Berryhill, Berran, Ranntry (rowan tree), Kirny (from the Gaelic *caorannaidh*) and Chuirin.

They have an important part in local folklore too. Within living memory, houses in the glen kept a cross of rowan twigs bound by red thread hidden in the roof to ward off witches and, in fact, one of the reasons that rowans so often grow near to the houses is that they were planted to keep away witchcraft (although they also had a more practical use which was to stabilise the foundations of the houses near which they grew and to improve drainage). The efficacy of these arboreal charms would seem to be proven by the absence of recorded instances of witchcraft in the glen.
Out on the hill, however, there is an almost supernatural quality to these sturdy trees that have to grow in impossibly precarious places out of the reach of sheep and deer. Some seem to grow from the rock itself, pushing out from a sheer cliff-face or perched atop a boulder.

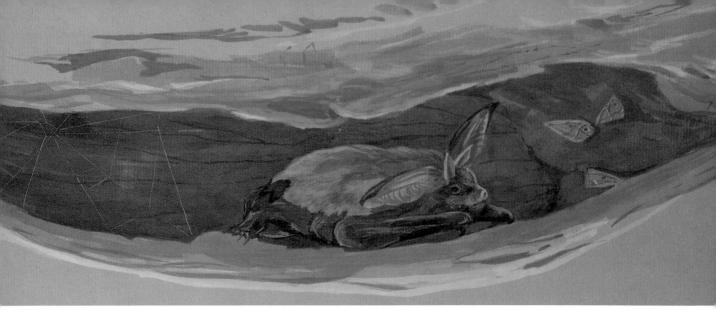

Sunday 9th *Night hunters*

I spent today exploring a belt of high woods and trying to find a bird that I thought might be there. I wouldn't have seen it if it hadn't turned its head to watch me walk by. It could have passed as just another piece of dead wood but for its piercing orange eyes. Owls always make easy subjects to paint and this one was no exception: the perfect model.

When I had finished painting, I walked back through another piece of woodland where I thought that I might find another long-eared owl. They usually roost, during the day, perched on a branch and pressed up next to the tree trunk but sometimes they roost in holes in trees. I was just checking a likely-looking crevice through my binoculars when I saw something move in the darkness. I set up my telescope and saw it again: a small pink ear. I don't know what it was doing, apparently alone this high up in the glen, but it was one of the best views I have had of a long-eared bat. At the base of the hole there was something sticking out: small, grey wings, the remains of unfortunate moths.

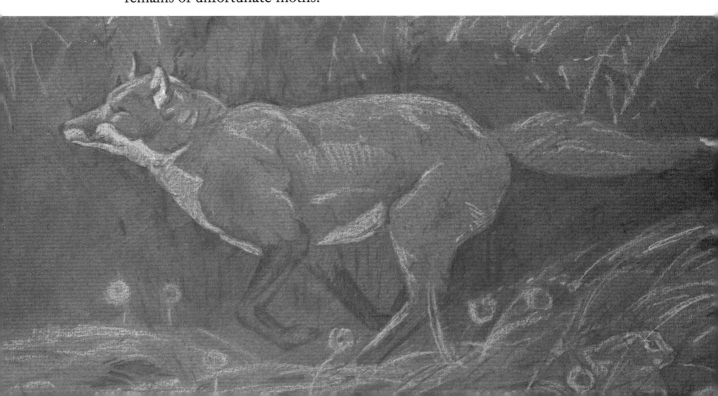

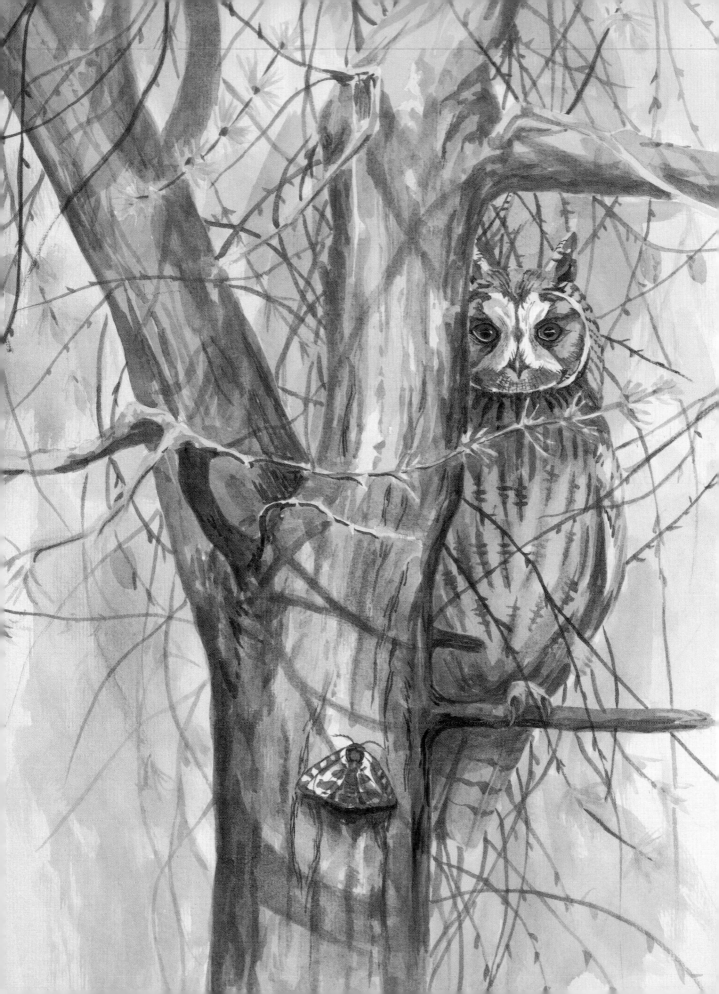

taschen
Pine Marten.

longer and stronger
forearms than most
other species of weasel.

bushy tail. and
more umber / brown.

climbing one day.

Wednesday 12th *Pine martens*

It was a showery day today and so I cheated. Rather than get soaked, out on the hill, I went to the local zoo to draw an animal that was once in the glen but is now, to the best of my knowledge, extinct there. I had great fun drawing the pine martens that ran around in a frenzied chase.

Persecuted by gamekeepers, pine martens were eradicated from large areas of the country during the last century. They were very nearly wiped out completely but are now making something of a comeback. They really are spectacular creatures and deserve a place in this book as an animal that once lived in the glen and was absent for a short while. With the right encouragement they may return one day.

Monday 17th *Uisge beatha*

I walked across the hills from Glen Lethnot to Glen Esk today, along the mounth road that runs through the Clash of Wirren, an impressive pass that cuts through the ridge between the glens. The road has two names: 'the whisky road' and 'the priest's road'. A secretive path that crosses many blind summits and hidden gulleys, it was the perfect route to smuggle illicit whisky out of the glen. At one time, illegal whisky making was a source of income for many families in the area and ponies were used to carry the illicit goods across this track at night and down into the Lowlands where it was in great demand.

Despite the difficulty of access, the excisemen and the army made regular forays into the hills where the stills were hidden and they laid ambushes along the roads to catch the pony trains. Glen Effock and the Hill of Rowan were once the sites of many stills that were hidden among the heather and bracken. When the excisemen were not about, plumes of smoke rose out of the ground from secret chimneys. I had a look at the Hill of Rowan and, sure enough, hidden in the bracken and little more than a depression now were the remains of a whisky bothy. At one end was a tiny break in the ring of the wall that must have been the door; barely enough for a man to crawl through.

Up and down the glen, you can still see the remains of the lime kilns that were used to make fertilizer for the barley. The farms could use as much barley as they could grow for making the whisky but when the illegal trade was finally stopped there was no market for the barley, nor any need for the kilns and without the income there was far less work in the glen and many people had to move away.

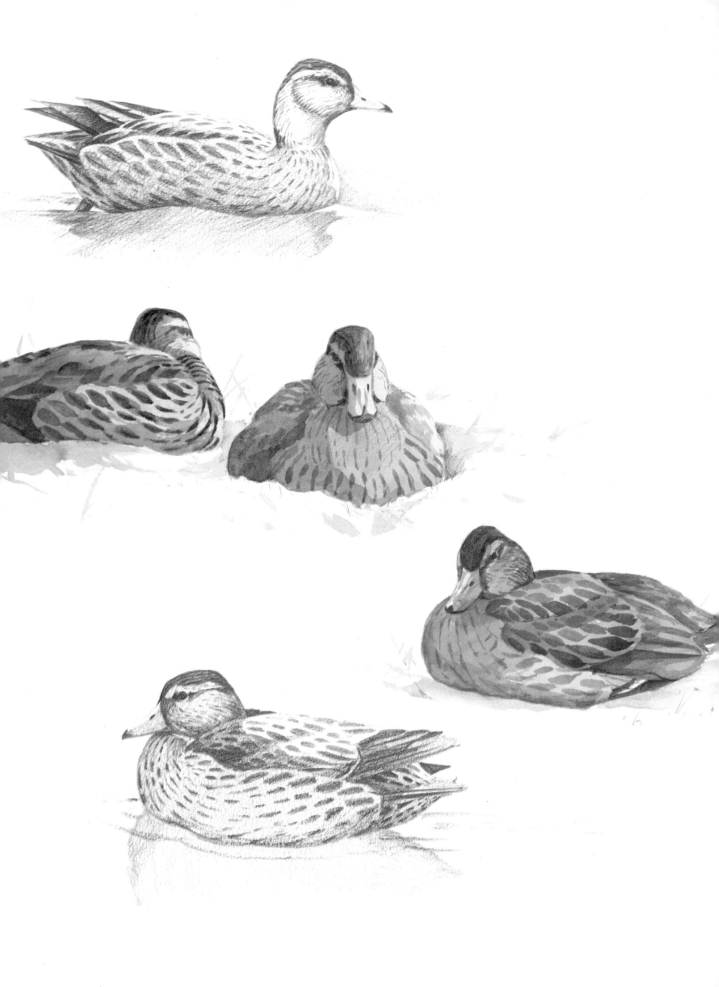

The track's other name, 'the priest's road', harks back to the time in the 18th century when the Episcopalian Reverend Rose was responsible for the two parishes and churches of Glen Esk and Glen Lethnot and gave services in each church. He often had to cross the mounth roads in treacherous weather. I read that there was a terrible feud between the Reverend Rose and his Presbyterian counterpart the Reverend Scott over their theological differences. At the time, some people felt that the Reverend Scott lost the argument, not because of his opponent's arguments or righteous cause but rather because of his sudden death after a fall from his horse. The different uses that the whisky/priest road was put to were not mutually exclusive. At one time, it was rumoured that a certain clergyman in Glen Esk was hiding whisky-runners and their wares in his manse.

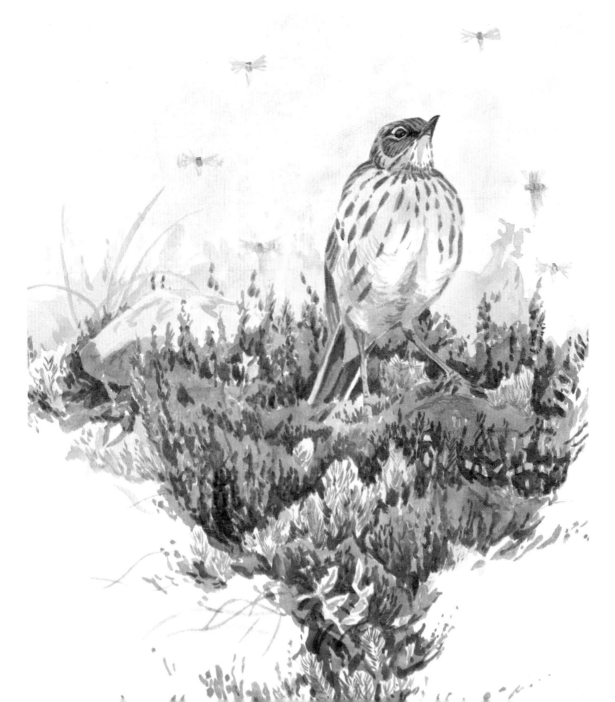

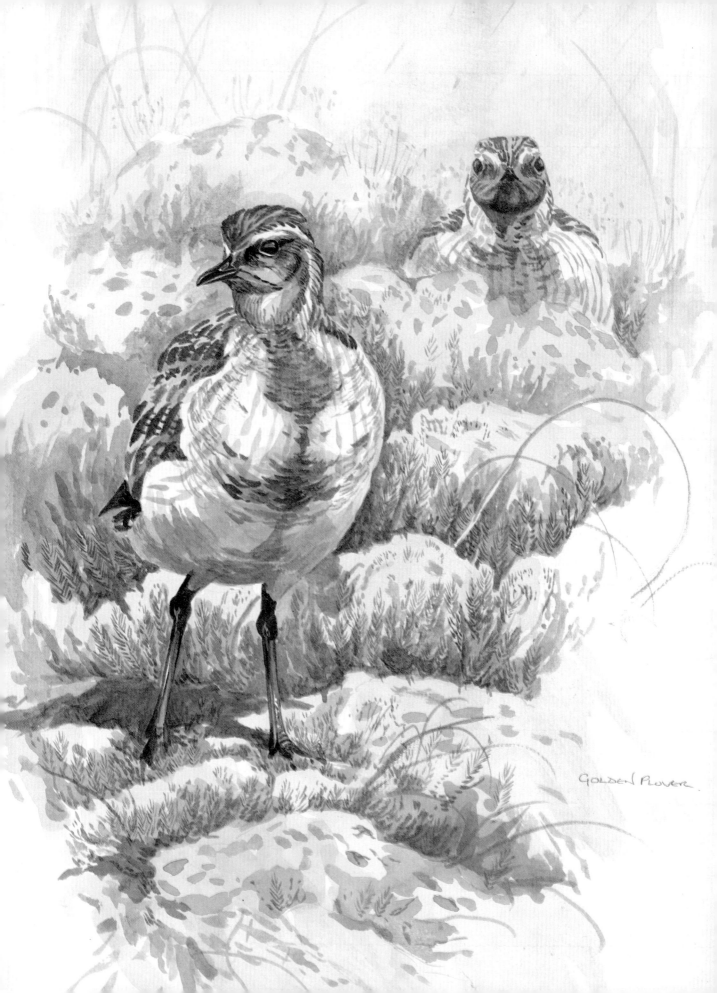

GOLDEN PLOVER

Friday 21st Hoverflies

I was surprised at the number of meadow pipits that are about this week. Parties of up to 400 are feeding on the sunny side of the slopes, and it is only when I sit down that I discover what is bringing them here. The heather bloom has attracted swarms of hoverflies that dart around from flower to flower. Some of the meadow pipits chase after them but others just stand, waiting for an insect to fly close enough to be caught. The hoverflies were only on the sunny patches. In the gulleys and on the far side of the hill where a shadow lays across the heather, it must be too cold for them.

I was surprised again to see golden plovers feeding on a mossy patch on the hillside. At this time of the year, I would expect them to be at the coast so perhaps they were simply passing through, taking a short cut from the east coast to the west. Their plumage is changing now. Neither the bold designs of summer nor the muted camouflage of winter, one reflecting bright sunlight on heather and moor and the other, the colours of mudflats and estuaries.

Friday 28th First fruits

A gang of tearaways plundering the orchard – and making no secret of it. This year's young starlings have discovered the joys of picking brambles. There aren't many bramble bushes high up in the glen as the winters are too harsh and the deer too desperate for fodder, but this one plant has found shelter in a ruined cottage. Huddled in the corner of the drystane walls, the deep red of the bramble stalks are exactly the same colour as the starling's legs and the leaves, like the young birds' feathers, are trimmed with brown. The birds seem to grow out of the bush itself.

Like thieves fighting over their spoils, they are squabbling among themselves and trying to win a space in the highest sprigs where the best fruits are to be found. So intent on quarrelling with one another are they that they seem to spend more time fighting than feeding. Low down in the bush, a few more pragmatic individuals are harvesting intently, hardly bothering with the commotion 'upstairs'. Now and again, a bird will dart into the mêlée to grab a berry from the midst of the contestants and disappear from sight into the depths of the thicket, no doubt to covet its prize. Sometimes they emerge, still carrying the bramble, not quite sure what to do with it now that they have won the trophy.

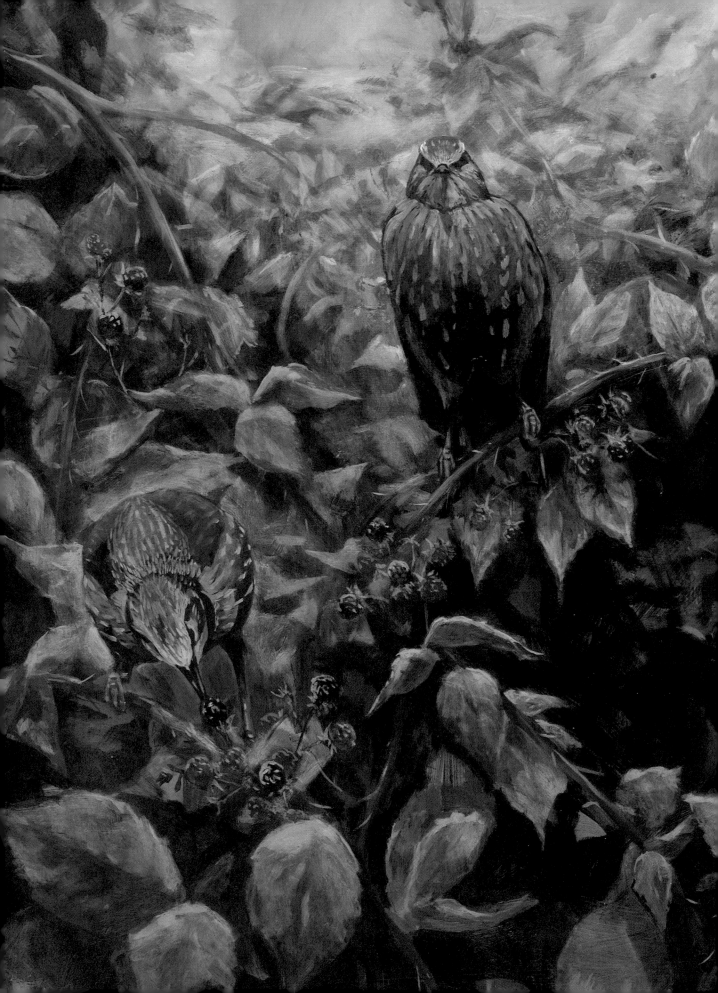

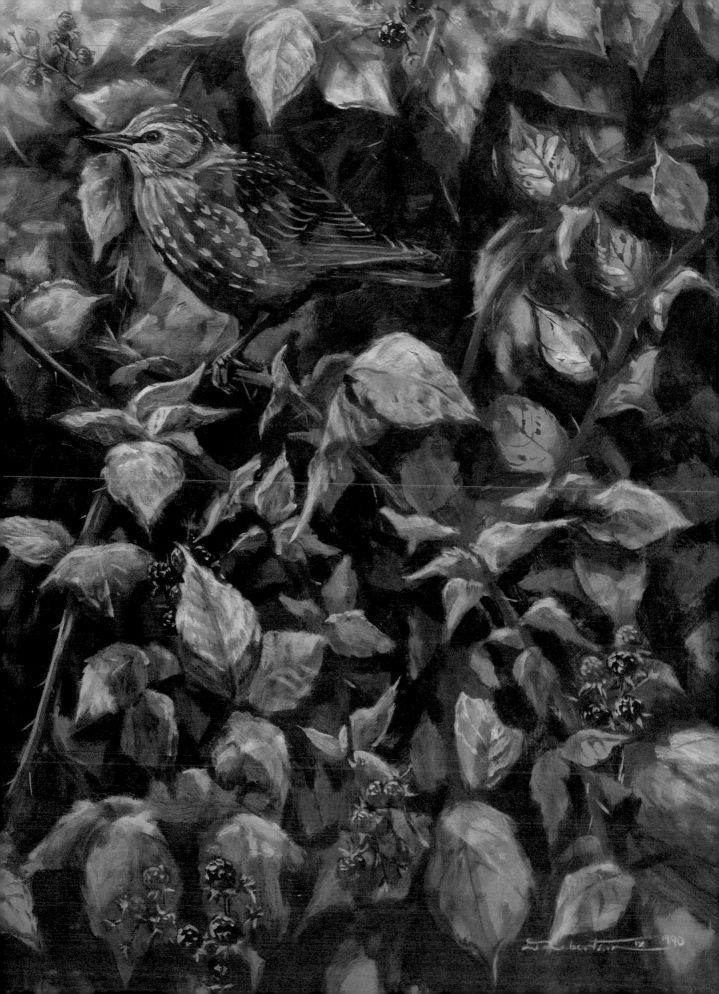

October • High lochans

Caterpillar, Corlochy, Esk
Oct '90 Emperor Moth.

Wednesday 3rd Redwings

The character of the glen changed suddenly this week. Like the Spirit of Winter itself, the wind tore down from the north-east and rushed through the glen, throwing wreathes of yellowing leaves before it. When I came here today, I was taken by surprise at how much things had changed. I could almost taste the frost on the air, mingling with the scents of autumn: the smoky smell of rotting leaves and fruit, sweet fungi and new earth. Yes, things had changed.

It was less like winter than the past two days had been and was now, in fact, a fine autumn morning. There were unfamiliar voices in the air. The last of summer's visitors have left and, brought in on the northerly winds, flocks of redwings now gleaned berries from the rowans. They quickly stripped all the fruit that remained on the low-lying trees and then moved higher up on the hillside to the more exposed boughs.

The bright red that gives the redwings their name seems so conspicuous that I never thought of it as camouflage, but now, hidden in the flame-red canopy of the autumnal rowans, I can hardly find them unless I follow the high-pitched calls that give them away. From their plumage I can tell that the cold wind has brought in birds from both Iceland and Scandinavia. It's strange to think of these birds from different countries meeting here, the heralds of winter plundering the glen.

Hot colours on a cold day: the red-winged thrushes, red rowan berries and leaves. Below them, red fungi grow in the leaf litter.

Common Snail, nr. Corlochy.
Esk. Oct '90

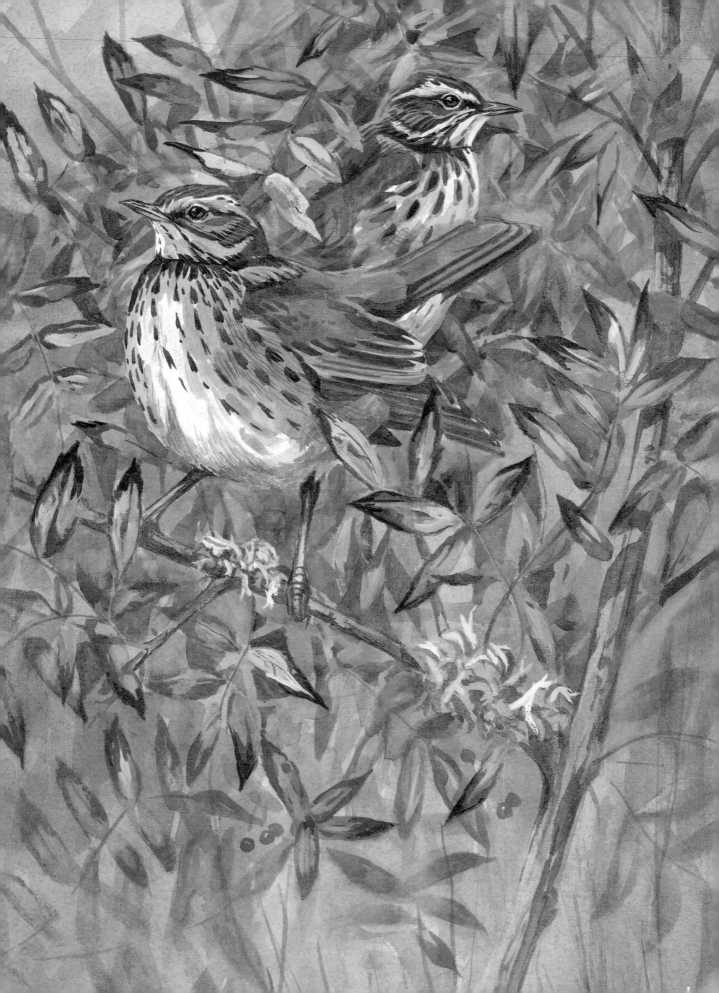

Saturday 6th **Caterans**

Autumn plunder has attracted many raiders to the glen. One lonely ridge in Glen Lethnot bears the name 'Shank of Donald Young'. When peoples' names appear on the map they usually indicate ownership or at least the exploits of a local man, but Donald Young could barely have known the place before he died there.

One night, over 200 years ago, a party of thirteen Deesiders went to raid cattle in the south. They crossed over the mounth roads into Esk and Lethnot and then on into the parish of Fern where they helped themselves to a good number of cattle. By the time the alarm was raised, they were already back up in the hills and heading into Lethnot, driving the kye before them. A local youth named MacIntosh mustered eighteen men and headed after the raiders but their cause seemed hopeless. The caterans were doubtless well away, and with such a head start that they were unlikely to be caught. As luck would have it, however, the men from Fern came upon the Deesiders in Lethnot where they had decided to stop and make a meal of one of the beasts for their breakfast. The two sides agreed to settle the matter by single combat between the leaders but a stray shot killed one of the men from Fern and general fighting broke out. Finally the cateran leader was hamstrung by a blow from behind and, still putting up a good fight although down on his knees, was run through by MacIntosh. The rest of the Highlanders fled but were overtaken and slain. The Shank of Donald Young is where one of them fell.

The fear of such raids by the Highlanders caused the construction of so many castles along the Angus glens but it is clear from the many castles in the Deeside glens that cattle rustling was rife throughout the whole area and some of the men from Esk were not averse to taking cattle from the north.

One of the main uses of the mounth roads was as droving routes for taking cattle south to sell. Many cattle had to be slaughtered in the autumn because they could not be fed through the winter and good prices were to be had in the Lowlands. Cattle from hereabouts were taken to Edzell, Perth, Forfar or Falkirk to be sold and were then driven to their final destination, often as far south as England.

The cattle-based culture had a character that was often as dramatic and violent as the American West. These forerunners of the Wild West cowboys had a code of morals and way of life where rustling and gun- or swordfights were common practice. The raiders often wore leather jerkins covered in silver studs. Not only to look impressive but to pay for a Christian burial if they should die away from home. Custom expected that a man's killer should pay for the funeral from this silver.

There could also be problems in being known as a man of wealth in the area. One night a party of cattle rustlers paid a visit to the miller of Craigendowie in Lethnot. Rumour had it that he had a chest of silver coins under his bed. Disappointed not to find the chest, his visitors decided that he must have hidden it elsewhere and so roasted his feet over a fire and threatened to take all his belongings and his wife away with them. The miller was adamant that there was no silver in the house and the cat-

erans, as good as their word, packed up his beer, meal and wife. They trooped off into the night, driving his kye before them. Apparently the Highlanders soon regretted their actions. The guidwife was far from pleased at being treated as their booty and cursed them loudly, barely pausing for breath, until they were quite tired of her company and decided to leave her behind. They dumped her unceremoniously at Stonyford, without her shoes, and she had to hobble back the two miles to the mill in her bare feet.

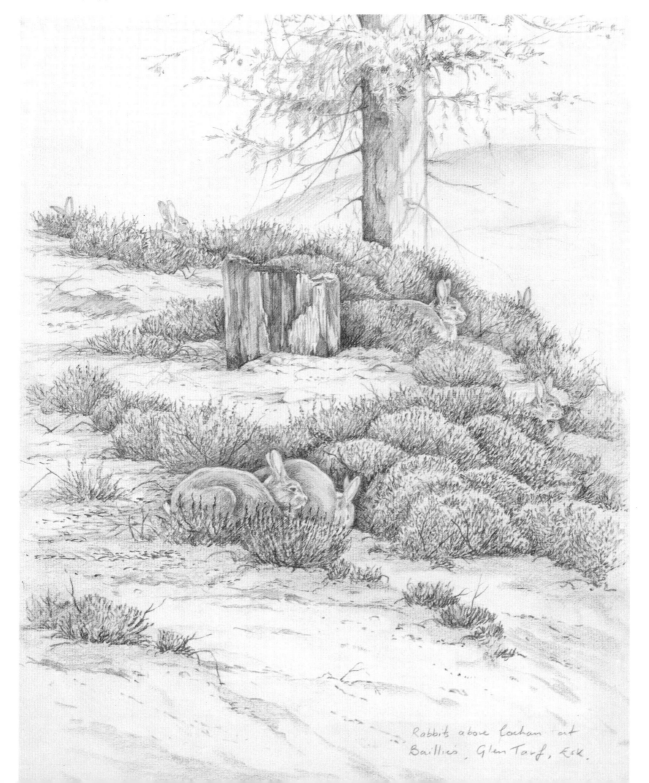

Rabbits above Lochan at
Baillies, Glen Tarf, Esk.

v Brown
chest
dark streaking

red/ochre scalloping

Juv. ♀ Hen Harrier

Injured bird kept by
Keith Brockie, Inchture.

Vivid Yellow Legs.

Monday 8th **Hen harrier**

I have seen the hen harriers about, quartering the slopes for prey. I had planned to do some sketches of them in flight but haven't been close enough for the time needed to draw them well. Keith Brockie, who lives nearby, is looking after an injured bird just now and he kindly let me go into the pen to make some sketches. It is a luxury to be able to draw from a captive bird – especially a wild one that eyes you with suspicion and does not have the lethargy of many zoo exhibits.

Friday 12th **Merlin**

Higher up on the hill, the sheltered places where water collects often remain green and lush while autumn turns the grass and heather nearby to brown. These often become resting places for travellers that are passing across the high ground and I thought that I might find ducks on the lochans today, but when I made my way up over the lip of the ridge I found it quiet and empty but for one bird.

A merlin was perched on an old post that had been driven into the lochside many years ago for some reason no longer obvious. The bird was an adult male and his dull blue plumage reflected the grey light of the low, cloudy sky. I made some sketches

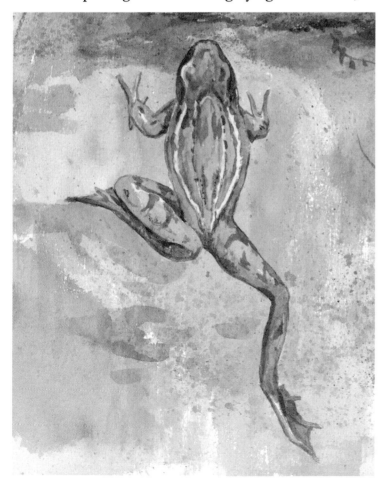

while the falcon scanned the lochside, waiting perhaps for a small bird to appear out of the clouds and shelter here out of the wind and drizzle. When he left it was without warning. Suddenly he wasn't on the post any more but slipping up the hillside and then cutting, out of sight, through the low cloud. Merlin never seem to glide, they dart, wings slicing through the air.

When I went over to the post, I found a dead frog there, hardly touched apart from the head but obviously the work of a bird of prey. I've never heard of Merlin eating frogs before but, of course, the culprit could have been something else, a kestrel perhaps, or buzzard. In such an open landscape, the post is the only obvious perch.

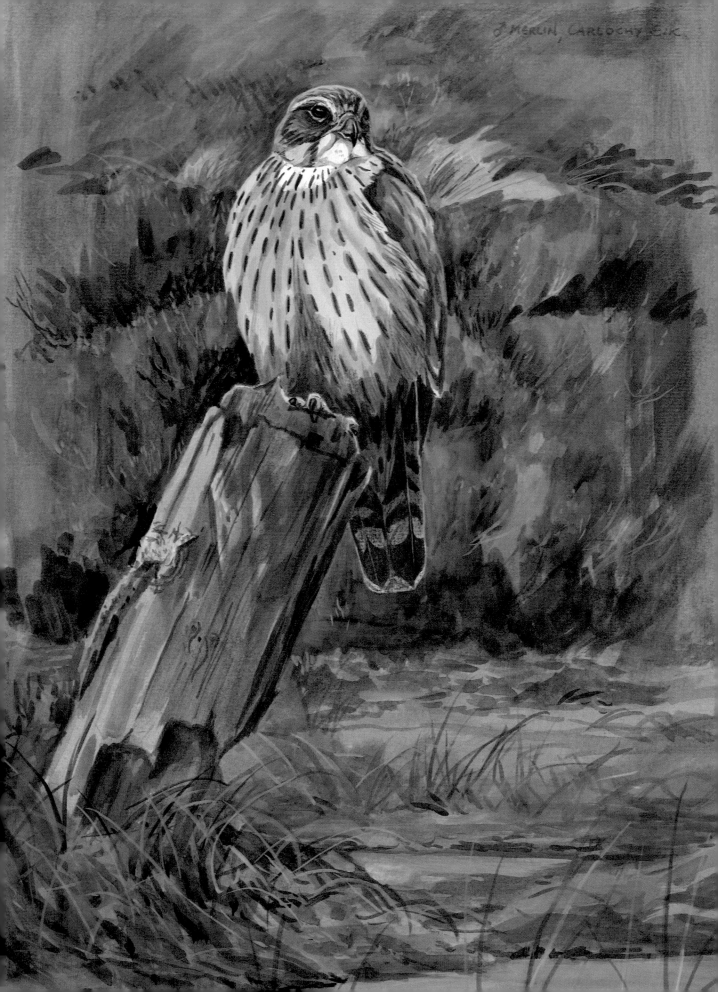

♂ MERLIN, CARLOCHY, E.K.

Tuesday 16th *The horse birds*

More birds from the north have arrived: earthbound in the wind and drizzle, a small party of greylag geese are roosting on the edge of Loch Lee. I managed to draw them from the car, rain blowing in through the window and clouding the lens of my telescope. These migrant birds have a peculiar quality, like sentinels, waiting and watching for a change in the skies that will allow them to continue on their way. Robust and heavy, they are horse birds. They arch their necks to watch me, occasionally stoop to graze, so that their weight and balance remind me somehow of heavy, Clydesdale horses.

The whole scene is monochrome, a study in grey. Even the loch's Gaelic name means 'grey' (*liath*) and it is bound up in the dull light. A grey day and the grey geese are waiting, watching on the grey loch.

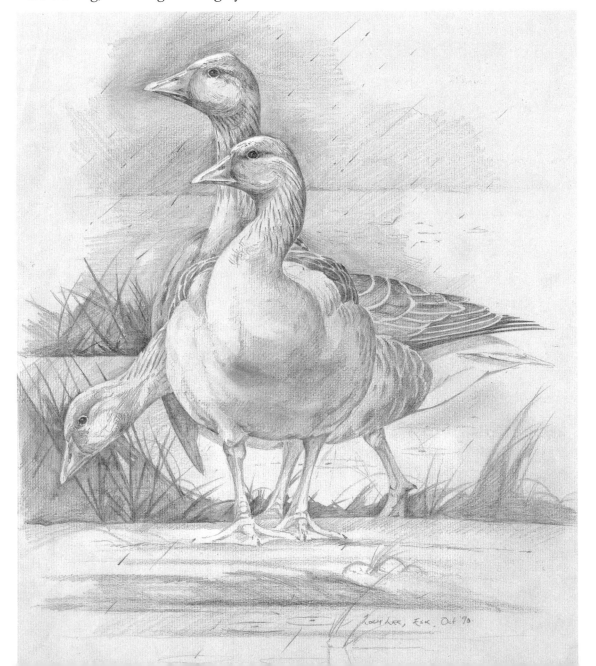

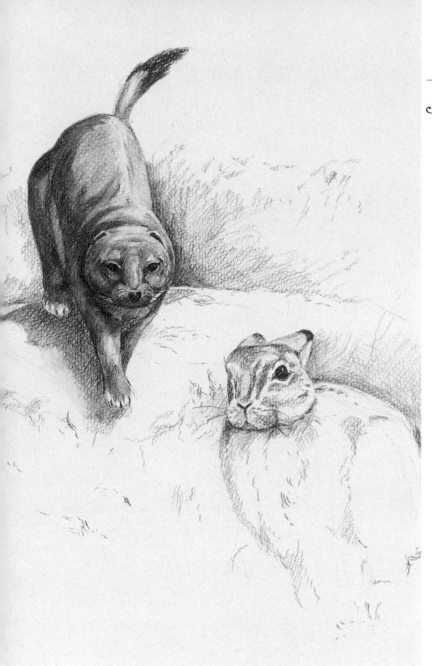

Sunday 21st *The hunt*

I was tramping about over the hill, just looking around, when I saw a red flash among the rocks. I knew instantly that it was a stoat but it was another few minutes before I actually saw it, pausing for a moment and rearing on its hind legs to get a better view. Then it was off again in frenetic, serpentine movements, twisting along the line of an old wall. Among the rocks it seemed to weave as if pulled by string, slipping through crevices, disappearing and then re-emerging several yards away. At last it put up a rabbit that streaked off across the heather. The stoat pursued, legs pounding fast, back arching high and the black tip of its tail flailing around behind. It nearly caught the rabbit, just reaching its rump, but the rabbit dodged and the stoat ran out of steam. It turned with barely a pause to rush back to the wall and continued its relentless patrol. I scanned the heather with my binoculars. Way up on the hill, a white tail was still moving as fast as four lucky rabbit's feet could carry it.

Thursday 25th *Carlochy*

I thought it was a snipe. Feeding by itself on this exposed lochan, high above any nearby woodland; it was quite out of place. I suppose it might have been a migrant bird, passing over the glen and coming down to the lush, green of the water's edge to feed. The woodcock reminded me of this little lochan's name, 'Carlochy' which could mean 'the lochan of the scrubby trees'. At one time it must have been surrounded by woodland of some sort. As I was drawing the visitor, another head popped up nearby and viewed the woodcock with interest. It was a snipe and possibly a migrant, too, but it seemed far more at home here.

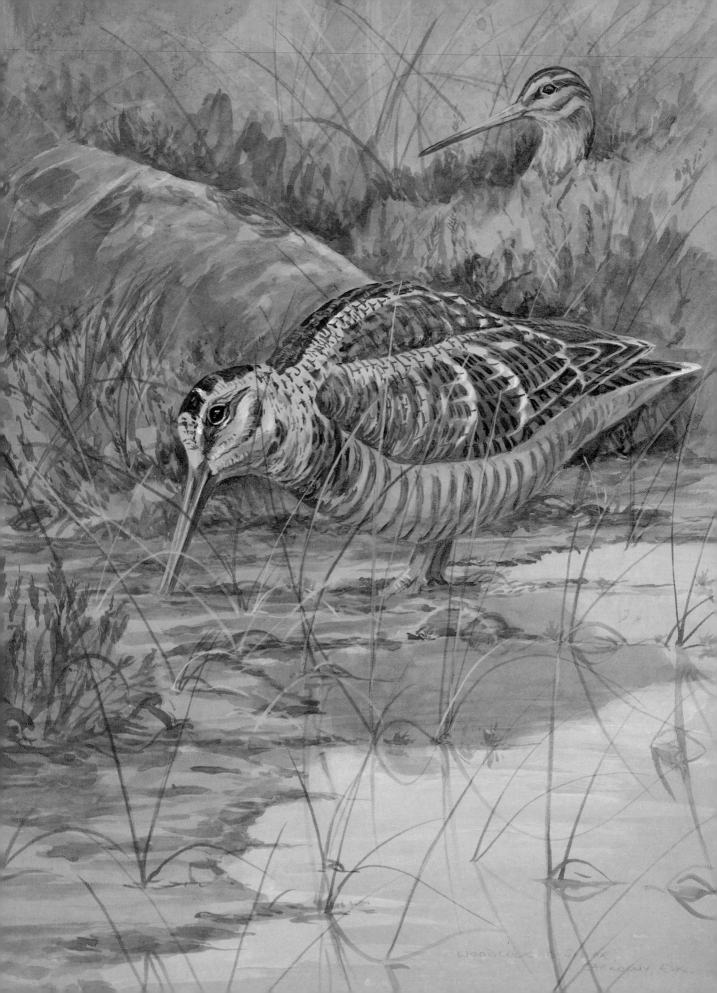

Friday 26th *Leaves*

The wind has blown leaves from the woodland below into the Carlochy. There were a pair of teal on the lochan when I arrived, their forms appearing a dull purple in the strong but hazy light. The drake seemed unnaturally dull, his colours far surpassed by the blazing reds and yellows of the leaves. I carried a few back with me to paint later because it was starting to rain.

On the way down, I found a big boletus mushroom on the wood's edge and ate it that evening for my supper.

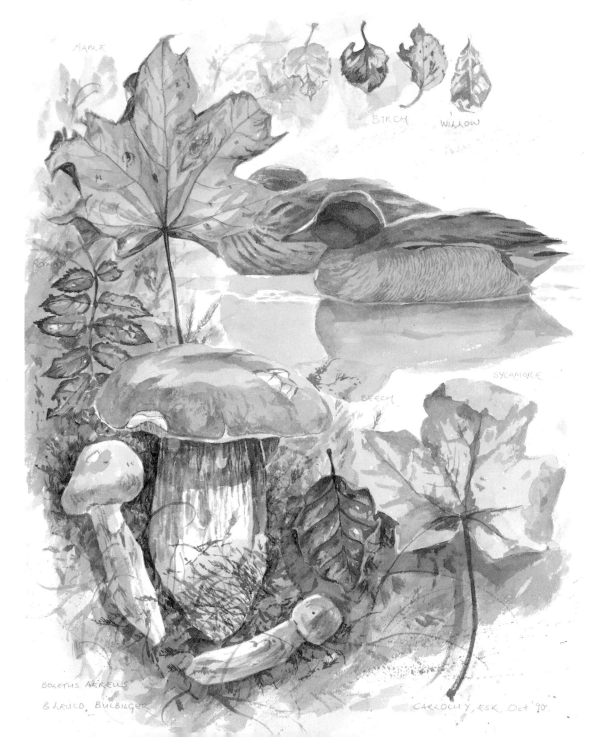

Tuesday 30th *Last harvest*

There seem to be fieldfare everywhere this week: high up on the open hill, roosting on the cliffs, feeding on the rowan berries, in the fields and gardens. They have a really evocative call that reminds me so much of cold, winter days. They are just about the last winter migrants to arrive and they must make do with the fruits that the earlier travellers have left them. I drew them as they were foraging in the apple tree in an old garden, low down in the glen. The whole scene seemed to sum up the turn of autumn into winter. Winter thrushes taking the last harvest; a poignant contrast of cold blues and warm reds.

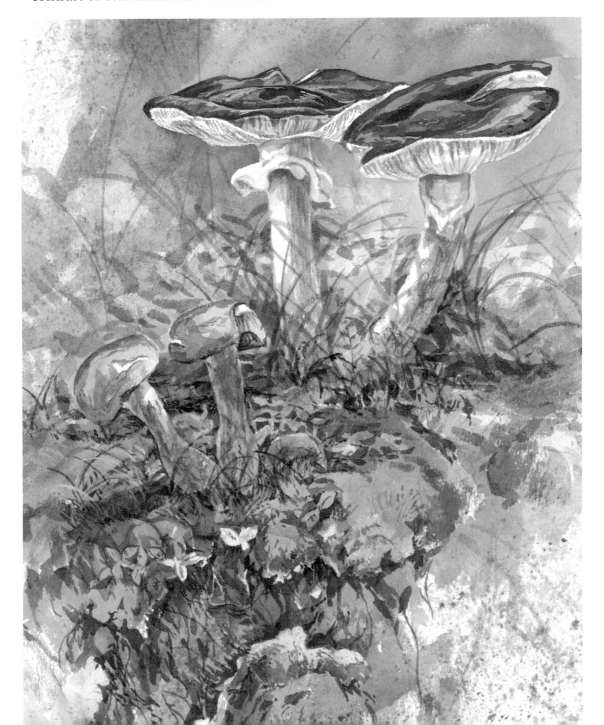

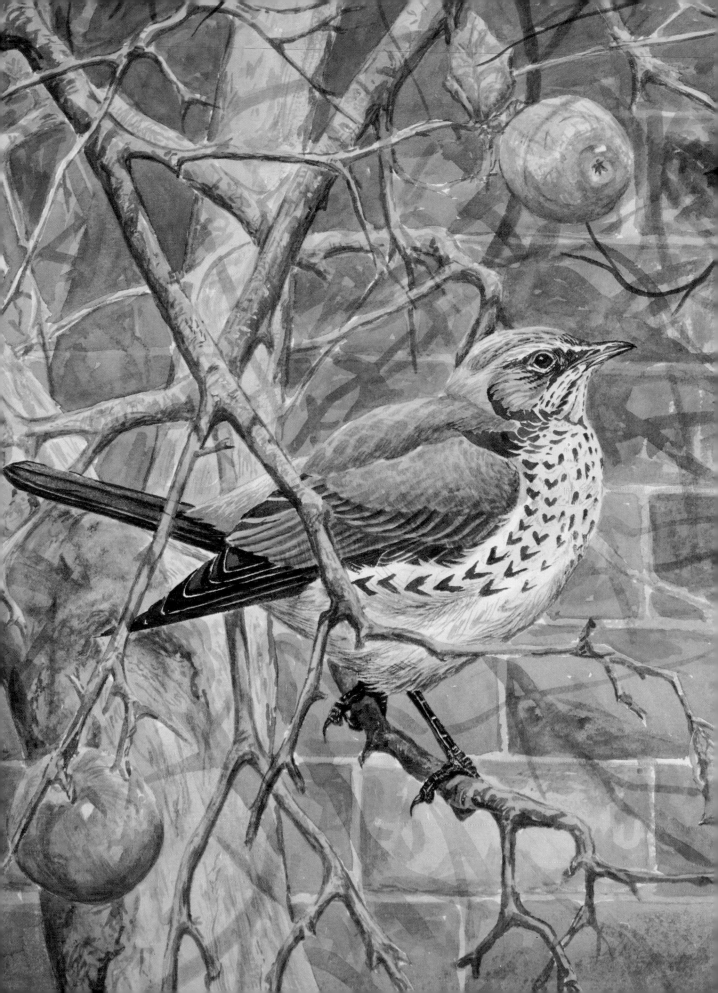

November • The high crags

Friday 2nd *Gladiators*

A desolate roaring echoes through the high reaches of the glen. Rutting stags bellow on the Carlochy of Mark, their calls amplified in the narrow confines of the valley and reverberating between the crags. Against the pale pinks of a cold, winter sky, the clouds smudge across the summits of the nearby hills and corries. They enclose the glen to form a huge echo-chamber. The air is full of sound. On the leeward side of the glen, out of the fiercely cold breeze, I can see the red deer feeding and resting. I made some sketches of these small parties moving uphill towards the arena of Carlochy. Now and again you can hear the clash and rattle of antlers far above.

I explored the crags below the Craig of Doune to find Balnamoon's Cave. It was covered with rank heather and bracken, almost completely hidden, and the rocks around the entrance were jacketed with folds of thick, green moss. A former laird of Balnamoon who was a staunch Jacobite hid in this small cave for many months after fleeing from Culloden. He had a large price placed on his head and English Redcoats combed the whole area looking for him. Fortunately for the laird, they were unable to find this hideout.

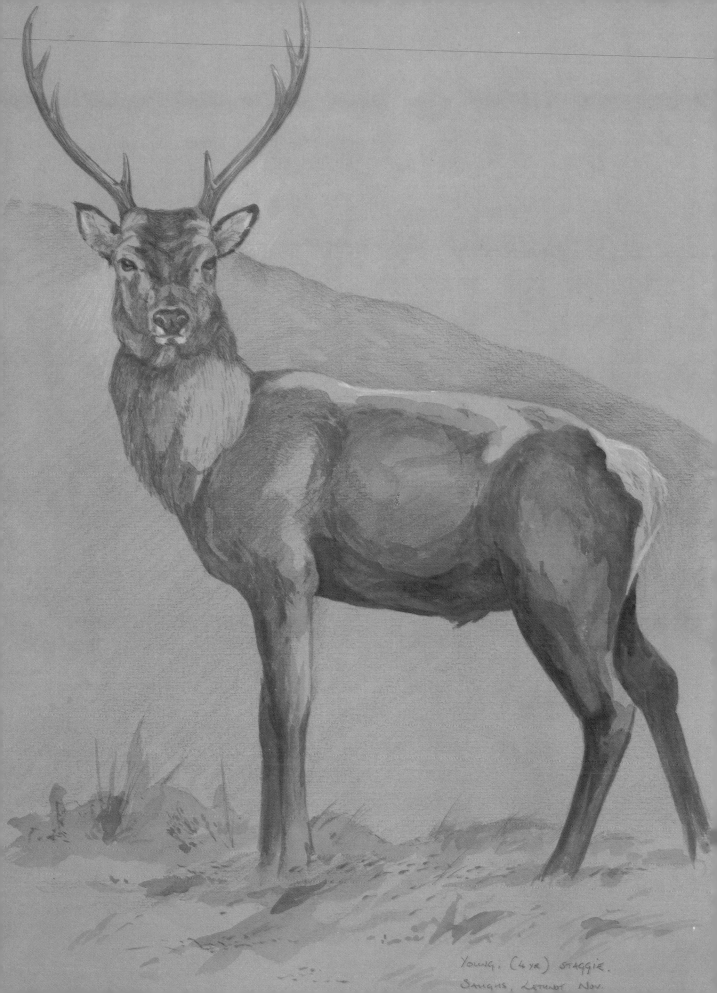

YOUNG. (4 YR) STAGGIE.
SANGHS, LETHEN? NOV.

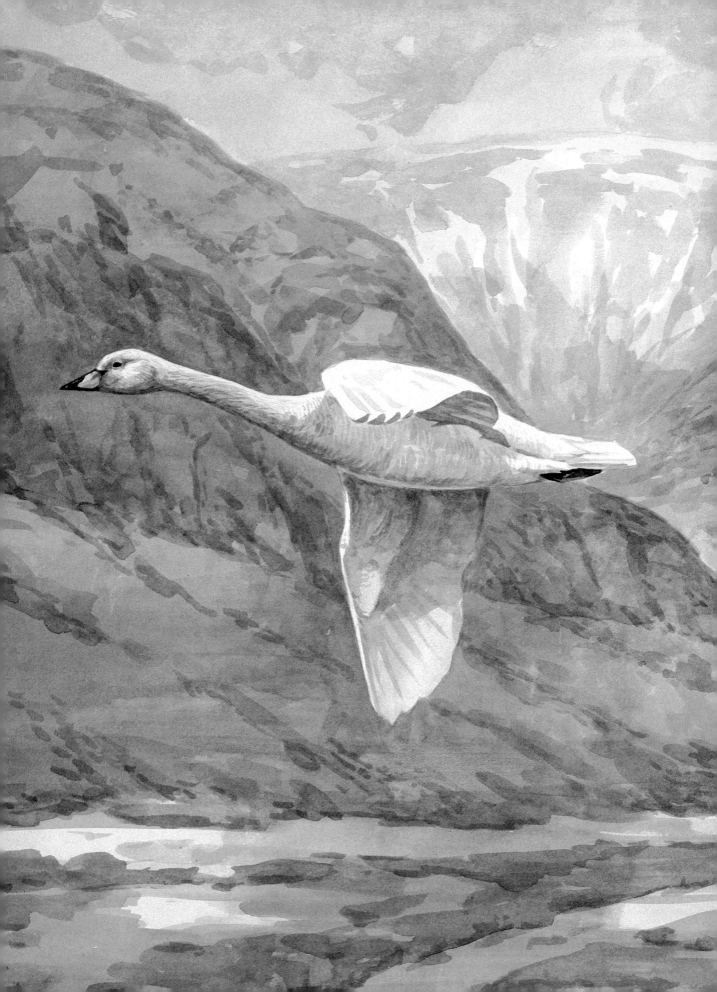

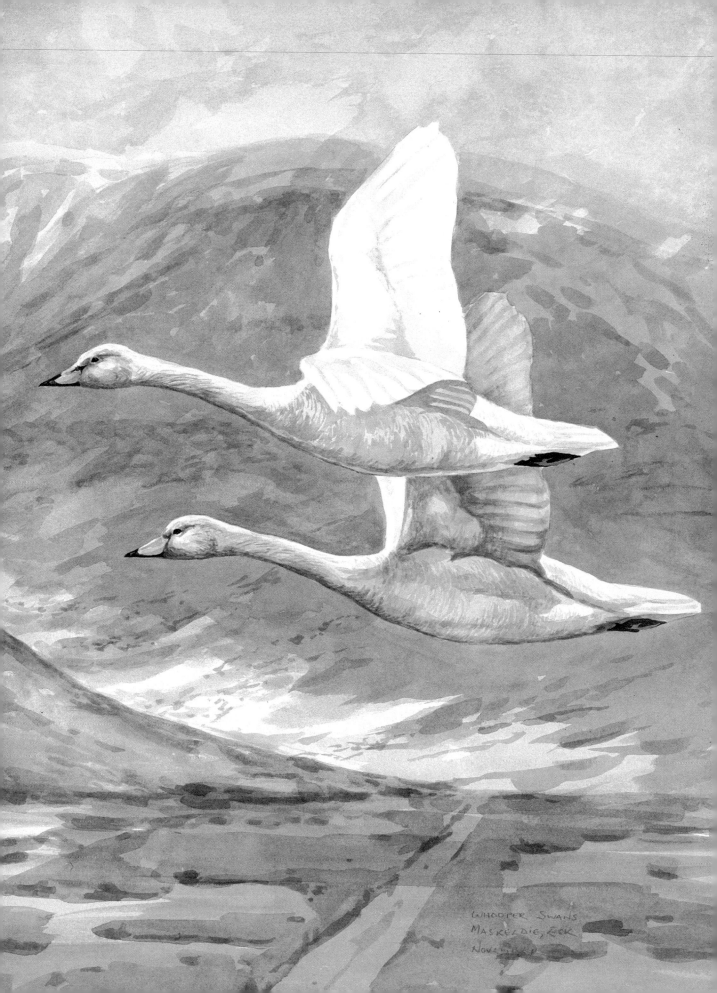

WHOOPER SWANS
MASKELDIE, EDR
NOVEMBER

Monday 5th *Fire and snow*

As white as new snow, a party of whooper swans flew south through Glen Lee. These birds from the far Arctic seem to have brought the icy blasts of winter with them, their wings conjuring with the cold air, whistling softly into the distance and then gone. There are only three birds, two adults and a youngster, their heads and necks still flecked with orange stains from the iron-rich pools of their breeding grounds. Just for a moment I managed to catch the leading bird in my telescope as it flew past the Craig of Maskeldie and I could see the crisp white of the bird's head picked out against the cold, blue rocks of the hill, flecks of iron like orange flames across its neck and forehead.

November the 5th. Traditionally a day for flames, and not simply to do with Guy Fawkes; this day is also a relic of the Celtic festival of Samain. Perhaps as part of the same fire-lore the one-time inhabitants of Auchronie used to keep their hearth-fire burning to prevent bad luck. Another family further down the glen sensibly put their fires out every night for the same reason.

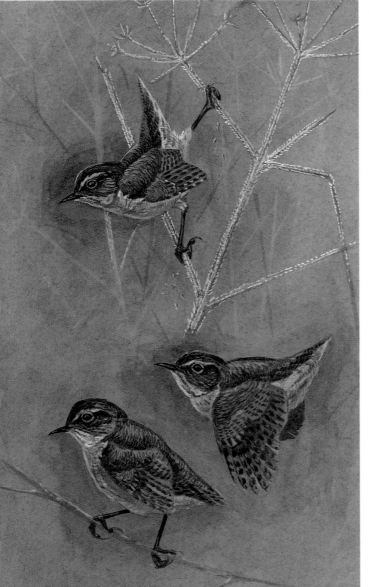

Thursday 8th *The blue robin*

In the sheltered places between rocks at the base of the crags you may find patches of thick bracken and nettles, although it's likely to be dead at this time of year. Sometimes there are still birds foraging or sheltering there even this late in the season. In one shadowed patch, I found two wrens darting among the withered plant stems. A hoar-frost had encrusted the vegetation with a delicate icing. I could hear them flitting through the cover. As they moved about, crystals would fall from the bracken onto the dead leaves below sounding like sand dropping on paper.

Painting from life always shows you something unexpected. In another patch of cover, I caught sight of a robin. Hidden deep in the warm brown of the bracken it appeared to be rich blue in colour rather than red. Out in the bright sunlight, the long shadows from the bird's own form muted the colours of its chest and even where the sun hit directly, strong, reflected light subdued the red markings.

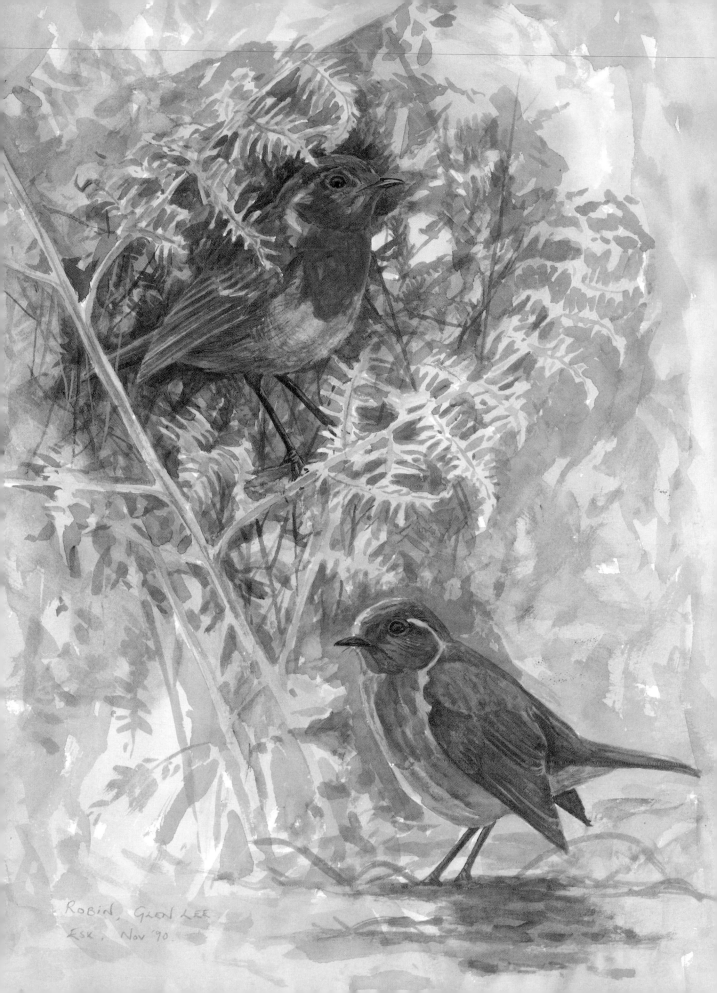

ROBIN, GLEN LEE
ESK, NOV '70

Saturday 10th *The wolf*

I was painting a clump of plants growing in a crack of rock on the Wolf Craig, high above Loch Lee, although I was finding it difficult to work in detail because my hands were shivering slightly with cold. I became aware of an uneasy feeling that had been growing for a few moments without my acknowledging it: I felt as if I was being watched. I couldn't see anyone about and I continued working but the feeling of disquiet increased. Then, I don't know why (I didn't hear a sound), I was absolutely certain that someone or something was behind me. I spun round, fully expecting to see something there, but the slope was empty. No matter how hard I tried to continue working I felt somehow that I really wasn't wanted there. Finally, I packed up and headed down the hill surprised that I really felt some panic and it took a little effort to overcome the temptation to run down the slope. Quite suddenly, as I neared the river, the feeling stopped. I don't know what provoked it but I have had similar, although less strong, impressions before in other places. It is tempting to put the experience down to some ghostly presence; I don't think I believe that but, then again, I really have no idea what to think could have had such a strange effect.

A relatively recent place-name on the map (in English rather than Gaelic) Wolf Craig indicates just how recently this area was inhabited by the creatures. There are many place names in the glen that refer to them; Wolf Grain, Wolf Burn, Wolf Hill (two of these) and perhaps some of the 'Lair' and 'Hunt' names that abound higher up in the glen. The last wolf in the region was shot in the early 18th century by a Mr Robertson, Laird of Nathro. The story goes that a local girl, sleeping one sunny afternoon on a nearby hillside, awoke to find the animal dozing on her lap. The story would have us believe that the girl slipped out of her dress so as not to wake the animal and ran down the glen in her petticoats to raise the alarm. Whatever the truth of the matter, after a long hunt the wolf was finally brought down on the West Wirren.

Wednesday 14th *Twite*

The wind has cleared the very last leaves from the rowans that hang on among the rocks, and there has been a dusting of snow over the tops of the higher hills.

There was a flock of twenty or so twite working their way along the crags on Craig Doune this afternoon and I was able to make some sketches of them as they perched on the rocks and among the scree. Light and shade can alter the form, tone and colour of birds (as with the robin I drew last week) but the weather itself can bring about a physical change. Down among the rubble, in the lee of the cliff, the twite perched quite upright, their appearance rather sleek but, higher up on the crags, they fluffed out to protect themselves against the cold. In the most exposed places, buffeted by the wind, their feathers were ruffled and their forms flattened to offer the least wind resistance.

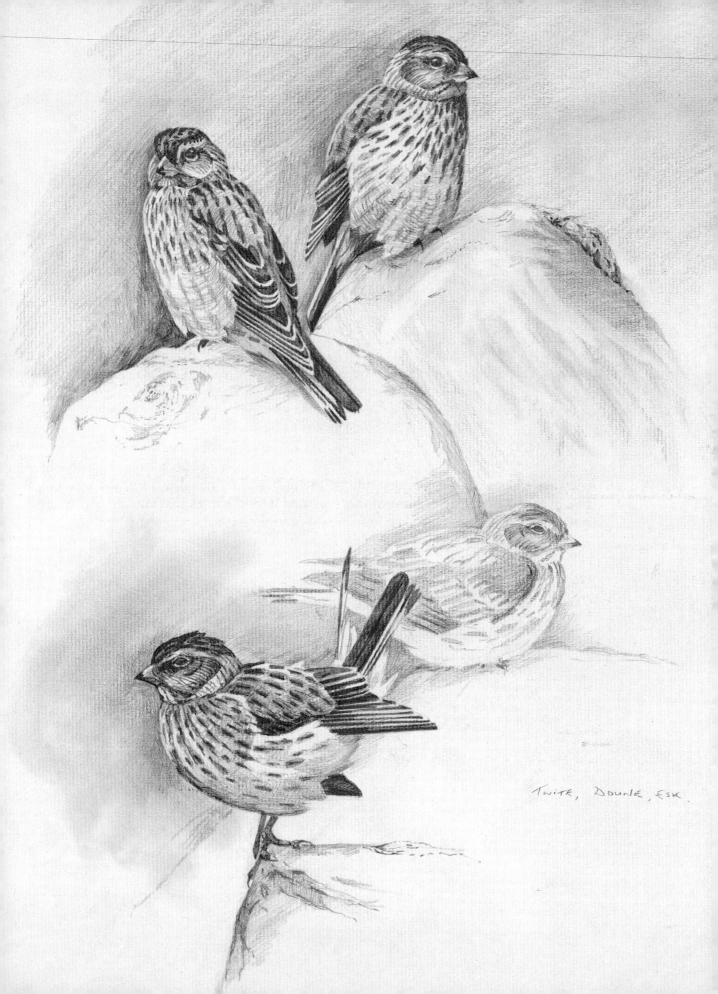

Twite, Doune, Esk.

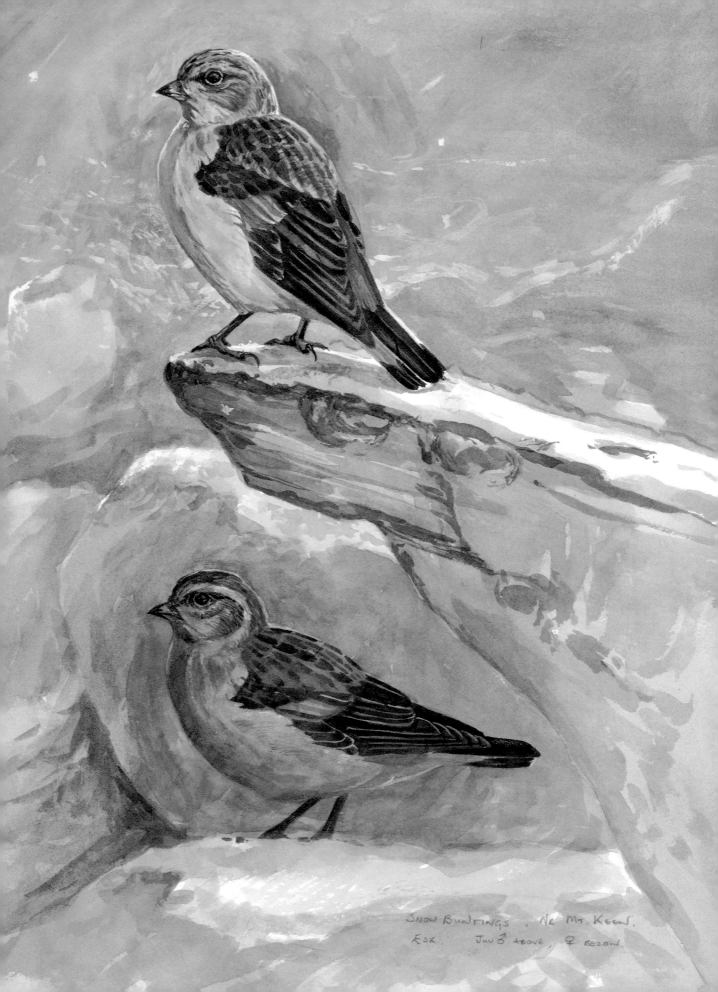

Snow Buntings. Nr Mt. Keen.
Esk. Jun 3 above, ♀ below.

Wednesday 21ˢᵗ *Snow messengers*

I climbed up over Mount Keen this morning, the thin cover of wet snow melting rapidly as the sun rose. In one of the corries, I heard a familiar, tinkling call. Small blobs of the snow seemed to move. Through my binoculars, I could see what I already knew to be there. A flock of snow buntings were chasing each other about among the patches of disappearing snow. The wind, however, was bitterly cold and they often sheltered among the rocks. The blue light of the early morning, reflected from the snow, turned the birds' white plumage to a series of blues and browns.

Not far away I found a set of footprints in the snow, each depression very round and running in a straight line. It was difficult to tell for sure, but there didn't seem to be any claw-marks. A fox, I thought at first, although they could have belonged to a wildcat; it was difficult to be sure as the snow was very thin and the prints rather indistinct.

Monday 26ᵗʰ *Eyes in the rock*

There are a lot of kestrels about today. I saw three lower down the glen, feeding on rabbit corpses by the road.

It had frozen hard overnight and the ground was solid underfoot so that I couldn't easily tell whether I was walking on turf or rocks. Occasionally my boots would break through the surface of a wet piece of ground with a sharp crack and squelch and before I knew it I had a boot full of cold, muddy water. Next to the track I came across some remains of a red deer, mostly hooves and offal. They are culling some of the hinds at this time of year. A young

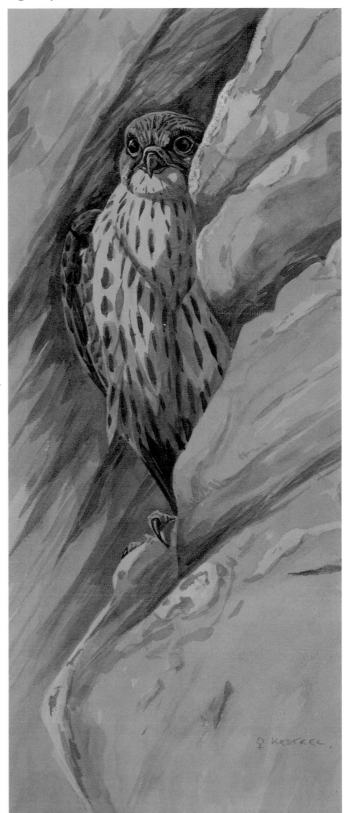

♀ KESTREL

kestrel had been picking over a discarded hoof-joint when I put her up out of the heather. I watched as she glided up to a sheltered corrie and then I sneaked over to a vantage point so that I could paint her.

I used a telescope to get a better view. I was quite close but she wasn't sure that I could see her. Half hidden behind an outcrop of rocks, her plumage merging with the cliff-face, she seemed to be part of the corrie itself. Obviously suspicious, she craned her neck out so that she could watch me but soon settled down again and fluffed herself out against the cold.

If I'm busy painting, I can sometimes forget, or just plain ignore, the weather around me – up to a point. I suddenly realised just how cold I was and had to pack up. I mistimed my return and had to walk back the last stretch in the dark. It was going to be a beautiful, clear night but very frosty. A thick mist was filling the low ground and in places it swirled heavily around my knees so that I could barely see where I was putting my feet.

Thursday 29th *False men*

Winter is deepening visibly in the glen. Snow now covers much of the hillsides as well as the higher summits. I took the Firmounth track over into Glen Tanar. It was a cold walk with snow flurries sweeping across the hills for most of the morning.

For a long time, I thought that the name Firmounth referred to the pinewoods that the road passes through; much as the Birsemounth that runs into the Forest of Birse is named after birchwoods. However, I discovered that 'Fir" is in fact a contraction of the Gaelic *Fhir-Breige* which means 'False-Men'. Walking along the mounth road it's soon obvious who the false men are: the cairns and upright boulders set along the route that stand out like the silhouettes of men on the horizon. These cairns were literally lifesavers during and after snowstorms when the hillside is unrecognisable and when losing the path could mean a slow death from exposure. The nearby hill of Mudlee Bracks means the hills of two falsities and is named after the two cairns on its skyline.

Even lower down the glen, snowstorms were a danger. The main road from Tarfside to Invermark used to run over the Hill of Rowan and many people lost their lives crossing this stretch of moorland. Consequently, the local masons built a refuge tower on the summit of the hill and supplied firewood in case of emergencies. It is still standing today.

There is something other-worldly about being on the hills during a snowfall. Completely cocooned by the weather and cut off from all points of reference, it is as if the rest of the world ceases to exist. It can be dangerous, though, and even during the short snow flurries of the morning I lost my bearings on a couple of occasions and, being without a compass, I might have lost my way if the path and markers had not been so obvious.

December • The high moorlands

Saturday 1st *Cartwheels*

The buzzards' mewing carried far on the still, frosty air and made me take a detour from the path I had planned to walk so that I could watch them better. There were two of them, sailing high on the updraught and circling on full, long-fingered wings. They spiralled above one another, playing in the air currents. I spent several hours sketching them and scribbling diagrams of their flight patterns.

Three times they grappled talons in the air. Both birds would fly, one above the other, and the lower bird would swoop upward and twist so that its partner could grip its feet. Talons would lock and they would fly like this for a moment before tumbling downwards, once again cartwheeling through the air like a strange avian meteorite before separating. This display serves to strengthen the bonding between the pair through the winter and signals to others that this is their territory. Winter is a hard time for almost all the creatures in the glen but, perhaps, relatively less so for the buzzards. Although they usually kill for themselves, they will scavenge on those animals that succumb to the elements.

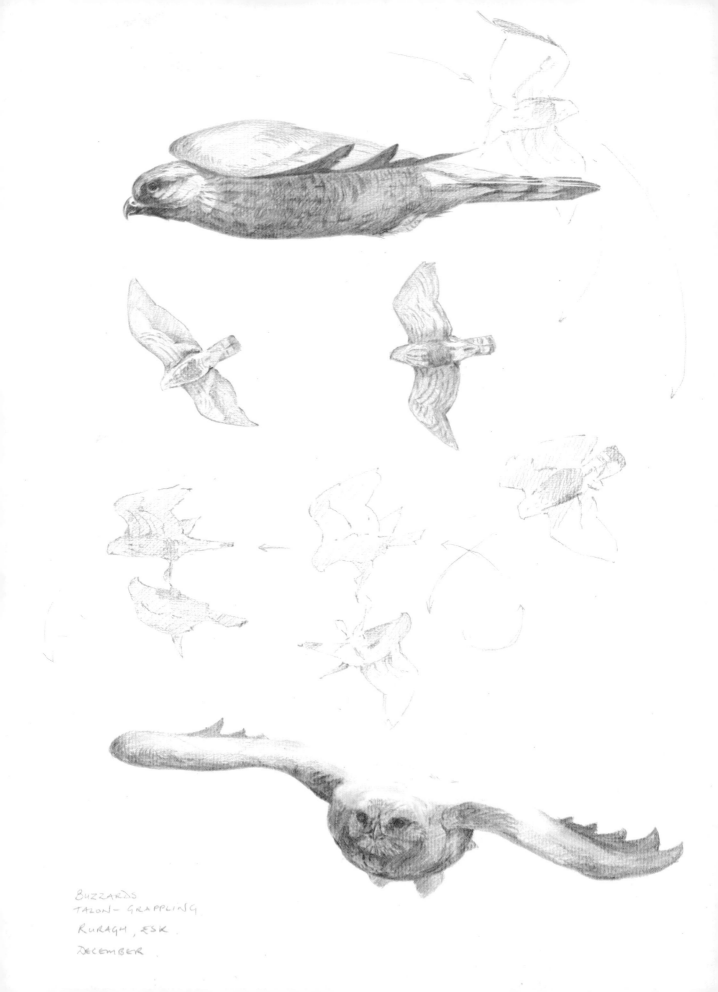

BUZZARDS
TALON-GRAPPLING
RUAGH, ESK.
DECEMBER

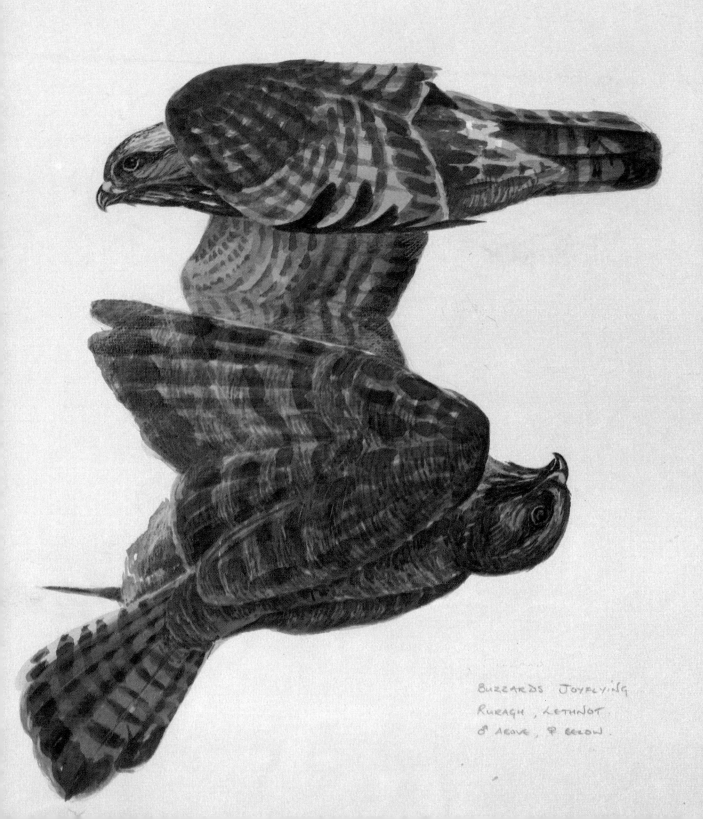

BUZZARDS JOYFLYING
RUBAGH, LETHNOT
♂ ABOVE, ♀ BELOW.

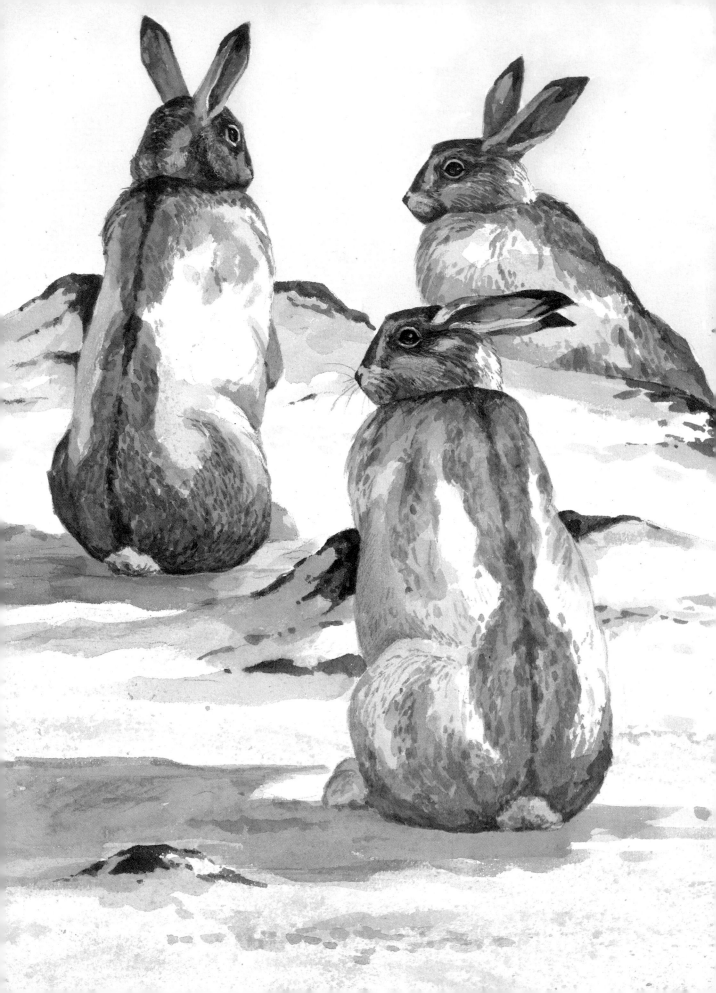

Tuesday 4ᵗʰ *Camouflage*

Snow is scraped across the contours of the hilltops and high moorland, lying icy-hard in the pools of shadow where it is hidden from the sun's tired gaze. On the sunnier slopes where the mountain hares feed, it crumples into slush and soaks the peat. Dark brown patches mark the edge of the snow-line.

As the season changes the colours of the landscape from the cold, dead browns of late autumn to the white depths of winter, the hares, too, moult into their winter coats. There is a lot of variety in the colour of the hares' coats just now. Many are still moulting and are at various stages of piebald brown and white. Feeding at the snow-line they seem to embody a certain tension that is present in both the weather and the landscape: autumn and winter, earth and snow. The hares that have completed their moult tend to feed higher up and are loth to cross any areas of dark ground: a patch of 'snow' can look very conspicuous when it gets up and dashes across the brown hillside.

Saturday 8ᵗʰ *Puir farin'*

It has been snowing quite hard over the past two days and a frost has now welded it firmly to the landscape. There have been a few more heavy falls today and the glen seems to be sinking under the weight of the soft, cold blanket.

This kind of weather brings hard times for many animals. I saw two pipits crouching among some shattered sticks of heather. There are no insects for them to eat here and the seeds that they feed on through the winter are buried beneath the snow. In the only place where the ground is uncovered the fierce wind sweeps the bare earth, and to search for food here they must brave the desperate chill of these exposed slopes and burn up precious energy just to stay warm. These birds will probably have to move down to much lower ground where the faring will be easier.

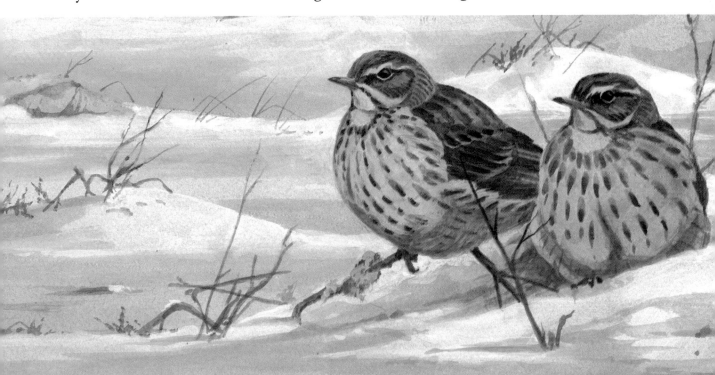

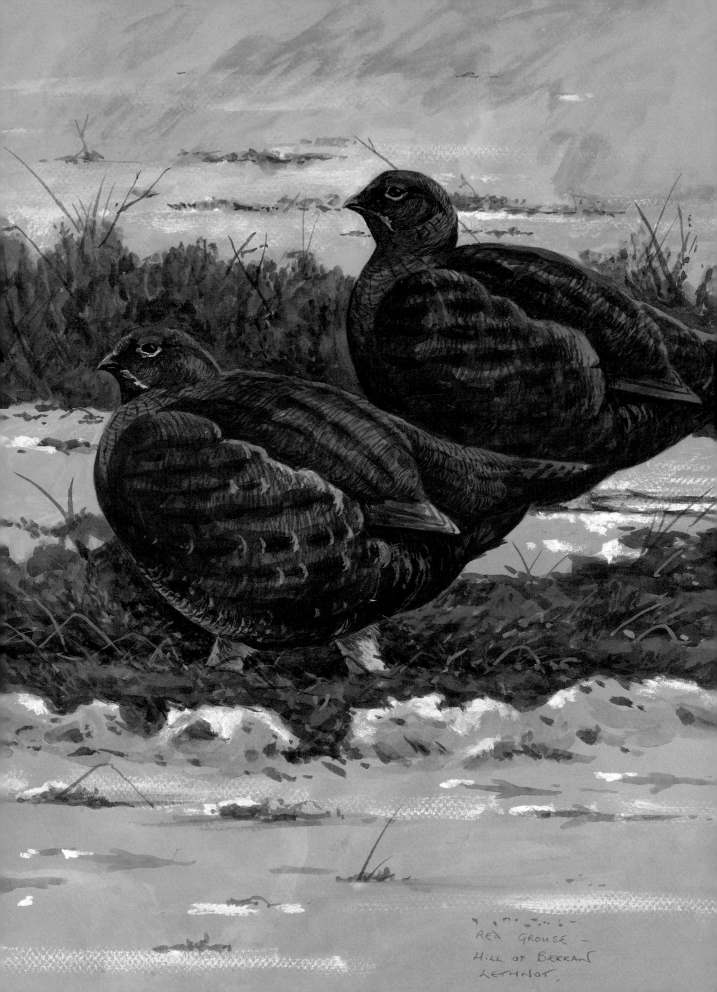

RED GROUSE —
HILL OF BERRAN
LETHNOT,

Monday 10th **Tracking**

An absolute silence lies over the glen. Not a breath of wind stirs the powdered snow or rattles the gnarled fingers of bracken that stick up through the icy sheets. There is a desolate atmosphere here today; the whole glen seems to be empty of life. It is a complete contrast to the impression given by the crazy criss-crossing of tracks that welter over the snow: rabbit, fox, hare, small birds and deer, even an otter dragging its low body through the snow near the river. The tracks make beautiful, chaotic patterns on the hillside but, if you look more closely, you can sometimes pick out the threads of individual happenings from the hillside tapestry: a fox patrolling its territory and stopping at an exposed tussock to mark it with urine; small birds (twite, I think) feeding on seeds among tall heather, one set of tracks hopping away and then the prints of the bird's wing-tips against the snow as it took off; two yards away a much larger set of wings pressed into the snow and a small depression scuffed away by a struggle, marked by a few drops of blood and a feather. A peregrine, perhaps, or a kestrel.

There was a bizarre set of tracks scratching over the ice of a frozen pool. Rabbits must have been skating around over the polished surface; I would have liked to have seen that.

I found a party of grouse feeding among exposed heather, crouching low and picking quietly over the open ground. I sketched them for a while and then tried to get closer but they were too wary and exploded into the air, shattering the cold silence with their 'aarrk-ark-arrr-arr-arrg'. The sounds echoed through the glen and then mumbled softly into the distance leaving the moorland still and quiet again.

Wednesday 12th **Stalking**

I had been tramping around all day, trying to find buzzards when I came across fox tracks in the deep snow. They were fresh and I scanned their path up the hillside with my binoculars. Between some boulders I caught sight of a red brush just before

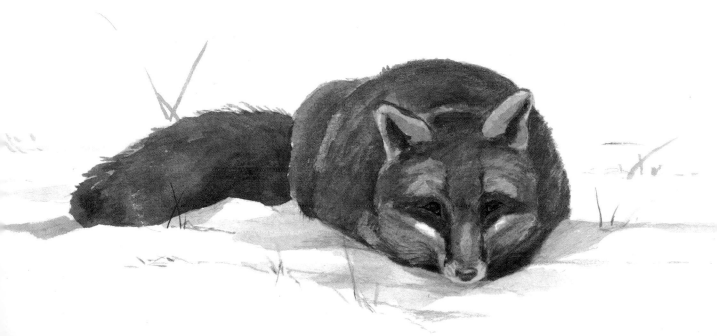

it slunk out of sight around the back of a cairn. The wind was blowing the right way and I thought that I might try to follow the fox. I went up the hillside and cut over the cairn the opposite way to try and surprise him. I found a vantage point and scanned the ground below me. He was skulking among some rocks and, fortunately, hadn't seen me, being more interested in some hares whom he was obviously stalking that were feeding on the blind side of the hillock. However, the hares soon became suspicious – even I could hear the snow crushing under his weight – and they started to edge away. The fox made a dash but, really, he hadn't got a hope of catching them. The hares shot off across the hill and left him floundering in the snow. He stared

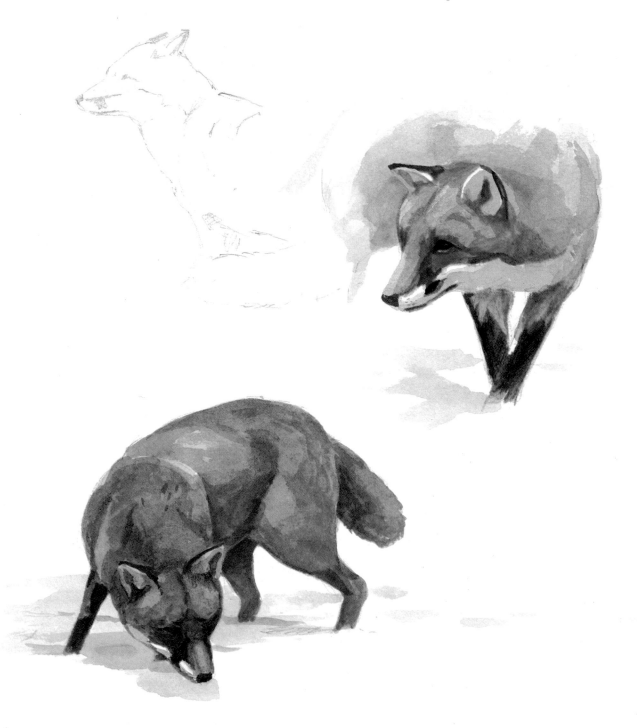

after them for a few minutes, panting, his lips curled up in what seemed like a wry smile. He looked around and I could imagine him thinking, 'I hope nobody saw that'. A quick shake and he trotted off as if he hadn't really fancied hares for his supper anyway. When I checked the map later, I discovered that the hill where I had seen the fox is called, appropriately enough, Tod Hill (*tod* being the old Scots dialect word for a fox). On older maps you can find several places in the glen with this name, and they probably marked the sites where foxes traditionally had their dens; dens may be used by successive generations of foxes so becoming established in areas that are usually well known to the local keepers.

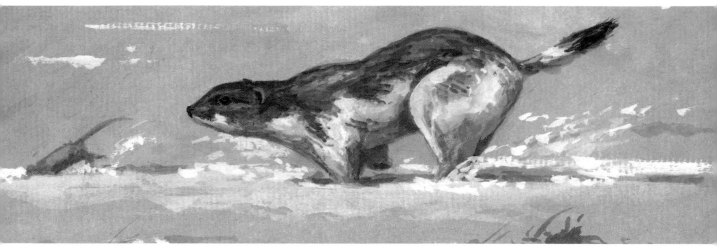

Saturday 15th *Thawing*

After a couple of days of rain most of the low-lying snow has already gone. Gaping scars have begun to cut across the white fastness of the hilltops and a warm sun glares down across the wet snow to accelerate its departure. I was looking about the higher ground today and it was incredibly hot for mid-December. As I worked my way through the tall heather, my feet dislodged lumps of snow that fell with a slushy thump onto the ground. I packed away my shirt and jersey and was walking in my T-shirt. My boots were soaking from the cold melt-water that ran in a slippery film over patches of ice and made progress difficult; a couple of times, I accidentally went tobogganing down a slope on my backside. I was even followed by some midges who had mistaken this warm spell for the onset of spring. Tonight's frost will probably finish them off.

I found some more of what looked like wildcat tracks in the same area as I came across them last month and made a note to check the spot again on my next visit.

On my way back, I saw a stoat scampering through the snow. A vole darted in front of it, disappearing below the snow surface into a hidden run but was then forced into the open again where the ground was bare. With a final pounce and shake the stoat finally caught its prey and in a few gulps it was gone. The stoat was moulting into ermine, its winter coat, while its head and back were still a rusty brown colour.

Tuesday 18th *Lichens*

Showers of sleet and snow kept me indoors today, so I made a few studies of some
lichens. At this time of year, they can seem to be the only living things still visible on
the high ground.

LECANORA

CLADONIA

BLACK SHIELD

LECANORA

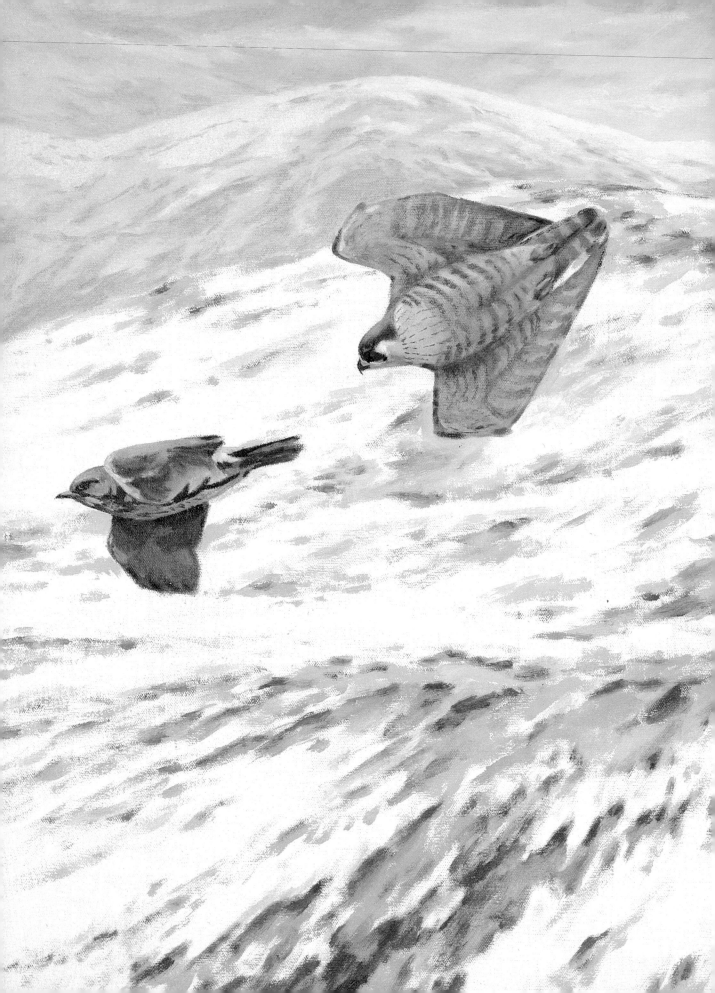

Friday 21st *Out of the blue*

I had been sitting for most of the day above a sheltered pass in the hope of spotting some wildcats returning along what I hoped might be a fairly regular track. It wasn't a cold day but I had been waiting a long time and my legs and hands had become quite numb.

During my wait I had seen a male peregrine flying over his territory and had watched him pass three or four times already during the morning when I heard the familiar 'cha-cha-chaking' call of fieldfares coming into the glen. As they flew past the hills in front of me I saw a dark shadow lift up above them and pause, hanging on its wings and silhouetted against the sun. The peregrine folded his wings against his body and fell like a missile out of the sky. Only then did the thrushes see him. They scattered, flapping their wings furiously. As the tiercel plummeted down onto the flock, he thrust out his 'shoulders' and closed in on his target. A fraction of a second later, I heard a sharp crack, not the dull thump that I had expected, and, in a cloud of feathers, something tumbled jerkily out of the sky. The peregrine soared up and then dropped out of sight after his victim. When I checked the area on my way back, I couldn't find the remains, just two tail feathers and some down scattered over the heather.

Thursday 27th *Carrion crow*

Another day spent trying to find wildcats without success. I found some crows pecking at discarded deer hooves that had been left on the hill by stalkers. The crows must have been very hungry because they let me get quite close. There can't be much meat on one of those hooves.

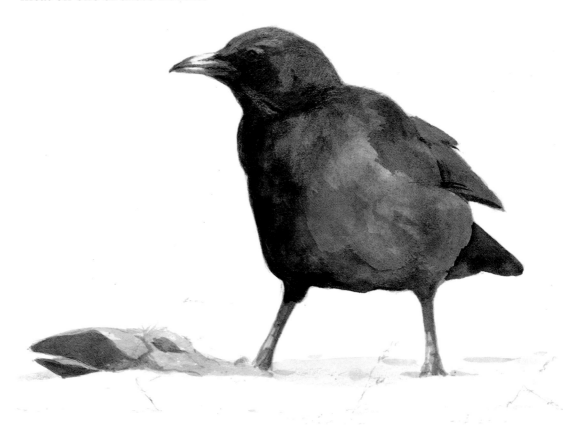

Friday 28th **The big cat**

Still looking for wildcats; I was watching an isolated clump of woodlands that had likely-looking tracks around it when I saw something move in the heather near the trees – at last, it was a wildcat. Like a huge ball of fur crouched in the heather, it was watching something on the ground and occasionally put out a claw to scratch at whatever it was. After a while it got up and ambled off into the woods and out of sight. A short while later I thought I saw it moving up the far hillside so I made my way up and around the opposite side of the hill in the hope of seeing it again, but by the time I had got there it had gone. I decided to stay and watch in the hope that it would come back.

After two hours of watching clouds slip across the far hilltops I had just about decided to give up when I saw what looked like a miniature tiger stalk across the snow-field only twenty yards in front of me. It might have looked small for a tiger but it was a huge cat; about three and a half feet from pink nose to stumpy, black tail-tip. She (I think) sauntered confidently past on long, thin legs; her coat blending with the subtle browns of the exposed heather. The low sunlight caught the hair of her nape and back, turning them to a burnished bronze. I couldn't resist making a noise so that she would stop. I whistled softly. She halted and swung her head towards me. For a full two seconds, we both stared at one another, transfixed. Then, almost somersaulting over herself, she spun around and sped off down the hill, her black tail bobbing behind her. I have seen wildcats in the glen twice before but one of them looked as if it might be at least partly feral cat. It had a white patch on its belly and its tail was almost entirely black with a scraggy, thin tip. The one I saw today, however, seemed to be very much a wildcat and the rings on her stumpy tail were well defined.

I ran over to get a last look at her but she was gone. She couldn't have been that far in front of me and it was quite uncanny to see the open hillside without any trace of the cat apart from her tracks tumbling down the slope.

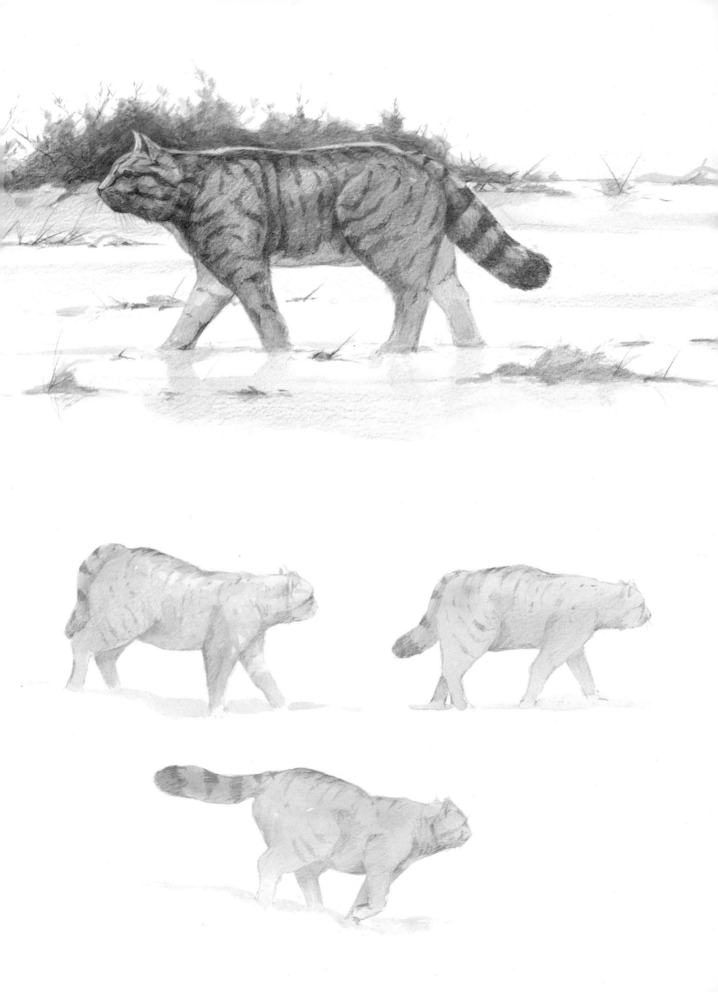

January • The high tops

Tuesday 1st **Tarmachan**

It's cold; very, very cold. Powdery spindrift rages across the rocky summit and fingers its way between stones, into my rucksack, my gloves and my hair. It rests on my eyebrows, hat and moustache, melts and freezes again in the wind that chills well below zero. The air is full of ice crystals, rattling like dry sand against my canvas jacket. Little icicles grow at the corner of my mouth and I turn my face away from the raw sting of the driving snow.

Ptarmigan sit tight in weather like this, conserving their energy for the coming of darkness when the temperature plummets. Incredibly hardy birds, they spend their entire lives on these rugged, desolate mountain tops. The Gaelic for ptarmigan, *tarmachan*, means 'gathering' and that is just what these birds were doing when I spotted them. Huddled together among the shelter of lichen-encrusted rocks, their white forms melded with the thin curtain of fine snow.

Too cold to do much drawing, I scribbled some sketches in a little notepad before my hands numbed waxy-white and I couldn't hold the pencil any more.

Friday 4th **On the rocks**

It's still icy-cold but a bright, clear sky makes drawing possible when I can find a sheltered spot out of the wind. Stalking uphill on the ptarmigan, I can get within ten yards while they pick their way cautiously among the scree. They stop now and then to peer warily back at me over the rocks. The strong sunlight glares off their white plumage and casts cold, blue shadows on the snow.

I stayed on the hill until the sun sank below the horizon, setting the snow-covered mountains ablaze with colour as it went. Where it lit the slopes, the spindrift glowed like a bank of fire. I painted the male ptarmigan standing in shadow against the pale pink of a sunlit hillside, the white plumage lost in blue-green shadows. He ran over the snow on his thickly feathered feet that act as snow-shoes and minimise heat loss. He stopped to feed energetically, his neck flicking backward rapidly as he plucked away at the heather, stocking up on fuel for the night.

Clear and primeval, a half-moon rose over the horizon. Its light, reflected off the snow, was so bright that I could easily read my map by it. As darkness fell the paint froze on the page, crystalising in circles of ice and turning the paper hard. When it thawed in my studio later that night, I had to blot the moisture off as the paint melted so that the colours would not run.

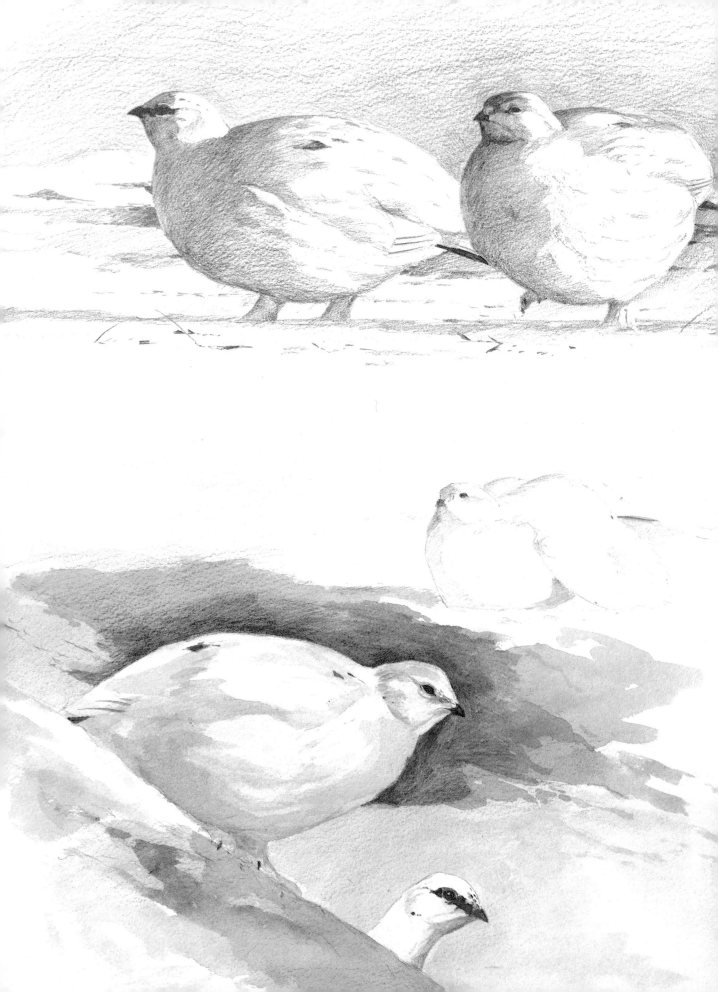

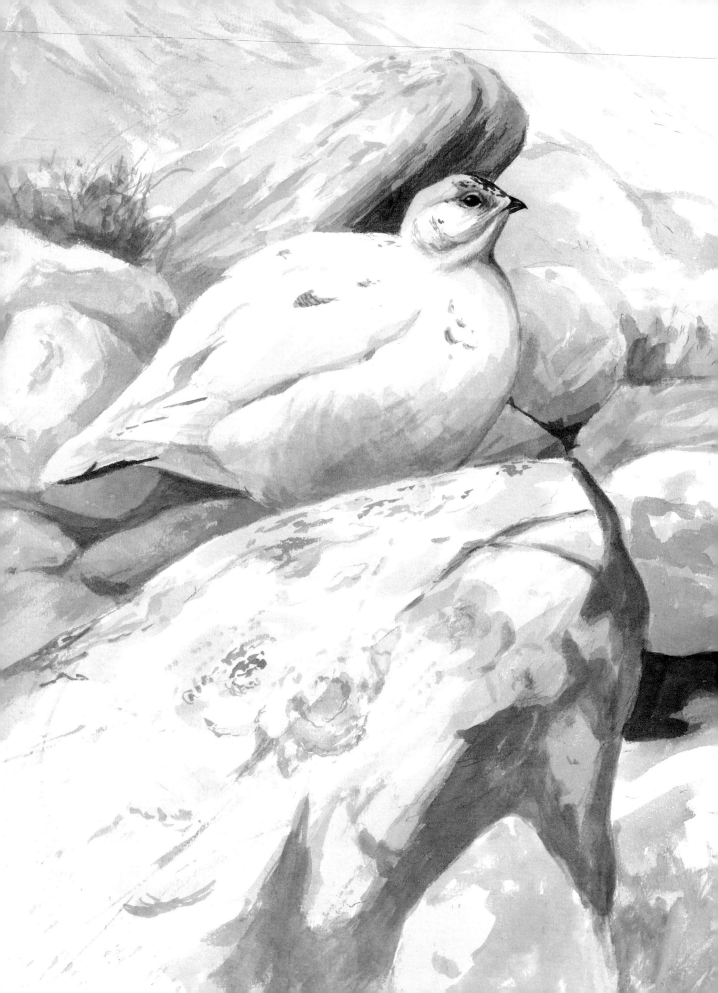

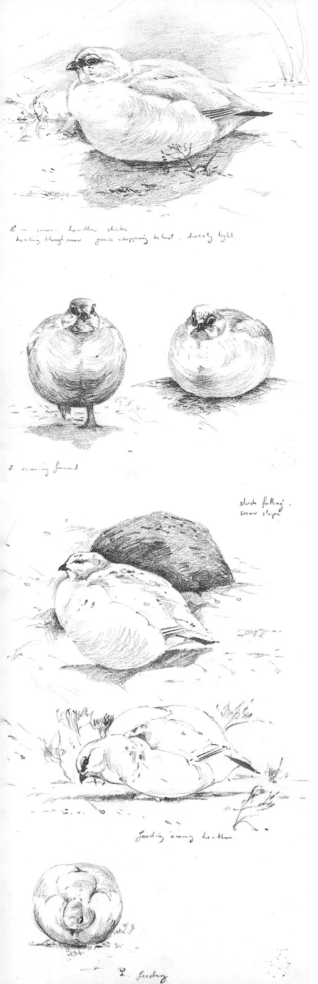

Saturday 5th *Prehistoric*

Not so desolate as last night, perhaps, but the hill-tops are lost to the world again this morning. Low, freezing clouds sit over the summits. As I climbed up into them, I could feel myself disappearing into a timeless landscape. I could imagine this place thousands of years ago when the great glaciers gouged out the glens. It is incredible to think that some creatures chose to inhabit this harsh environment. A ptarmigan burst up from under my feet; the snow driving into my eyes had prevented me from seeing him sitting tight in the drift. There was a small hole in the snow filled with the bird's droppings, like an ashtray full of cigarette butts, still warmed by its plump body. Ptarmigan have lived on these hills since the last ice age, inhabiting the tundra that followed the retreating glaciers. They were left marooned on the 'islands' of sub-arctic habitat that still exist on the mountain tops, as the lower tundra was replaced by a succession of birch and pine forest.

Impossible to work in the freezing mist, I made my way to below the cloud line and was able to approach a big mountain hare who was huddled up on a sheltered slope. His coat was a thick, yellow-white and when the sun momentarily broke through, it stood out subtly from the cold blues of the snow. I climbed up to a cairn on the lee of the hill and found a whole group of hares feeding on exposed heather. A site like this is one of the few places that they can find food. The snow has been swept thin by the wind and the hares can dig through it to the vegetation beneath; everywhere else the snow is just too deep. I made a sketch of the hares and a pair of ptarmigan who had also staked their claim to this island of life in the frozen white desert.
Walking back downhill, I followed the lines of hare prints over the snow. Big snowshoe feet, covered with thick fur, allow them to cross deep drifts with ease and where I floundered up to my knees, their tracks ran daintily over the surface.

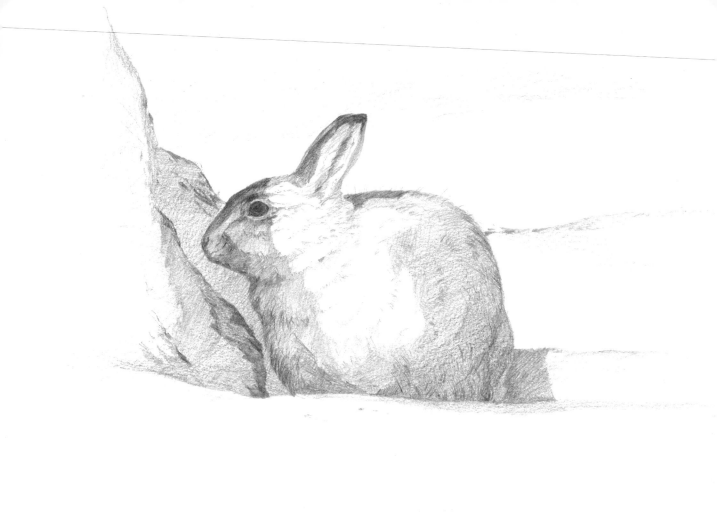

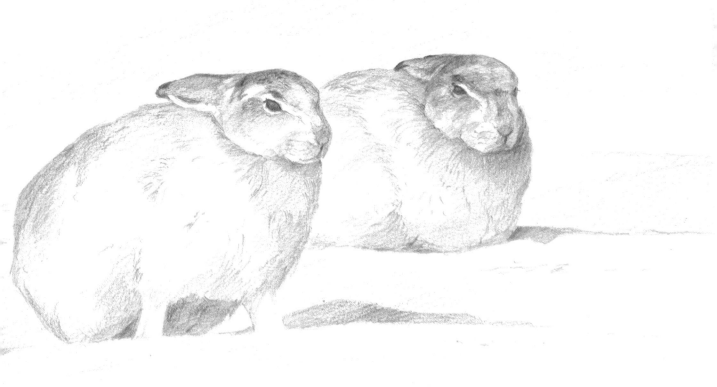

Tuesday 8th *Volcanic*

It was too overcast to do much outside so I went collecting rocks today. Up on the summits you can feel the bare bones of the landscape, see the structure of the hills. These mountains are the worn down stumps of Everests that were thrust up by the impact of continental plates some four hundred million years ago. These rocks are evidence of the enormous pressure that was exerted: granites and quartz formed by huge stresses underground; volcanic rocks spewn out at the edge of the folding; stress lines running where the stone was compressed and changed from sediment into granite. In places the rocks are splintered into sharp fragments by the ice action. Lower down they are rounded by the wear of erosion. In some places you can see the ridges where they have been gouged by glaciers. It is almost impossible to imagine the massive forces that thrust up the mountains and gouged out the glens. I took the rocks back to my studio to draw, comfortably, out of the cold and snow.

Friday 11th *Shelter*

Heavy snow forced me back down the hill well before I reached the summits. Around the lip of a steep corrie, I found a sheltered spot to drink some hot coffee and warm my body. Feet numb from the cold, face stinging, I watched a billowing cloud of snow stretch out horizontally from the top of the cliff, spin upwards and, losing the updraught, fall down onto the small lochan way below. Or rather to where the lochan should be. I could only see a thin grey line of bare ice at one end. The rest of it is buried under featureless drifts.

In a crevice at the far side of the cliff, I saw something white. A peregrine, sheltering like me, in the lee of the corrie. It sat in the dull shadow of an overhang, framed by small icicles that twisted out of the snow above. I did some sketches of the bird, which was looking thoroughly bedraggled, and hoped to work them up from the pencil notes at a later date. I didn't try to get any closer. I didn't want to flush the falcon out of cover and I also desperately wanted to get myself back home and into a hot bath. The wind had blown snow into my jacket hood and water was beginning to trickle maliciously down my back.

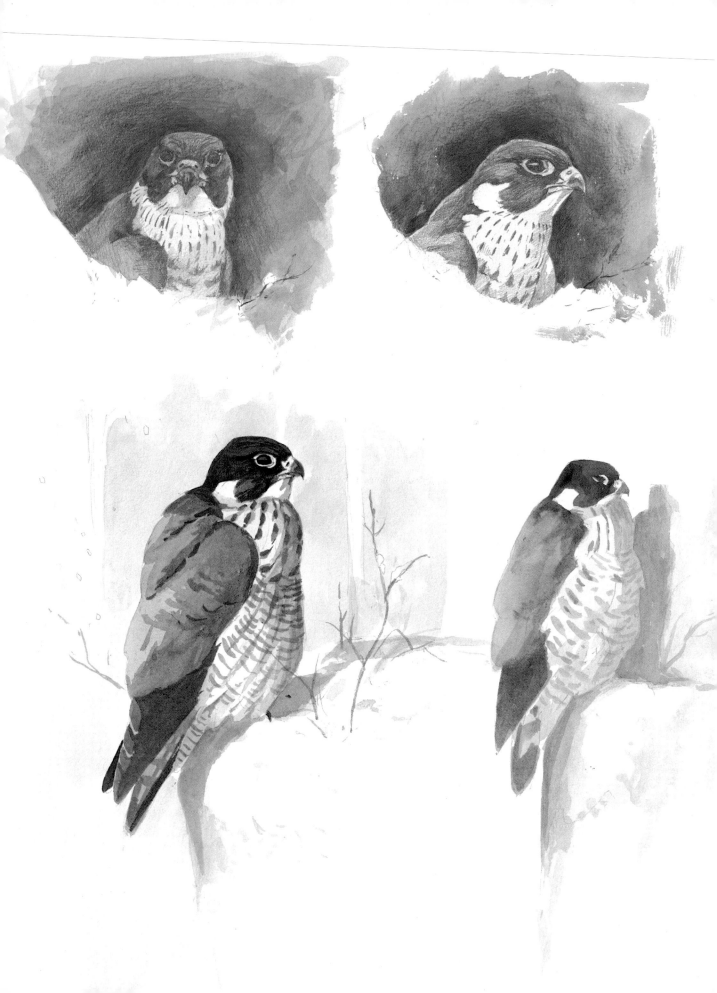

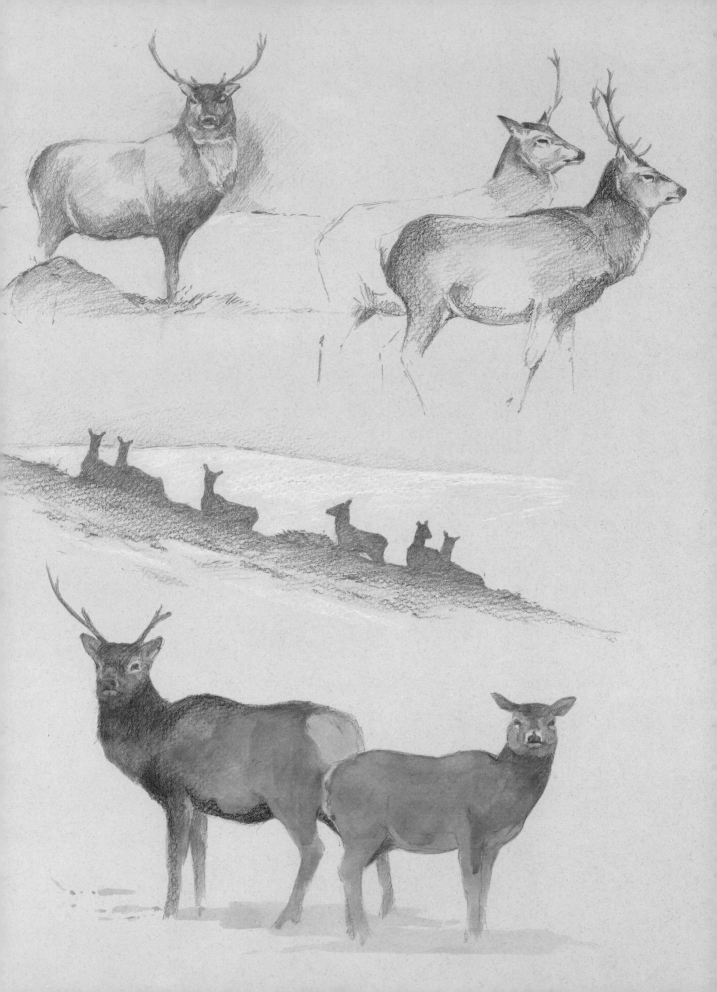

Monday 14th *Walking on air*

An illusion of space and light caused by the curtain of spindrift that whips across the ridge, half a dozen red deer were apparently flying through the air as they crossed the high ground between the glens. I was very surprised to see them here at all. They usually spend this time of year lower down in the glen, foraging at the forest edge. A stalker once told me that red deer can sense an oncoming break in the weather, moving lower down the glen before the storms break and returning to the mountains just as the thaw is about to set in. Watching this small herd it certainly seemed possible, for they gave the impression that they belonged to some mystical race of beasts. They crossed the invisible ridge and the spell was broken. Trotting across the plateau they disappeared down into the next glen, an Indian-trail of splayed prints winding away after them. I remember once seeing a red deer stag standing on a summit that was all but obscured by mist. Only the last few metres of the hill and the stag himself were visible, floating on an island in the air.

On the way back downhill I saw a hind's carcass near the trees. She had probably succumbed in the recent bad weather. Foxes had found her and eaten much of the forequarters, disembowelled her and rolled the offal downhill so that the meat would not spoil. Yellow urine splashes staked their claim at the wood-edge. A large bird of prey had been at the corpse as well, picked big holes in the flanks. It must have been an eagle, judging from the deep slashes in the hide and the large prints around the carcass in the snow.

Friday 18th *Fiach*

Like a black hole cut precisely out of the air, the ravens appeared suddenly against a paper-white sky and compassed a neat course between the summit and the far crags. They soared above the cliffs, lifting right up into the sky until they became distant specks among the clouds.

Like the ptarmigan, the ravens stay here year in, year out, through desolate winters and Highland summers. They are usually the earliest birds in the glen to breed and the female of this pair is already sitting in her nest on a nearby ledge used year after year by successive pairs of ravens. In fact, ravens have

flown here since long before men ventured into the glen. They nested not only on the mountain crags but in the ancient forests that covered the valley and lower slopes. They display their ownership of this territory which echoes with the deep, dark, ancient notes of their call as it has done with generations of their kind who have watched these same summits and corries change very little over the centuries.

There are many summits in the district named after these birds but in Glen Esk, their names, associated with prophecies of storms and rain, are given particularly to the Branny and the Forbie (Corbie) burns that swell with melting snow water as the first eggs are laid.

Tuesday 22nd *Joy-flying*

Ravens will mob almost any bird of prey, but are themselves rarely set upon by others. Eagles are more often their victims and are sometimes taunted mercilessly by these black pirates. Today, however, I watched a pair of golden eagles joy-flying near the ravens' cliffs. One raven flew up to intercept them, but was driven off by both birds. The other raven sat tight under an overhang, deciding, perhaps, that discretion was the better part of valour. Today was the eagles' day and these were their cliffs, for the moment at least. They soared along the lip of the corrie, fingering the updraught with the tapered feathers of their broad wings. First one, then the other, closed their wings and fell out of the air, straight down. Just three yards from the ground they thrust out their 'shoulders' and, using their momentum to get lift, arched upwards without even opening their wings until they reached the air currents at the cliff-top; spreading their broad wings like huge sails they rose once more.

The smaller male glided slowly in a wide loop, out to the far hills and back, without a single wing-beat and by the time he reached the cliffs again he had lost height. The female closed her wings, dived past the male and then swung upwards to meet with him. At the last moment she flung out one wing, fanned her tail and flipped over backwards. For one precarious moment their talons touched, hanging, for what could only have been an instant but seemed an impossible length of time, before they separated, flapping hard to gain height once again.

As if from nowhere, the ravens appeared. They had sought the advantage of height and flown in behind the female eagle who was labouring in the calm air in the lee of the mountain. One raven flew above her so that she could not escape into the updraught, occasionally pouncing down onto her back. The other dodged in behind and tweaked repeatedly at her tail. By the time the male eagle had turned, his mate was passing above him, still harried by both birds. One raven broke away to deal with the male while the other followed the female, still pecking at her tail. A couple of fierce scoldings and the male followed after her, a golden glint disappearing down the glen below me.

Ten minutes later, I saw the ravens return, calling victoriously to one another, having reclaimed the skies above their cliff.

Sunday 27ᵗʰ *Iolaire*

I was exploring some of the more remote summits and found a party of mountain hares scuffling about among the rocks on the hill-top. They were scraping away at the icy snow to get at the vegetation beneath – mainly lichens, mosses and stunted heather, from what I could see. The dull, mid-afternoon light gave their coats a dark colour, as if smudged with ash. I had been watching them for a while when, all of a sudden, the hares froze. For an instant the mountain-top was completely still as a large shadow swept in behind me. Then, as if a starting pistol had been fired, all the hares on the summit (at least a dozen more than I had originally seen) broke into full sprint and scattered. For a moment the shadow hesitated, pivoted slightly against the circle of the sun, and turned its bright yellow bill and eyes on its target. Slipping out of the sky the silhouette melted into its true colours of gold and brown. and took on the form of strong, broad wings and a powerful, heavy head and neck. The eagle fixed a straight line on a young hare, swept in behind it, and attacked. The hare dodged and the eagle, showering snow and earth up behind it, bounced up off the ground. For a fraction of a second I thought that the hare had escaped but the eagle still had momentum and, dropping straight out of the bounce, slammed into the hare's hind quarters. The hare's white head and forelegs twisted upwards as the large wings closed around it like a dark cloak, and then I heard its last cry, a scream of utter panic that had a shockingly human quality. The screaming stopped and I could see the eagle adjusting its grip on the carcass as it flew off with its prize.

At the time, I could remember little of the incident but the sweep of huge, dark wings against the snow; a yellow eye and bill moving against lichen-yellow rocks and a hare, its coat charcoal-flecked, dashing out just in front of its own, blue shadow. But when I got back to the studio, I could close my eyes and picture the scene vividly. I unpacked my sketchbooks and scribbled down all I could remember, working out the angle of the eagle's wings and the position of the hare so that I could transfer them to a larger painting. When drawing birds in flight, I find it useful to imagine that I can fly, to try to feel the movement of the air over the wings and feathers so that I can adjust the drawing accordingly. The long 'fingers' of an eagle's wing are formed by the deep notches on the primary flight feathers. An eagle can angle each one of these fingers so that they act as individual aerofoils and give extra lift when gliding. More importantly however, this extra lift that they provide for the eagle's relatively short wing allows it to manoeuvre well when close to the ground so that it can catch darting prey like the mountain hare.

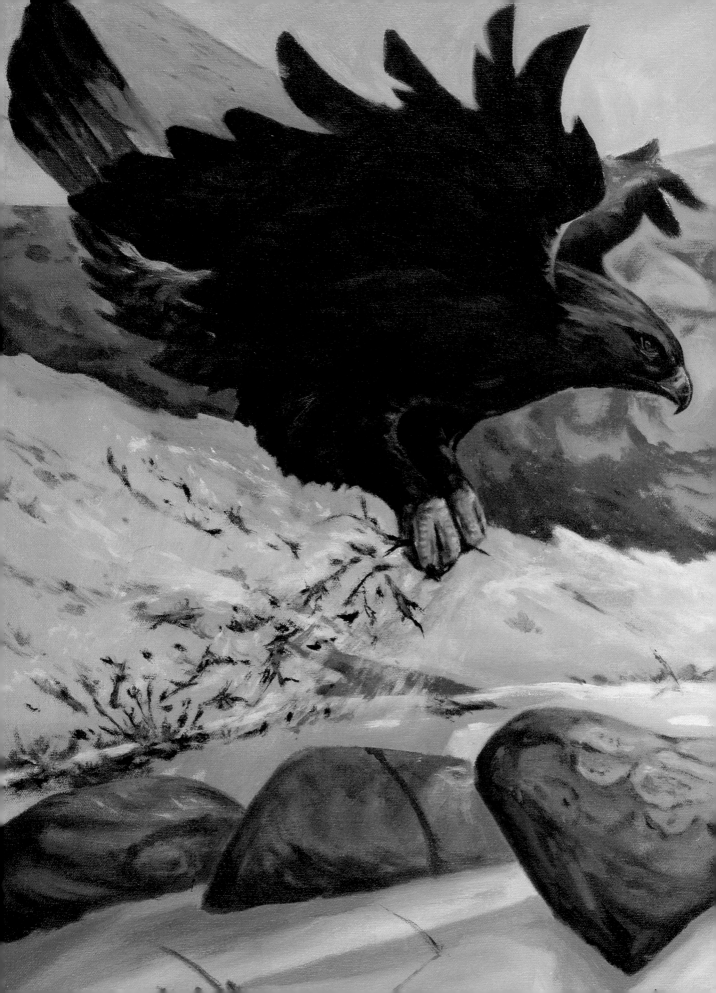